Light—Science & Magic

Fourth Edition

Light—
Science & Magic

An Introduction to Photographic Lighting

Fourth Edition

Fil Hunter
Steven Biver
Paul Fuqua

ELSEVIER

Amsterdam • Boston • Heidelberg • London
New York • Oxford • Paris • San Diego
San Francisco • Singapore • Sydney • Tokyo
Focal Press is an imprint of Elsevier

Focal Press

Focal Press is an imprint of Elsevier
225 Wyman Street, Waltham, MA 02451, USA
The Boulevard, Langford Lane, Kidlington, Oxford, OX5 1GB, UK

Notices
Knowledge and best practice in this field are constantly changing. As new research and experience broaden
our understanding, changes in research methods, professional practices, or medical treatment may become
necessary.

Practitioners and researchers must always rely on their own experience and knowledge in evaluating and using
any information, methods, compounds, or experiments described herein. In using such information or methods
they should be mindful of their own safety and the safety of others, including parties for whom they have a
professional responsibility.

To the fullest extent of the law, neither the Publisher nor the authors, contributors, or editors, assume any
liability for any injury and/or damage to persons or property as a matter of products liability, negligence or
otherwise, or from any use or operation of any methods, products, instructions, or ideas contained in the
material herein.

Library of Congress Cataloging-in-Publication Data
Hunter, Fil.
 Light—science & magic / Fil Hunter, Steven Biver, and Paul Fuqua. —4th ed.
 p. cm.
 ISBN 978-0-240-81225-0
 1. Photography—Lighting. I. Fuqua, Paul. II. Biver, Steven. III. Title.
 TR590.H84 2011
 778.7'2—dc23

 2011018511

British Library Cataloguing-in-Publication Data
A catalogue record for this book is available from the British Library.

For information on all Focal Press publications
visit our website at *www.elsevierdirect.com*

12 13 14 15 16 5 4 3 2 1

Printed in China

Typeset by: diacriTech, Chennai, India

Contents

CONTENTS

CONTENTS

CONTENTS

Dedications

I can't pay back the small handful of people who taught me most, but I can follow their example and teach others as well as I can. This book is my effort to do just that.

These are those people: Ruth Reavis, who expected me to work harder; Geneva Highfill and Wanda Walton, who taught the language; Betty Welch, who taught the mathematics; and Ross Scroggs, Sr., who taught me about photography and about the difference between humans and apes. Since then, I've tried my best to become a human.

Whatever errors I've made in this book reflect my own sloppiness and none of their teaching.

Without these people, this book wouldn't exist. Still, my most heartfelt thanks must go to wonderful Robin. Without her, I might no longer exist.

Fil Hunter

I would like to thank Vance Bockis, Farrah Abubaker, Jade Biver, Tony Burke, Mike Jones, Priscilla Jerez, Howard Connelly, and the wonderful folks at Lensbaby. I would also like to thank my wonderful family for all their support and contribution to this book.

Steven Biver

With gratitude to my ever patient wife, and undying admiration for Robert Yarbrough—a teacher who taught.

Paul Fuqua

With great appreciation to our publisher, Cara St. Hilaire; editor, Stacey Walker; and the rest of the wonderful Focal Press staff who have stood by and helped us in so many ways over the years.

The three of us

Introduction

It gives us, your authors, great pleasure to welcome you to this new edition. We would also like to thank you for all the support you have shown for *Light—Science & Magic* over the past near quarter of a century. We sincerely appreciate it.

Since our previous edition, the photographer's world—and everybody else's—has changed radically. Long established markets, relationships, and business models have shrunk, if not completely collapsed. Once valued skill sets have been rendered useless, and the fees clients are willing to pay have been reduced in every market sector. All in all, it's fair to say that not all things are rosy in today's stressed-out image-making world.

There is, however, also a good—a very good—side to things. While it is true that on the one hand we photographers may be challenged as perhaps never before, it is also true that over the past several years manufacturers have swamped us with a seemingly endless flood of truly amazing gear. New generations of cameras, lighting gear, high-resolution printers, and sophisticated software have revolutionized how we work and how we think.

Today, it is commonplace for us to do that of which we could not even dream those few years ago when the previous edition of this book rolled off the presses. And so it goes. In some ways we are worse off than we once were. In others, we are better off.

And then there is *light*—the collective result of all those busy little photons that buzz around the universe as they have since its creation. Light is everything for us. Light is, always has been, and always will be the very foundation of that amazing amalgamation of art and science we call photography. And now, thanks to your continued support, there is this, the newest edition of *Light—Science & Magic*. Our greatest hope for it is that it will, like earlier editions, help students to understand how light behaves, and always will. Armed with these timeless principles, one is ready to do battle—and thoroughly enjoy it—in this new and crazy world of picture making.

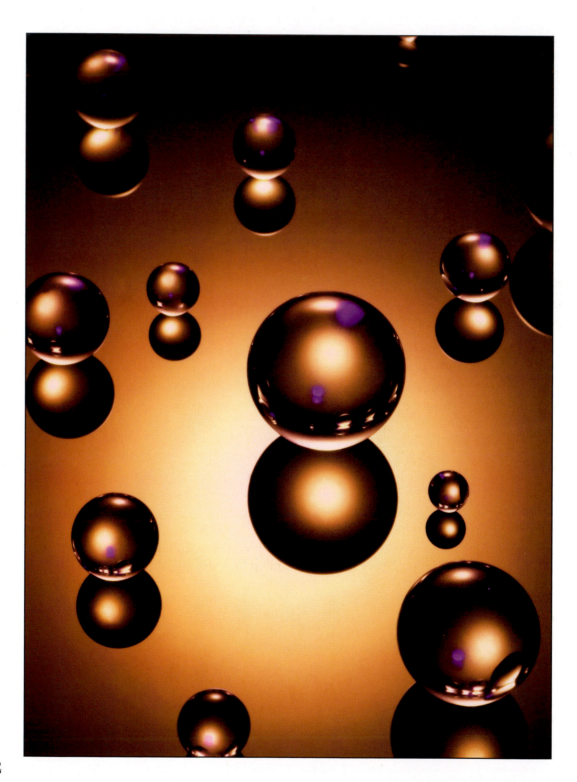

How to Learn Lighting

Light—Science & Magic is a discussion, not a lecture. You bring to this discussion your own opinions about art, beauty, and aesthetics. We do not intend to change those opinions and may not even influence them very much. We will be more bored than flattered if reading this book causes you to make pictures that look like ours. For better or worse, you have to build your own pictures on your own vision.

What we *do* have to offer you is *a set of tools*. This book is about technology. Science. Brass tacks. It is information for you to use when you please, if you please, and how you please. This does not, however, mean that this book is not about *ideas*, because it is. The basic tools of lighting are principles, not hardware. Shakespeare's tool was the Elizabethan English language, not a quill pen. A photographer without mastery of lighting is like a Shakespeare who could speak only the language of the people in the Globe Theatre pit. Being Shakespeare, he still might have come up with a decent play, but it certainly would have taken a lot more work and, very likely, more blind luck than most people are entitled to expect.

Lighting is the language of photography. Patterns of light convey information just as surely as spoken words. The information that light conveys is clear and specific. It includes definite statements, such as "The bark of this tree is rough" or "This utensil is made of stainless steel, but that one is sterling."

Lighting, like any other language, has a grammar and a vocabulary. Good photographers need to learn that grammar and vocabulary. Fortunately, photographic lighting is a lot easier to master than a foreign language. This is because physics, not social whim, makes the rules.

The tools we have included in this book are the grammar and vocabulary of light. Whatever we say about specific technique is important only to the extent that it proves the principles. *Please, do not memorize the lighting diagrams in this book.* It is entirely possible to put a light in exactly the same spot shown in the diagram and still make a bad picture—especially if the subject is not identical to the one in the diagram. But if you learn the principle, you may see several other good ways to light the same subject that we never mention and maybe never thought of.

WHAT ARE "THE PRINCIPLES"?

To photographers, the important principles of light are those that predict how it will behave. Some of these principles are especially powerful. You will probably be surprised to find how few they are, how simple they are to learn, and how much they explain.

We discuss these key principles in detail in Chapters 2 and 3. They are the tools we use for everything else. In later chapters we put them to work to light a wide range of subjects. At this point we will simply list them:

1. The effective *size of the light source* is the single most important decision in lighting a photograph. It determines what types of shadows are produced and may affect the type of reflection.
2. Three *types of reflections* are possible from any surface. They determine why any surface looks the way it does.
3. Some of these reflections occur only if light strikes the surface from within a limited *family of angles.* After we decide what type of reflection is important, the family of angles determines where the light should or should not be.

Just think about that for a minute. If you think lighting is an art, you're exactly right—but it's also a technology that even a bad artist can learn to do well. These are the most important concepts in this book. If you pay close attention to them whenever they come up, you will find they will usually account for any other details you may overlook or we forget to mention.

WHY ARE THE PRINCIPLES IMPORTANT?

The three principles we have just given are statements of physical laws that have not changed since the beginning of the universe. They have nothing to do with style, taste, or fad. The timelessness of these principles is exactly what makes them so useful. Consider, for example, how

they apply to portrait style. A representative 1952 portrait does not look like most portraits made in 1852 or 2012. However, and this is the important point, *a photographer who understands light could execute any of them.*

Chapter 8 shows some useful approaches to lighting a portrait. But some photographers will not want to do it that way, and even fewer will do so in 20 years. We do not care whether or not you use the method of portrait lighting we chose to demonstrate. We do, however, care very much that you understand exactly *how and why* we did what we did. It is the answers to those very "hows" and "whys" that will allow you to produce your own pictures your own way. Good tools do not limit creative freedom. They make it possible.

Good photographs take planning, and lighting is an essential part of that planning. For this reason, the most important part of good lighting happens before we turn on the first lights. This planning can take many days or it can happen a fraction of a second before pressing the shutter release. It does not matter when you plan or how long it takes, as long as you get the planning done. The more you accomplish with your head, the less work you have to do with your hands—you can think faster than you can move.

Understanding the principles we presented earlier enables us to decide what lights need to be where before we begin to place them. This is the important part. The rest is just fine-tuning.

HOW DID WE CHOOSE THE EXAMPLES FOR THIS BOOK?

The portrait is but one of the seven basic photographic subjects we discuss. We chose each subject to prove something about the basic principles. We also lit the subject to show the principle, regardless of whether there might be other good ways to light the same thing. If you know the principles, you will discover the other ways without any help from us.

This means that you should give at least some attention to every representative subject. Even if you have no interest in a particular subject, it probably relates to something you do want to photograph.

We also chose some of the subjects because they are rumored to be difficult. Such rumors are spread usually by people who lack the tools to deal with such subjects. This book dispels the rumors by giving you those tools.

In addition, we tried to use studio examples whenever possible. This does not mean *Light—Science & Magic* is only about studio lighting. Far from it! Light behaves the same way everywhere, whether it is

controlled by the photographer, by the building designer, or by God. But you can set up indoor experiments like ours at any hour of any day regardless of the weather. Later, when you use the same lighting in a landscape, on a public building, or at a press conference, you will recognize it because you will have seen it before.

Finally, we chose each example to be as simple as possible. If you are learning photography, you will not have to leave the setup in your living room or in your employer's studio for days at a time to master it. If you teach photography, you will find that you can do any of these demonstrations in a single class session.

How We Created the Cover

Before the publishing of this fourth edition of *Light—Science & Magic*, several of those who saw its cover asked how our co-author, Steven Biver, made it (Figure 1.1). With that in mind, we offer the following explanation:

The basic setup. The first thing that Steven did was to place a sheet of glossy black Plexiglas on his studio table (Figure 1.2). Next, he suspended frosted diffusion material above it as shown in the diagram. (This could have been done in any number of ways. Steven chose to

1.1 This is the cover image without the type.

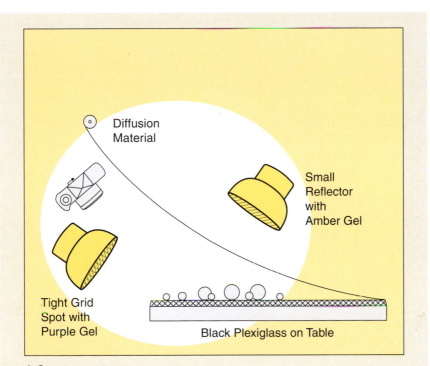

1.2 Lighting Diagram For Cover Image

clamp it to the back of the table and attach it to a bar suspended between two stands at the front.)

The lights. Once he had the table and diffuser arranged, Steven set up the two lights he planned on using. The first, his main light, was a flash head fitted with a small reflector to which he attached an amber gel. He then secured this light to a boom and suspended it over the center of the diffusion material, and about 1.5 feet above it. Next, Steven fitted a small reflector with a tight grid to which he attached a purple gel. He then put this head on a small stand and placed it close to and camera left of his camera.

The "pose." The arrangement of the clear acrylic balls on the black was very much a work in progress. Because the balls tended to roll off the table at inappropriate moments, Steven resorted to holding each in place with a tiny bit of wax. Later, during postproduction, he digitally "airbrushed" away any of these that showed.

The results. When Steven made his exposures, the amber-colored main light produced a soft, circular glow in the middle of his composition. The grid spot at the front of his setup produced the small purple highlights on all the acrylic balls. In addition, because of refraction, both lights produced even smaller secondary highlights on all the balls.

And finally. This was an interesting shot to make. We encourage any of you who might be interested to try making a similar image. A quick check online will provide plenty of sources for the kinds of Plexiglas sheeting, diffusion material, and acrylic balls Steven used.

We would love to see the results of your efforts. So would plenty of other photographers. And that's what the *Light—Science & Magic* site on Flickr is all about. So go ahead and post your work. Become a member of the "family."

TO DO, OR NOT TO DO?

If you are learning photography without any formal instruction, we suggest you try all of the basic examples in this book. Do not simply read about them. What happens in your head is the most important part of lighting, but the eye and the hand are still essential. Guided experience coordinates the three.

When we talk about soft shadows or polarized direct reflections, for example, you already know how they look. They happen in the world, and you see them every day. But you will know them and see them still better once you have made them happen.

If you are a student, your class assignments will keep you busy enough without any further demands from us. Your teacher may use the exercises here or invent new ones. Either way, you will learn the principles in the book because they are basic. They happen in all lighting situations.

If you are a professional photographer trying to expand your areas of expertise, your judgment about what exercises you need is better than ours. Generally, these will be those that are least like the things you are already photographing. You may find our basic examples to be too simple to be an entertaining challenge. Try complicating things a bit. Add an unexpected prop, an unusual viewpoint, or a special effect to our basic example. You might as well get a striking portfolio piece out of the effort while you are at it.

If you are a teacher, you can look at this book and see that most of the exercises show at least one good, simple, easy-to-master way to light even those subjects with reputations for maximum difficulty: metal, glass, white on white, and black on black.

Notice, however, that although we've done this in almost every case, we weren't able to do it in absolutely every one of them. The "invisible light" exercise in Chapter 6, for example, is pretty difficult for most beginners. Some students may also find the secondary background behind the glass of liquid in Chapter 7 to be beyond the limit of their patience. For this reason, if you find anything in this book that you haven't already done with your own hands and eyes, we strongly encourage you to be sure to try it yourself before deciding whether it is appropriate to the skills of your students.

WHAT KIND OF CAMERA DO I NEED?

Asking "What kind of camera do I need?" may seem silly to experienced photographers. But we have taught this material. We know how many students ask it, and we have to answer it. There are two good answers,

and they contradict each other slightly. The weight we place on each answer matters more than the answers themselves.

Successful photographs depend on the photographer more than the equipment. Inexperienced photographers work best with the camera with which they are familiar. Experienced photographers work best with the camera they like. These human factors sometimes have more to do with the success of a photograph than the purely technical principles.

Ideally, people learning photography should shoot digitally for the instant feedback this approach provides. Shooting digitally is far less expensive, and the quality that many of today's digital cameras provide borders on amazing. Of the many photographs in this book, we made all but a handful digitally.

Just which digital camera you should get is up to you. Fortunately, most manufacturers offer a number of reasonably priced cameras. Check out the many reviews that you will find in photography magazines and on the web. Talk to other photographers and, if possible, deal with a camera store whose sales staff knows what they are talking about. Camera clubs are also another good source of information, and if you are in school, your instructor will also be able to help you select the camera that best fits your needs and budget.

A WORD OF CAUTION

Any way you look at it, the advent of the digital world has been a wonderful thing for students. It is not, however, a totally win–win situation. Any digital camera is, at its heart, a computer. Because of this, the camera maker can program the camera to alter the image without the foreknowledge or consent of the photographer! This is often a good thing. The camera's decisions are, in our experience, more often than not correct. Sometimes, however, they are not.

A still bigger problem is that it is harder for the student to know whether what's happened, for better and for worse, is because of the camera's decision or because of the photographer's decision. You may make mistakes that the camera fixes, costing you a learning experience, or the camera can make a mistake and you innocently blame yourself for it.

In light of the preceding paragraphs, we offer two suggestions:

1. *Develop at least a minimal competence in postproduction skills.* You do not have to be a whiz-bang Photoshop genius to be an effective digital shooter. You do, however, need to learn at least the basics of one of the numerous (and now often amazingly inexpensive) digital editing programs that are now available.

2. *Shoot in the Raw format.* Because of its minimal in-camera compression, it stores far more of the visual information that reaches your camera's sensor than does the alternate JPEG format. Thus, during postproduction when you are fine-tuning your images, your software has far more digital information with which to work. And this can make a big difference—a *very* big difference.

Unfortunately, this book does not have the space needed to deal with the above two issues in detail. Digital cameras and postproduction software differ from each other because of the many decisions their designers, programmers, and manufacturers have made. If you are a student, the remedy for this is a close, ongoing talk with your instructor about what's happening in your pictures. If you are an experienced photographer, you can already tell when the camera is helping you and when it is hurting you.

The hardest path is that of a novice photographer attempting to learn the material in this book without the benefit of formal instruction. What we *can* offer those photographers is the assurance that the material can, indeed, be learned exactly that way. All three of the authors of this book did so. Talk with other photographers as much as possible. Ask questions, and always share with others whatever you have learned.

WHAT LIGHTING EQUIPMENT DO I NEED?

We expect you to ask this question, and we offer this two-part answer:

1. *No photographer has enough lighting equipment to do every assignment as well as possible.* No matter how much lighting equipment you have, there will be times when you want more. Suppose, for example, you can illuminate a large set to shoot at f/96 at 1/5000 a second. (Please call the fire department before turning on this apparatus.) You will probably then find that you want still more light in a particular shadow, or you may find that you need to light a still larger area to fit the required composition.
2. *Most photographers have enough equipment to do almost every assignment well.* Even if you have no lighting equipment at all, you may be able to get the job done. Can the subject be photographed outdoors? If not, sunlight through a window may be a good light source. Inexpensive tools, such as white cloth, black paper, and aluminum foil, can allow you to control sunlight as effectively as the best manufactured equipment.

Good lighting equipment is a great convenience. If the sun moves too far across the sky before you are ready to expose, you may have to wait until it returns the next day and hope there is no more and no less

cloud cover the second time around. Professional photographers know that convenience becomes necessity when they have to photograph what the client wants when the client wants.

This message is not aimed at professionals, however. They already know how to do whatever is needed with whatever is available. We are more interested in encouraging students now. You have advantages that professionals do not. Within broad limits, you can select the size of your subject.

Small scenes require less light. You may not have a 3-by-4-foot soft box, but a desk lamp with a 60-watt bulb with a tracing paper diffuser can light a small subject nearly as well.

Lack of equipment is, no doubt, a handicap. You know it and we know it. But it is not necessarily an insurmountable obstacle. A good dose of creativity may well overcome it. Just remember that creative lighting is the result of planning the lighting. Part of that creativity means anticipating the limitations and deciding how to best work around them.

WHAT ELSE DO I NEED TO KNOW TO USE THIS BOOK?

We assume you know basic photography. You know how to determine a reasonable exposure, at least close enough that bracketing can cover errors. You understand depth of field. You have mastered the basic operation of your camera.

That is all. We have no intention of being ruthless in our examination of your background credentials. Just to be safe, however, we suggest you keep a good basic photography book on hand when you read this one. (We did when we wrote it.) We do not want you to find easy material difficult just because we unknowingly use a technical term you have not seen before.

Finally, do not overlook the Internet. There is a wealth of information on it about lighting and photography. A search here and a search there are moments well spent by any photographer, advanced or beginner.

WHAT IS THE "MAGIC" PART OF THIS BOOK?

Learn about the light and the science. The magic will happen.

2

Light: The Raw Material of Photography

In some ways, photographers resemble musicians more than painters, sculptors, and other visual artists. This is because photographers, like musicians, are more interested in the manipulation of energy than that of matter.

Photography begins the moment light is emitted from a source. It climaxes with still more light reflected from a printed page or beaming from a monitor and striking a human eye. All steps between manipulate light, whether to control it, to record it, or, ultimately, to present it to a viewer.

Photography is the manipulation of light. Whether those manipulations serve artistic or technical purposes hardly matters; the two are often synonymous. Whether the manipulations are physical, chemical, electrical, or electronic, they are all motivated by the same mission and guided by the same understanding of how light behaves.

In this chapter we are going to talk about light, the raw material from which we make pictures. You, reader, are already familiar with most of the ideas we will discuss. This is because you have been learning to see since the day you were born. Even if you happen to be a novice photographer, the occipital lobe of your brain has enough information about the behavior of light for you to be a master.

We want to attach words and labels to some of this unconscious and semiconscious information. This will make it easier for us to talk about light with other photographers, just as musicians find it easier to say "b flat" or "4/4 time" instead of humming a scale or tapping a rhythm.

This is the most theoretical chapter in this book. It is also the most important because it is the foundation for all that follows.

WHAT IS LIGHT?

A complete definition of the nature of light is complex. In fact, several Nobel Prizes have been awarded for various contributions to the working definition we use today. We will simplify our discussion by using a definition adequate for applied photography. If you are still curious after reading this, see any basic physics text.

Light is a type of energy called *electromagnetic radiation*. Electromagnetic radiation travels through space in tiny "bundles" called *photons*. A photon is pure energy and has no mass. A box of photons the size of an elephant weighs nothing.

The energy of the photon produces an *electromagnetic field* around the photon. A field is invisible and cannot be detected unless there is a material object in the field on which it can exert a force. This sounds pretty mysterious until we realize that one common example of a field is the magnetic field surrounding an ordinary magnet. We cannot tell the field exists unless we move a nail close enough for the magnet to attract it. Then the effect of the field is apparent: the nail jumps to the magnet.

Unlike the field around the magnet, however, the electromagnetic field around the photon is not constant in strength. Instead, it fluctuates as the photon travels. If we could see this change in the strength of the field it would look something like Figure 2.1.

Notice that the strength of the field moves from zero to its maximum-positive strengths and then back to zero; it then repeats the pattern in the negative direction. This is why the field around a beam of light does not attract metal like an iron magnet does. The field around a photon of light is positive half of the time and negative the rest of the time. The average charge of the two states is zero.

As the term implies, an *electromagnetic field* has both an electrical component and a magnetic one. Each component has the same pattern of fluctuation: zero to positive, to zero, to negative, and back to zero again. The electrical component is perpendicular to the magnetic one.

The relationship between these two components is easier to see if we assume that Figure 2.1 represents just the magnetic component. Then, if you turn this book so that the edge of the page is toward you, the same diagram will represent the electrical field. Whenever the strength of either the magnetic or the electrical component is at its maximum, the other is at its minimum, so the total field strength remains constant.

All photons travel through space at the same speed, but the electromagnetic field of some photons fluctuates faster than that of others. The more energy a photon has, the faster the fluctuation. Human eyes can see the effect of this difference in photon energy levels and in the

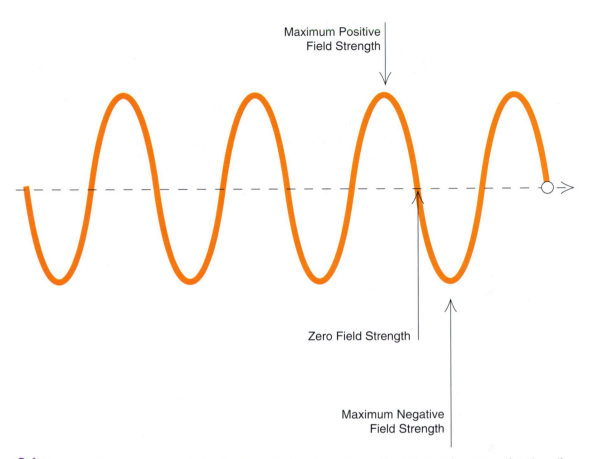

Maximum Positive
Field Strength

Zero Field Strength

Maximum Negative
Field Strength

2.1 The magnetic field around a photon fluctuates from its maximum-positive to its maximum-negative strength as the photon travels. The electrical field behaves exactly the same but out of phase with the magnetic field; whenever one field is at its maximum, the other is at its minimum strength.

rate of field fluctuation. We call the effect *color* (**Figure 2.2**). Red light, for example, has less energy than blue light, so the rate of its electromagnetic field fluctuation is only about two thirds as fast.

We call the rate of fluctuation of the electromagnetic field its *frequency*, and we measure it with the unit called *Hertz*, or, for convenience, megahertz (1 megahertz = 1,000,000 Hertz). Hertz is the number of complete wavelengths that pass a point in space each second. Visible light is only one narrow range out of all the many possible electromagnetic frequencies.

Electromagnetic radiation can travel through a vacuum and through some forms of matter. We know that light, for example, can pass through transparent glass. Electromagnetic radiation is not closely related to mechanically transmitted energy, such as sound or heat,

15

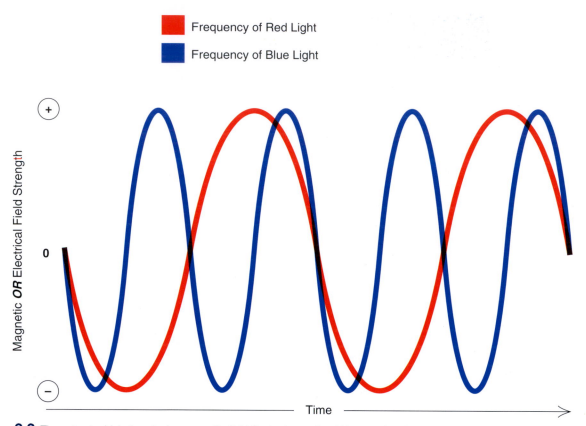

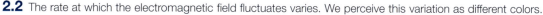

2.2 The rate at which the electromagnetic field fluctuates varies. We perceive this variation as different colors.

which can travel *only* through matter. (Infrared radiation and heat are often confused because they tend to accompany one another.) Sunlight reaches Earth, and very much beyond, without any fiber-optic lines to get it here.

Modern cameras are sensitive to a wider range of electromagnetic frequencies than the human eye can perceive (Figure 2.3). This is why a picture can be degraded by ultraviolet light, which we cannot see in a landscape, and, even worse, film can be degraded by x-rays, which we cannot see emitted by a machine at an airport.

HOW PHOTOGRAPHERS DESCRIBE LIGHT

Even if we confine our attention to the visible portion of the electro-magnetic spectrum, everyone knows that the effect of one group of photons may be radically different from that of another. Examining our album of mental images, we all see the difference between an autumn sunset, a welder's arc, and an early morning fog. Even in a standard

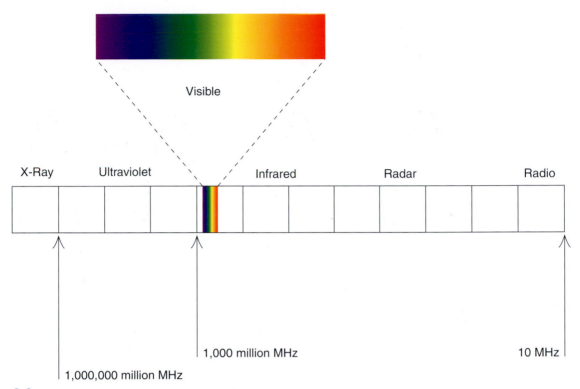

2.3 This diagram shows the electromagnetic spectrum. Notice that visible light is only one small part of it.

office location, the decision to install fluorescent tubes, tungsten spots, or large skylights can have a major effect on the decor (as well as on the mood and the productivity of the occupants).

Photographers, however, are interested in more than just the mental images of a given lighting effect. They need technical descriptions of the effect. Being able to describe the light is the first step in being able to control it. Or if the light is not controllable, as it is not in a landscape or an architectural picture, describing the light implies seeing the light well enough to know whether to shoot or to wait until conditions improve.

As photographers, we are primarily concerned with the brightness, color, and contrast of the light. In the following pages, we will take a brief look at each.

Brightness

To a photographer, the single most important quality of a light source is its brightness. A brighter light is almost always a better light.

17

At the most basic level, if the light is not bright enough, we cannot get a picture. If the light is brighter than the minimum we must have, then we can probably get a better picture.

Photographers who use film can use a smaller aperture or a faster shutter speed if they have more light. If they do not need, or want, a smaller lens opening or a shorter exposure time, then more light allows using a slower, finer grained film. Either way, the image quality improves.

Even if film is irrelevant, the brightness of the light source still is important. Videographers prefer a smaller aperture for most shots, as do still and motion picture photographers. Furthermore, adequate illumination allows a videographer to forego boosting the gain on the camera. This produces sharper pictures on the screen with better color saturation and less video noise.

Usually photographers prefer a dimmer light source only when there is an aesthetic improvement in one of the other qualities of light: the color or the contrast.

Color

We can use light of any color we please, and very strongly colored lights frequently make an artistic contribution to the photograph. Nevertheless, most pictures are made with white light. However, even "white" light comes in a range of colors. Photographers consider light to be "white" when it is a roughly even mix of the three primary colors: red, blue, and green. Human beings perceive this combination of light colors to be colorless.

The proportions of the color mixture may vary to a great extent, and people still cannot perceive any difference, unless they have the different light sources side by side for comparison. The eye can detect a very slight change in the color mixture, but the brain refuses to admit the difference. As long as there is a reasonable amount of each primary color, the brain says, "This light is white."

Digital cameras make the same automatic adjustment to color that the brain does, but not nearly as reliably. Photographers must therefore pay attention to the differences between various white light sources. To classify variations in the color of white light, photographers borrow the color temperature scale from physicists. The *color temperature scale* is based on the fact that if we heat a material in a vacuum hot enough, it will glow. The color of this glow depends on how much we heat the material. We measure *color temperature* in degrees on the Kelvin temperature scale. The measurement unit, *degrees Kelvin*, is simply abbreviated "K."

It is interesting that light with a *high* color temperature is composed of a disproportionate amount of those colors artists call *cool*. For example, 10,000°K light has a great deal of blue in it. Similarly, what physicists tell us is a *low* temperature source has much of those colors artists call *warm*. Thus, a 2000°K light tends toward the red to yellow family of colors. (None of this is surprising. Any welder can tell us that the blue–white welding arc is hotter than the piece of red-hot metal getting welded.)

Photographers use three standard light color temperatures. One of these is 5500°K and is called *daylight*. There are two tungsten color temperature standards, 3200°K and 3400°K. The last two are close enough together that sometimes the difference between them does not matter. These three light standards were developed for film, and we can still buy film that is *color balanced* for any of these three light color standards. Digital cameras, however, offer much more flexibility by adjusting numbers in the data processing to effectively allow shooting properly color-balanced pictures not only with light temperatures between any two of the three standards but also at temperatures much lower than 3200°K and much higher than 5500°K.

Contrast

The third important characteristic of a photographic light is its contrast. A light source has *high contrast* if its rays all strike the subject from nearly the same angle. Light rays from a *low-contrast* source strike the subject from many different angles. Sunlight on a clear day is a common example of a high-contrast light source. The rays of sunlight in Figure 2.4 are parallel to one another and all strike the subject from the same angle (despite the apparent difference in angle caused here by having to draw three dimensions on flat paper).

The easiest way to recognize a high-contrast light source is the appearance of the shadows. In the diagram, we see that no light enters the shadow area. This causes the edge of the shadow to be sharp and clearly defined. We made Figure 2.5 with such a light source. Notice the crisp, hard-edged shadow of the pepper.

A shadow with sharply defined edges is called a *hard shadow*. For this reason, high-contrast light sources are also said to be *hard lights*.

Now let us imagine what happens when cloud cover obscures the sun. Look at Figure 2.6. The sunlight scatters as it passes through the cloud. Consequently, the light that passes through the clouds strikes the subject from many different angles. Therefore, on an overcast day sunlight becomes a low-contrast light source.

19

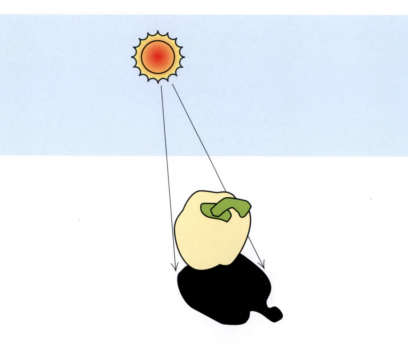

2.4 The rays from a small, high-contrast light source all strike a subject at approximately the same angle, producing a hard-edged shadow.

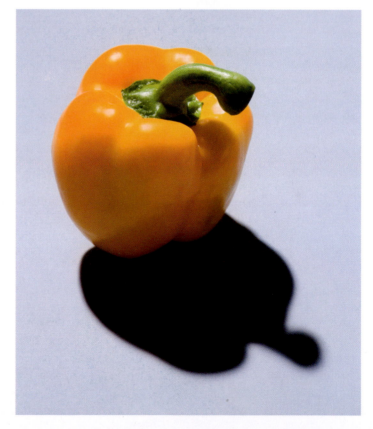

2.5 Hard-edged shadows are characteristically produced by small light sources.

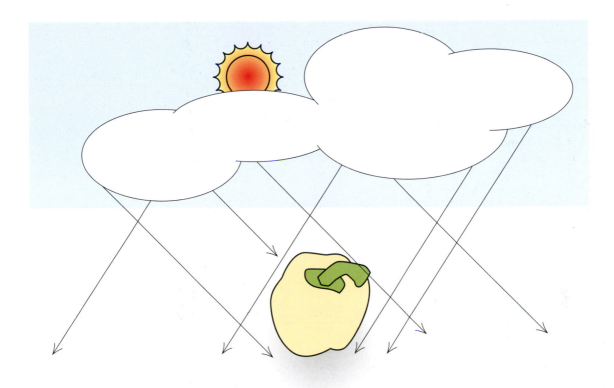

2.6 The cloud scatters the sun's light rays, causing them to strike the subject from many angles. This produces the soft shadow characteristic of large lights.

Again, the contrast of the light source is revealed by the appearance of the shadow. Some of the rays of light partly illuminate the shadow, especially at its edge. This difference is apparent in Figure 2.7.

In the photograph using low-contrast light, the shadow of the pepper is no longer clearly defined. It is no longer hard. The viewer cannot decide exactly what part of the tabletop is in shadow and what is not. A shadow such as this one, with no clearly defined edge, is called a *soft shadow*, and the light producing it is called a *soft light*.

Notice that we are using the words *hard* and *soft* only to describe how sharply the edge of a shadow is defined. We are *not* using these terms to describe how light or dark the shadow is. Notice that the *center* of each shadow is about the same gray in each picture. A soft shadow may be either light or dark, just as a hard shadow may be either light or dark, depending on factors such as the surface on which it falls and how much light gets reflected into the shadow by nearby objects.

For single light sources, the *size* of that source is the primary factor influencing its contrast. A small light source is always a hard light source,

21

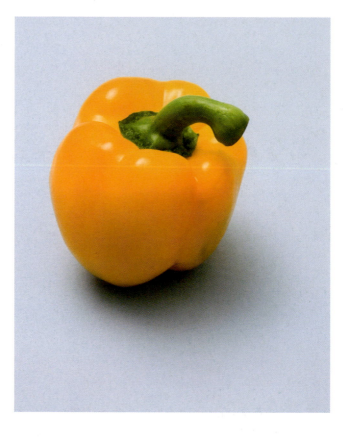

2.7 A shadow so soft that much of it is just barely visible is the result of a very large light source.

and most large sources are soft ones. We see that the sun in Figure 2.4 occupies little area in the diagram, so it is a small light source. The cloud covers a greater area in Figure 2.6, making it a large source.

Notice that the physical size of a light does not completely determine its effective size as a photographic light source. We know that the sun is more than 1 million kilometers in diameter. However, it is far enough away to act as a small source for a photographic subject on Earth.

If we could move the sun close enough to us, it would become an extremely large light source. We could then make softly lit photographs in sunlight, even without any cloud cover, assuming we could find a solution to the heat problem! Another extreme example has a more practical use: a small lamp on a laboratory workbench can be an effectively large source if we put it close enough to an insect specimen.

Be aware, however, that the correlation between the size of a light source and its contrast is just a generality, not an absolute. Remember that we can optically alter a light with special attachments. For example, a spot attachment can focus the light rays of a strobe head,

The Contrast of a Photograph

The contrast of the light is only one of the influences on the contrast of a photograph. If you are an experienced photographer, you know that you can find high contrast in an image with low-contrast light and vice versa.

Contrast is also determined by subject matter composition, exposure, and development. As everyone knows, a scene that includes black and white subjects is likely to have more contrast than one with entirely gray objects; but a software Levels or Curves adjustment can produce high contrast, even in an entirely gray scene in very-low-contrast lighting.

The relationship between exposure and contrast is a bit more complex. Increased and decreased exposure can reduce contrast in an average scene. However, increasing exposure will increase contrast in a dark subject, whereas decreasing exposure may increase contrast in a light gray scene.

We will talk about the relationship between lighting and contrast throughout this book, and we will show how exposure affects contrast in Chapter 9.

and a grid blocks the rays from all but a narrow range of angles. In neither case can the light strike the subject from many different angles. This makes a light equipped with such a device hard, regardless of its size.

LIGHT VERSUS LIGHTING

We have talked about the brightness, color, and contrast of light. These are all of the important characteristics of light. However, we have said very little about *lighting*. Indeed, the little we have said about lighting has more to do with the absence of light, the shadows, than with the light itself.

Shadow is the part of the scene that the light does not strike. *Highlight* is the area illuminated. We want to talk about highlight, but we are not quite ready for it. If you look at the two pepper pictures, you will see why. The two photographs have very different lighting, and you can see a difference in the highlights in the two pictures. However, the difference in the two highlights is minor; most viewers will notice only the difference in the shadow.

Is it possible that lighting determines the appearance of the shadow, but not the highlight? Figures 2.8 and 2.9 prove otherwise.

The glass bottles in Figure 2.8 were illuminated by a small, high-contrast light source. Figure 2.9 is the result of a large, soft source. Now the difference in the highlights is obvious. Why does the contrast of the light have such a dramatic effect on the appearance of the highlight on the bottle but almost no effect on the pepper? As you look at the examples, you already know that the difference in the lighting is caused by the subject itself.

23

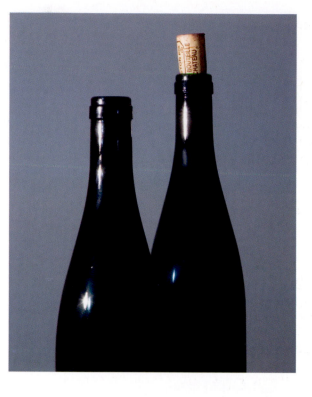

2.8 A small light source produces small, hard highlights on these glass bottles. Compare these with the highlights in the following photograph.

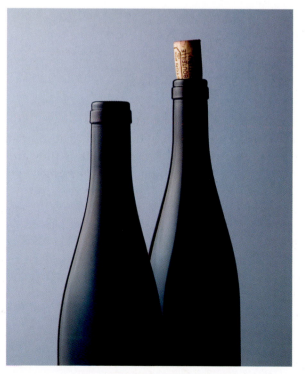

2.9 We produced these large highlights on the bottles by using a large light source.

Photographic lighting is more than just light. Lighting is a relationship between the light, the subject, and the viewer. If we want to say any more about lighting, we must talk about the subject.

HOW THE SUBJECT AFFECTS LIGHTING

Photons move. Photographic subjects often sit still. This is why we tend to consider light to be the "active" player in the photographic event. But this attitude handicaps our ability to "see" a scene.

Two identical photons striking two different surfaces can appear dramatically different to the eye and to the camera. The subject changes the light, and different subjects change the light in different ways. The subject plays an active role, just as the photon does. To perceive or to control lighting, we have to understand how the subject does that.

The subject can do three things to a photon that strikes it: it can transmit, absorb, or reflect that photon.

Transmission

Light that passes through the subject, as in Figure 2.10, is said to be *transmitted*. Clean air and clear glass are examples of common materials that transmit light.

Showing you a photograph of transmitted light would be useless. A subject that *only* transmits the light cannot be seen. The subject that does not alter the light in some way is invisible. Of the three basic interactions between the light and the subject, simple transmission is the least significant in a discussion of photographic lighting.

However, the simple transmission shown in Figure 2.10 can occur *only* if the light strikes the surface at an angle perpendicular to it. At any other angle, the transmission of the light has accompanying refraction. *Refraction* is the bending of rays of light as they are transmitted from one material to another. Some materials refract light more than others. Air, for example, refracts light very little, whereas the glass used in a camera lens refracts it a great deal. Figure 2.11 illustrates the phenomenon.

Refraction is caused by a variation in the speed of light caused by the material through which it is transmitted. (The speed of light is constant *in a vacuum*.) The light in Figure 2.11 is slowed as it enters the denser glass. The photons that strike the glass first are the first to have their speed reduced. The other photons, still in air, race ahead, causing a bending of the ray. Then the ray bends a second time, but in the opposite direction, as each photon regains its speed upon exiting back into the air.

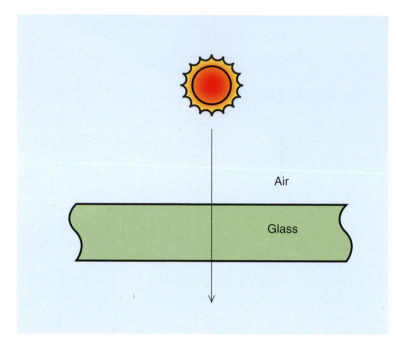

2.10 Transmitted light. Clear glass and clean air are common materials that transmit visible light well.

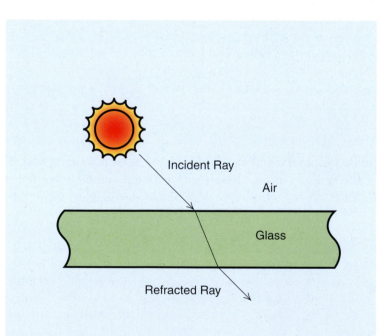

2.11 A light ray striking a light-transmitting material at any angle bends. This bending is called *refraction*. Dense glass, such as that used for camera lenses, refracts light especially strongly.

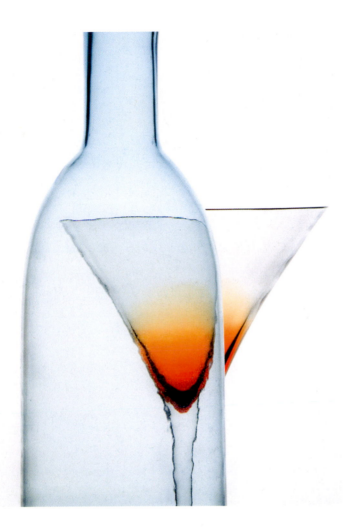

2.12 The foreground glass bottle refracts the image of the cocktail glass in the back.

Unlike simple transmission, refraction can be photographed. This is one of the reasons that completely transparent subjects are not invisible. Refraction causes the wavy edge of the martini glass in Figure 2.12.

Direct and Diffuse Transmission

So far we have talked about *direct transmission*, in which light passes through a material in a predictable path. Materials such as white glass and thin paper scatter the light rays in many random, unpredictable directions as they pass through. This is called *diffuse transmission* (Figure 2.13).

Materials that produce diffuse transmission are called *translucent* to distinguish them from *transparent* materials, such as clear glass, which do not significantly diffuse the light.

27

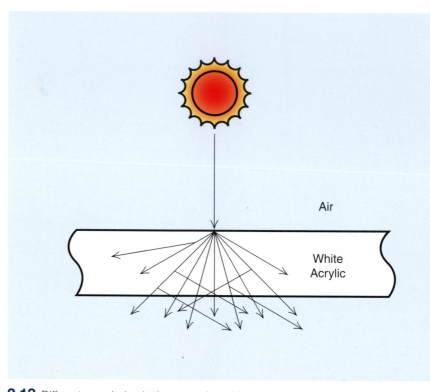

2.13 Diffuse transmission is the scattering of light passing through a translucent material.

Diffuse transmission is more important when we talk about light *sources* than in discussing photographic *subjects*. Covering a small light with a large translucent material is one way to increase its size and, therefore, to soften it. A diffusion sheet in front of a strobe and the clouds covering the sun, as in Figure 2.6, are examples of translucent materials serving such a function.

Translucent *subjects* are of little special importance to photographers because their translucence usually requires no special lighting consideration. This is because they always absorb some of the light and reflect some of the light, in addition to transmitting it. Absorption and reflection are both more major influences on photographic lighting. We will deal with these next.

Absorption

Light that is *absorbed* by the subject is never again seen as visible light. The absorbed energy still exists, but the subject emits it in an invisible form, usually heat (Figure 2.14).

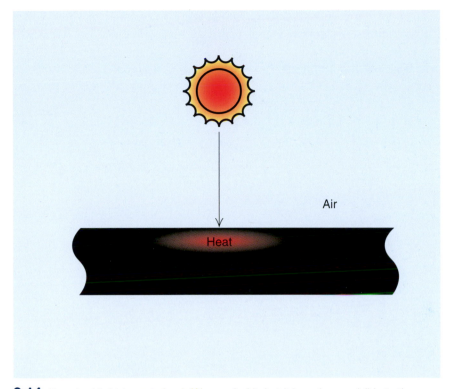

2.14 Absorbed light turns to heat. We can feel it, but it is no longer visible to the camera.

Like transmission, simple absorption cannot be photographed. It is "visible" only when we compare it to other light in the scene that is not absorbed. This is why highly light-absorbing subjects, such as black velvet or black fur, are among the most difficult things to photograph.

Most subjects absorb part, but not all, of the light striking them. This partial absorption of light is one of the factors that determine whether we see a given subject as black, white, or some intermediate gray. Any particular subject will also absorb some frequencies of light more than others. This selective absorption of certain light frequencies is one of the factors determining the color of a subject.

Reflection

Reflection is light striking a subject and bouncing off. You know that and need no further explanation from us. The concept is easy because we use it daily. Reflection makes vision possible. We do not see objects; we see light. Because most objects produce no light, their visibility depends

entirely on light reflected from them. We do not need to show you a photograph of reflection. Almost any picture you have on hand will serve the purpose.

However, the familiarity of reflection does not mean that it needs no further discussion. On the contrary, its importance demands that we devote most of the next chapter to it.

3

The Management of Reflection and the Family of Angles

In the previous chapter we looked at light and how it behaves. We learned that the three most important qualities of any light source are its *brightness*, *color*, and *contrast*. We also learned that the subject, not just the light, has a major influence on lighting. A subject can transmit, absorb, or reflect the light that strikes it.

Of the three ways the subject can affect the lighting, reflection is the most visible. Highly transparent subjects have minimal effect on light, so they tend to be invisible. Highly absorbent subjects may also be invisible because they convert light into other forms of energy, such as heat, which we cannot see.

Photographic lighting, therefore, is primarily an exercise in reflection management. Understanding and managing reflection, for the result the photographer wants, is good lighting. In this section, we will look at how subjects reflect light and how to capitalize on those reflections.

We will begin our discussion of reflection with a "thought experiment." We would like you to create three different images in your mind. First, on a desktop, imagine a piece of very thick, perfectly smooth, gray paper. The gray should be a medium one, light enough to write on but dark enough that no one would confuse it with white. Next, visualize a piece of metal of the same size as the paper. We suggest old pewter. The metal should also be smooth and exactly the same gray as the paper. Third, make a mental ceramic tile, very glossy and the same shade of gray as the other two subjects. Finally, put the three mental images together on the same desk and examine the differences you see in the three subjects.

Notice that none of the subjects transmits any light. (That is why we made the paper thick.) Furthermore, they all appear to absorb the same amount of light (because they are all the same gray). Yet the difference in the three subjects is apparent. You have seen it. (If not, try again, and you will, now that you know we expect you to do so!)

The reason that these subjects, with identical transmission and absorption, appear different is that *the subjects reflect the light differently*. The reason you can see the differences without looking at examples on this page is that they are part of that visual knowledge you already have in the occipital lobe of your brain.

In this chapter, we are not going to tell you very many things your brain does not already know. We will, however, put some of that knowledge into words. This will make it easy for us to talk about reflection for the rest of this book.

TYPES OF REFLECTIONS

Light can reflect from a subject as *diffuse reflection, direct reflection*, or *glare*. Most surfaces cause some of each of these three types. The proportions of each type of reflection vary with the subject, and it is the proportion of each reflection in the mix that makes one surface look different from another.

We are going to examine each of these types of reflections in some detail. In each case, we will assume that the reflection is a perfect example, uncontaminated by either of the other two. This will make it easier to analyze each of them. (Events in nature sometimes offer nearly perfect examples.)

For now, we do not care what type of light source might be producing any of the following examples. Only the reflecting surface matters. Any sort of light could work.

Diffuse Reflection

Diffuse reflections are the same brightness regardless of the angle from which we view them. This is because the light from the sources is reflected equally in all directions by the surface it strikes. Figure 3.1 shows a diffuse reflection. In it we see light falling on a small white card. Three people are pointing their cameras at it.

If each of these individuals were to photograph the white card, each of their pictures would record the subject as the *same* brightness. On film, the image of the card would have the same density in each negative. Neither the angle of illumination of the light source nor the

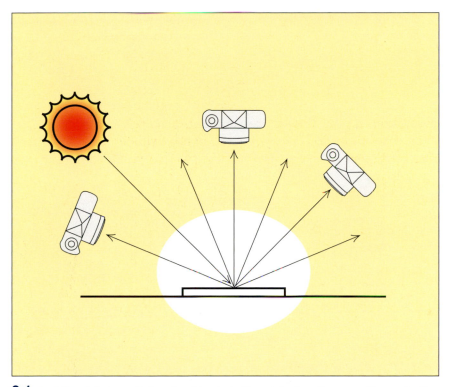

3.1 A white card gives off almost nothing but diffuse reflection. Because diffuse reflection from a light source is reflected equally in all directions from the surface, all three cameras see the card as having the same brightness.

camera's angle of view would affect the brightness of the subject in such a picture.

Other than in lighting textbooks, no surfaces reflect light in a perfectly diffuse manner. However, white paper approximates such a surface. Now look at Figure 3.2. Notice that the scene contains a mostly white diagram.

There is a reason that we chose to put the white circuit diagram in this particular example. All white things produce a great deal of diffuse reflection. We know this because they appear white regardless of the angle from which we view them. (Walk around the room you are in now. Look at the white objects and the black objects from different angles. Notice that the apparent brightness of the black objects may change with viewpoint, but the white objects stay about the same.)

The contrast of the light source does not affect the appearance of a diffuse reflection. It is worth proving this with one more picture of the

35

3.2 The diagram in this scene gives off primarily diffuse reflection. It would appear white from any angle.

Diffusion Confusion

Photographers diffuse the light source by reflecting the light from an umbrella or by covering it with a translucent material. We call light passing through translucent material *diffuse transmission*. Now we speak of *diffuse reflection*. The two concepts have enough in common that we should pay special attention to the differences between them.

Diffusing the light source has no effect on whether the reflection is diffuse. Remember that small light sources are always "hard" (undiffused) and that large light sources are almost always "soft" (diffused). Then notice that Figures 3.2 and 3.3 show diffuse reflections produced by both diffused and undiffused light sources. Similarly, Figures 3.5 and 3.6 show direct reflections produced by diffused and undiffused light sources, as you'll see later in the chapter.

The word *diffusion* is a good one because its meaning is perfectly consistent in both uses. In each case, it means a scattering of the light. But *what* does the scattering—the light or the subject? The source determines the type of light, and the surface determines the type of reflection. Any light can produce any reflection, depending on the subject.

3.3 The soft shadows prove we used a large light. The highlights on the diagram look similar because the size of the light source does not alter the appearance of diffuse reflection.

same scene. A small light was used for the earlier photograph. We could see that by the hard shadows cast by the objects in it. Now look at Figure 3.3 to see what happens when we use a large light instead.

Predictably, the large light source has softened the shadows in the scene, but notice that the highlights on the paper look about the same. The diffuse reflection from the surface of the paper is identical to that in Figure 3.2.

So we now have seen that neither the angle nor the size of the light source affects the appearance of a diffuse reflection. However, the distance from the light to the surface of the subject does matter. The closer the light gets to the subject, the brighter the subject becomes and, at a given exposure setting, the lighter the subject appears in the finished picture.

Specular Reflection and Specular Light

Photographers sometimes call direct reflection *specular reflection*. As a synonym for direct reflection, this is a perfectly good term. If you use the word *specular* in this way, please feel free to substitute the words as you read *direct reflection*.

However, some photographers also use *specular* to mean smaller, brighter highlights within a large one; others mean highlights created by a small light source. *Direct reflection* does not necessarily imply either of these. Because *specular reflection* has different meanings to different people, we will not use the term in this book.

Modern usage adds further inconsistency. Originally, *specular* was used to describe *only* the reflection, not the source of the light. (The Greek root means "mirror.") Today, some photographers use *specular light* as a synonym for *hard light,* but a "specular" light source does not necessarily produce a "specular" reflection. A hard light is always hard, but the way it reflects depends on the surface of the subject. So we will always call specular lights *hard* to make it clear that we are talking about the light, not the reflection.

The Inverse Square Law

A diffuse reflection gets brighter if we move the light source closer to the subject. If we needed, we could calculate this change in brightness with the inverse square law. The *inverse square law* says that intensity is inversely proportional to the square of the distance. Thus, a light at any particular distance from the subject will light the subject with an intensity four times as bright as the same light twice as far away. Similarly, a light will have nine times the intensity of the same light moved three times as far from the subject. As the intensity of the light falling on the subject varies, so does that of the diffuse reflection.

Ignoring the math, this simply means that reflection from a surface gets brighter if we move the light closer and it gets dimmer if we move the light farther away. Intuitively, this seems immediately obvious. Why even bother to mention it? Because such intuition is often misleading. Some subjects, as we shall soon see, do not produce brighter reflections as the light moves closer to them.

Direct Reflection

Direct reflections are a mirror image of the light source that produces them. They are also called *specular reflections*.

Figure 3.4 is similar to Figure 3.1, but this time we have replaced the white card with a small mirror. Both the light source and the observers are in the same positions as they were in earlier.

Notice what happens. This time one of the three cameras now sees a blindingly bright reflection, whereas the others see no reflection at all in the mirror.

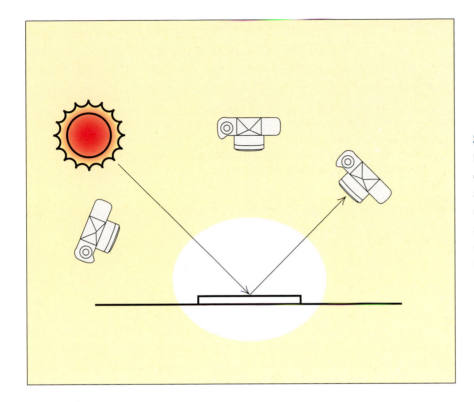

3.4 Direct reflection. Looking at the mirror, one of the cameras sees a blinding reflection of the light source, whereas the others see no reflection at all.

This diagram illustrates the direct reflection produced when a light is directed at a polished surface such as glass. The light rays bounce from the smooth surface at the same angle at which they hit it. More precisely stated, *the angle of incidence equals the angle of reflectance.* This means that the point at which direct reflections can be seen is exactly determined by the angles between the light source, the subject, and the camera viewpoint.

So with all that in mind, it is easy to understand why the three cameras see such a difference in the brightness of the mirror. Those positioned on each side receive no reflected light rays. From their viewpoint, the mirror appears black. None of the rays from the light source is reflected in their direction because they are not viewing the mirror from the one (and *only*) angle in which the direct reflection of the light source can happen.

However, the camera that is directly in line with the reflection sees a spot in the mirror as bright as the light source itself. This is because the angle from its position to the glass surface is the same as the angle from the light source to the glass surface. Again, no real subject produces a perfect direct reflection. Brightly polished metal, water, or glass may nearly do so, however.

39

Breaking the Inverse Square Law?

Did it alarm you to read that the camera that sees the direct reflection will record an image as bright as the light source? How do we know how bright the direct reflection will be if we do not even know how far away the light source is?

We do not need to know how far away the source is. The brightness of the image of a direct reflection is the same regardless of the distance from the source. This principle seems to stand in flagrant defiance of the inverse square law, but an easy experiment will show why it does not.

You can prove this to yourself, if you like, by positioning a mirror so that you can see a lamp reflected in it. If you move the mirror closer to the lamp, it will be apparent to your eye that the brightness of the lamp remains constant.

Notice, however, that the *size* of the reflection of the lamp *does* change. This change in size keeps the inverse square law from being violated. If we move the lamp to half the distance, the mirror will reflect four times as much light, just as the inverse square law predicts, but the *image* of the reflection covers four times the area. So that image still has the same brightness in the picture. As a concrete analogy, if we spread four times the butter on a piece of bread of four times the area, the thickness of the layer of butter stays the same.

Now we will look at a photograph of the scene in the previous diagram. Once again, we will begin with a high-contrast light source. Figure 3.5 has a mirrored surface instead of the earlier diagram. Here we see two indications that the light source is small. Once again, the shadows are hard. Also, we can tell that the source is small because we can see it reflected in the mirrored surface of the DVD. Because the image of the light source is visible, we can easily anticipate the effect of an increase in the size of the light. This allows us to plan the size of the highlights on polished surfaces.

Now look at Figure 3.6. Once again, the large, low-contrast light source produces softer shadows. The picture is more pleasing, but that is not the important aspect. More important is the fact that the reflected image of the large light source completely fills the DVDs. In other words, the larger light source fills the *family of angles that causes direct reflection*. This family of angles is one of the most useful concepts in photographic lighting. We will discuss that family in detail.

The Family of Angles

Our previous diagrams have been concerned with only a single point on a reflective surface. In reality, however, each surface is made up of an infinite number of points. A viewer looking at a surface sees each of

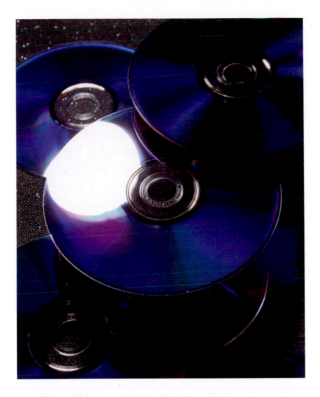

3.5 Two clues tell us this picture was made with a small light source: hard shadows and the size of the reflection in the DVD.

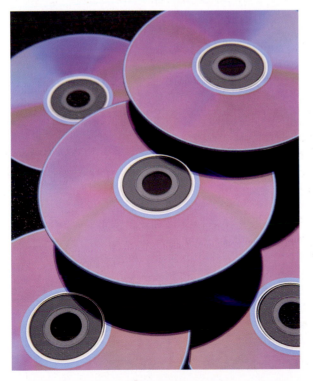

3.6 A larger light softens shadows. More important, the reflection of the light now completely fills the DVDs. This is because the light we used this time was large enough to fill the family of angles that causes direct reflection.

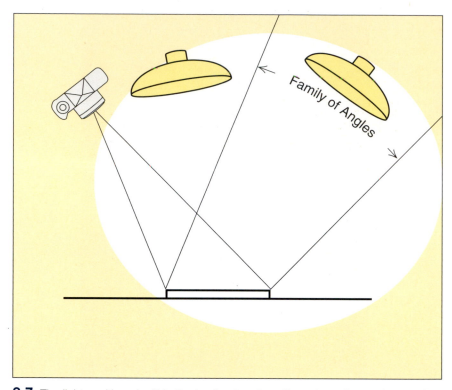

3.7 The light positioned within the family of angles will produce direct reflection. The other light, outside the family of angles, will not.

these points at a slightly different angle. Taken together, these different angles make up the *family of angles that produces direct reflection*.

In theory, we could also talk about the family of angles that produces diffuse reflection. However, such an idea would be meaningless because diffuse reflection can come from a light source at *any* angle. Therefore, when we use the phrase *family of angles* we will always mean those angles that produce direct reflection.

This family of angles is important to photographers because it determines where we should place our lights. We know that light rays will always reflect from a polished surface, such as metal or glass, at the *same* angle as that at which they strike it. So we can easily determine where the family of angles is located, relative to the camera and the light source. This allows us to control if and where any direct reflection will appear in our picture. Figure 3.7 shows the effect of lights located both inside and outside this family of angles. As you can see from Figure 3.7, any light positioned *within* the family of angles *will* produce a direct reflection. A light placed anywhere else will not. Consequently, any light positioned *outside* of the family of

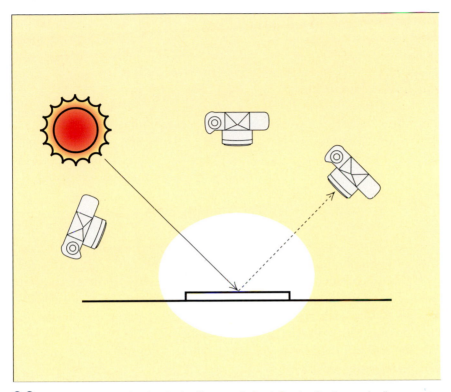

3.8 Polarized direct reflection looks like unpolarized direct reflection, only dimmer.

angles *will not* light a mirror-like subject at all, at least as far as the camera can see.

Photographers sometimes want to see direct reflection from most of the surface of a mirror-like subject. This requires that they use (or find in nature) a light large enough to fill the family of angles. In other scenes, they do not want to see any direct reflection at all on the subject. In those instances, they must place both the camera and the light so that the light source is not located within the family of angles. We will use this principle repeatedly in the coming chapters.

Polarized Direct Reflection

A *polarized direct reflection* is so similar to an ordinary direct reflection that photographers often treat them as the same. However, these reflections offer photographers several specialized techniques and tools for dealing with them.

Like the direct reflection, only one viewer in Figure 3.8 will see the reflection. Unlike the direct reflection, an image of the polarized reflection is always substantially dimmer than a photograph of the light

43

source itself. A *perfectly* polarized direct reflection is exactly half as bright as an unpolarized one (provided the light source itself is not polarized). However, because polarization is inevitably accompanied by absorption, the reflections we see in the scene are more likely to be much dimmer than that.

To see why polarized reflection cannot be as bright as an unpolarized direct reflection, we need to know a bit about polarized light. We have seen that the electromagnetic field fluctuates around a moving photon. Figure 3.9 represents this fluctuating field as a jump rope being swung between two children. One child is spinning the rope while the other simply holds it.

Now, let's put up a picket fence between the children, as shown in Figure 3.10. The rope now bounces up and down instead of swinging in an arc. This bouncing rope resembles the electromagnetic field along the path of a photon of polarized light.

Molecules in a *polarizing filter* block the oscillation of the light energy in one direction, just as the picket fence does to the oscillating energy of the jump rope. The molecular structure of some reflecting surfaces also blocks part of the energy of the photon in the same manner. We see such a photon as a polarized reflection or glare. Now suppose, not being satisfied with eliminating just a part of the children's play, we install a horizontal fence in front of the first, as shown in Figure 3.11.

With the second fence in place, if one child spins the rope, the other sees no rope movement at all. The crossed picket fences block the transmission of energy from one end of the rope to the other. Crossing the axes of two polarizing filters blocks the transmission of light, just as the two picket fences do with rope energy. Figure 3.12 shows the result. Where the polarizers overlap with their axes perpendicular, none of the type is visible on the page. The transmission of light reflected from the page to the camera has been completely blocked.

A lake, painted metal, glossy wood, or plastic can all produce polarized reflection. Like the other types of reflections, the polarization is not perfect. Some diffuse reflection and some unpolarized direct reflection are mixed with the glare. Glossy subjects produce a greater amount of polarized reflection, but even matte surfaces produce a certain amount.

Polarized direct reflection is more visible if the subject is black or transparent. Black and transparent subjects do not necessarily *produce* stronger direct reflections than white ones. Instead, they produce weaker diffuse reflection, making it easier to *see* the direct reflection. This is why you saw the change in apparent brightness of the black objects, but not of the white ones, when you walked around your room a while ago.

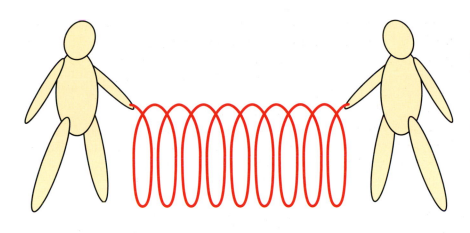

3.9 The oscillating electromagnetic field around a photon represented as a jump rope. The child on the left is spinning the rope while the one on the right holds on.

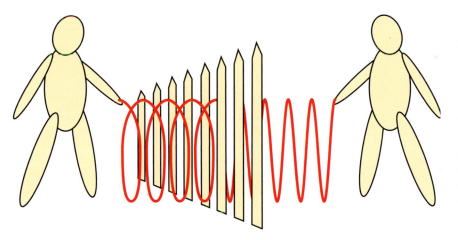

3.10 When the children spin the rope through the picket fence, it bounces up and down instead of spinning in an arc. A polarizing filter blocks the oscillation of light energy in much the same way.

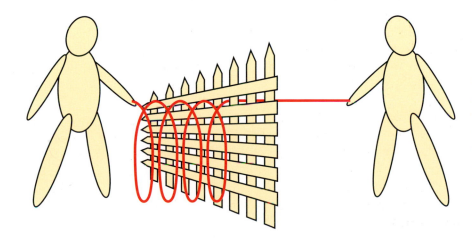

3.11 Because we've added a horizontal fence to the first, when one child spins the rope, the other will see no movement.

45

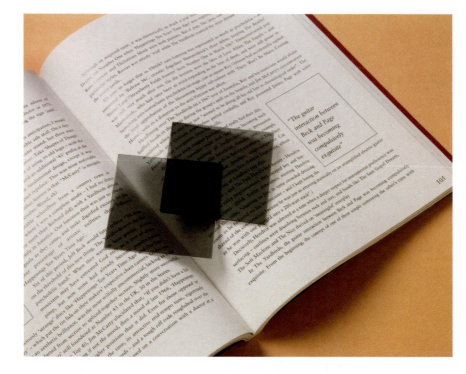

3.12 The axes on the two overlapping polarizers are perpendicular. They block light much as the two fences did with the energy of the jump rope.

Glossy black plastic can show us enough polarized reflection to make a good example. The scene in Figure 3.13 includes a black plastic mask and a feather on a sheet of glossy black plastic. We used the same camera and light position as in the pictures of the diagram and mirrored surface. You can tell by the size of the reflections that we used a large light source.

Both the mask and the plastic sheet produce nearly perfect polarized reflection. From this angle, glossy plastic produces almost no unpolarized direct reflection; black things never produce much diffuse reflection. However, the feather behaves quite differently. It produces almost nothing but diffuse reflection.

The light source was large enough to fill the family of angles defined by the plastic sheet, creating direct reflection over the entire surface. The same light was large enough to fill only part of the family of angles defined by the mask. We know this because of the highlights we see only on the front of the mask.

Now look at Figure 3.14. We made it with the same arrangement used in the previous picture, but now we've placed a polarizing filter over the camera lens. Because polarized reflection was almost the only reflection from the black plastic in Figure 3.14, and because the polarizing filter blocks glare, little of the light reflected from any of the black plastic items photographed reached the camera. As a result, the plastic now looks black.

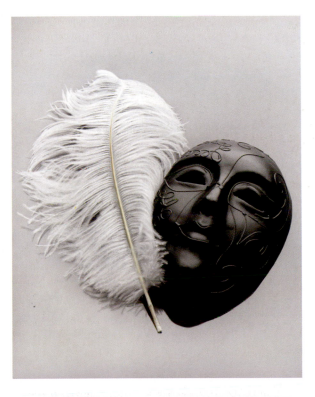

3.13 The glossy black plastic sheet and mask produce almost nothing but polarized direct reflection. The feather gives off almost nothing but diffuse reflection.

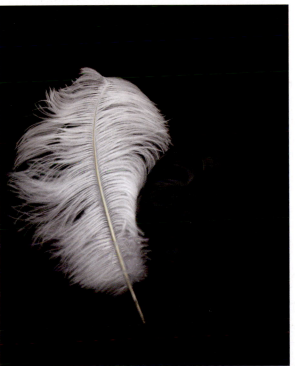

3.14 A polarizer over the camera lens blocks the polarized direct reflection. Only the feather, which gives off diffuse reflection, is easily visible.

We did have to open our aperture by about two stops to compensate for the neutral density of the polarizing filter. How do you know that we did not accidentally miscalculate the exposure? (Maybe we did so deliberately, just to get the image dark enough to prove our point.) The feather proves that we did not. The polarizer did not block the diffuse reflection from the feather. So with accurate exposure compensation, the feather is about the same light gray in both pictures.

Is It Polarized Reflection or Ordinary Direct Reflection?

Polarized and unpolarized direct reflections often have similar appearance. Photographers, out of need or curiosity, may want to distinguish one from the other.

We know that direct reflection appears as bright as the light source, whereas polarized direct reflection appears dimmer. However, brightness alone will not tell us which is which. Remember that real subjects produce a mixture of reflection types. A surface that seems to have polarized reflection may actually have weak direct, plus some diffuse, reflection.

Here are a few guidelines that tend to tell us whether a direct reflection is polarized:

- If the surface is made of a material that conducts electricity (metal is the most common example), its reflection is likely to be unpolarized. Electrical insulators such as plastic, glass, and ceramics are more likely to produce polarized reflection.
- If the surface *looks* like a mirror—for example, bright metal—the reflection is likely to be simple direct reflection, not glare.
- If the surface does not have a mirror-like appearance—for example, polished wood or leather—the reflection is more likely to be polarized if the camera is seeing it at an angle of 40 to 50 degrees. (The exact angle depends on the subject material.) At other angles, the reflection is more likely to be unpolarized direct reflection.
- The conclusive test, however, is the appearance of the subject through a polarizing filter. If the polarizer eliminates the reflection, then that reflection is polarized. If, however, the polarizer has no effect on the suspect reflection, then it is ordinary direct reflection. If the polarizer reduces the brightness of the reflection but does not eliminate it, then it is a mixed reflection.

Turning Ordinary Direct Reflection into Polarized Reflection

Photographers often prefer that a reflection be polarized reflection so that they can manage it with a polarizing filter mounted on their camera

Increasing Polarized Reflection

Most photographers know that polarizers can eliminate polarized reflection they do not want, but in some scenes we may like the polarized reflection and want even more of it. In such cases we can use the polarizer to effectively *increase* the polarized reflection. We do this by rotating the polarizing filter 90 degrees from the orientation that reduces reflection. The polarized light then passes through easily.

It is important to understand that a polarizer always blocks some unpolarized light. By doing this, in effect, it becomes a neutral density filter that affects everything except direct reflection. Thus, when we increase the exposure to compensate for the neutral density, the direct reflection increases even more.

lens. If the reflection is not glare, the polarizer on the lens will have no effect except to add neutral density.

However, placing a polarizing filter over the *light source* will turn a direct reflection into polarized reflection. A polarizer on the camera lens can then manage the reflection nicely.

Polarized light sources are not restricted to studio lighting. The open sky often serves as a beautifully functional polarized light source. Facing the subject from an angle that reflects the most polarized part of the sky can make the lens polarizing filter effective. This is why photographers sometimes find polarizing filters useful on subjects such as bright metal, even though the filter manufacturer may have told them that polarizers have no effect on such subjects. In those cases, the subject is reflecting a polarized source.

APPLYING THE THEORY

Excellent recording of a subject requires more than focusing the camera properly and exposing the picture accurately. The subject and the light have a relationship with each other. In a good photograph, the light is appropriate to the subject and the subject is appropriate to the light.

The meaning of *appropriate* is the creative decision of the photographer. Any decision the photographer makes is likely to be appropriate if it is guided by understanding and awareness of how the subject and the light *together* produce an image.

We decide what type of reflection is important to the subject and then capitalize on it. In the studio, this means manipulating the light. Outside the studio, it often means getting the camera position, anticipating the movement of the sun and clouds, waiting for the right time of day, or otherwise *finding* the light that works. In either case, the job is easier for the photographer who has learned to see what the light is doing and to imagine what it could do.

Surface Appearances

All surfaces produce diffuse, direct, and polarized reflection in varying degrees. We see all of these reflections, but we are not always conscious of them.

Years of programming enable our brains to edit the image of the scene. This editing minimizes reflection that is distracting or trivial to the subject. At the same time, it maximizes the importance of whatever light is essential to our comprehension of the scene. The psychological image in the brain may be quite different from the photochemical one the eye actually sees.

Psychologists have not completely explained why this difference exists. Movement certainly has something to do with it, but not everything. Some visual defects are less disturbing in a motion picture than they might be in a still photograph, but not much.

Photographers know that the brain cannot edit an image of the scene as well as the scene itself. We discovered that fact when we learned how quickly we could spot defects in our images, even though we could not see them at all when we carefully examined the original scene. Unconscious parts of our brain did us the "service" of editing the scene to delete extraneous and contradictory data. The viewer becomes fully conscious of the same details upon seeing the picture.

How do pictures reveal details we might never otherwise notice? This is a question for another book. This book is about what we need to do about that fact and how to take advantage of it. When we make a picture we have to consciously do some of the editing that other observers do unconsciously.

THE PHOTOGRAPHER AS AN EDITOR

Photographic lighting deals mainly with the extremes: the highlights and the shadows. When we are happy with the appearance of these two, we are likely to be pleased with the middle range also. Highlight and shadow together reveal form, shape, and depth. But *highlight alone* is usually enough to reveal what the *surface* of an object is like. In this chapter we will concern ourselves primarily with highlight and surface. Most of our example subjects will be flat—two dimensional, or nearly so. In Chapter 5 we will complicate matters a bit with three-dimensional subjects and a more detailed discussion of shadow.

In the previous chapter, we saw that all surfaces produce both diffuse and direct reflections and that some of the direct reflections are polarized. But most surfaces do not produce an even mix of these three types of reflections. Some surfaces produce a great deal more of one than another. The difference in the amounts of each of these reflections determines what makes one surface look different from another.

One of the first steps in lighting a scene is to look at the subject and decide what kind of reflection causes the subject to appear the way it does. The next step is to position the light, the subject, and the camera to make the photograph capitalize on that type of reflection and minimize the others.

When we do this we *decide* what kind of reflection we want the viewers to see. Then we engineer the shot to make sure they see that reflection and not others.

"Position the light" and "engineer the shot" imply moving light stands around a studio, but we don't necessarily mean that. We do exactly the same thing when we pick the camera viewpoint, day, and time outside the studio. We will use studio examples in this chapter simply because they are easy for us to control to demonstrate the specifics clearly. The principles apply to any type of photography.

In the rest of this chapter, we will see some examples of subjects that require us to capitalize on each of the basic kinds of reflections. We will also see what happens when we photograph reflections that are inappropriate to those subjects.

CAPITALIZING ON DIFFUSE REFLECTION

Photographers are sometimes asked to photograph paintings, illustrations, or antique photographs. Such *copy work* is one simple example of a circumstance in which we usually want *only* diffuse, and not direct, reflection.

Because this is the first concrete demonstration of lighting technique in this book, we will discuss it in great detail. The example shows

how an experienced photographer thinks through *any* lighting arrangement. Beginners will be surprised at the amount of thinking involved in even such simple lighting, but they should not be dismayed by it. Much of this thinking is identical from one picture to the next, and it quickly becomes so habitual that it takes almost no time or effort. You will see this as we progress, and we will omit some of the detail in future chapters.

Diffuse reflection gives us the information about how black or how white the subject is. The printed pages of this book have blacks and whites determined by areas that produce a great deal of diffuse reflection—the paper—and those that produce little diffuse reflection—the ink.

Because diffuse reflection can reflect light frequencies selectively, it also carries most of the color information about the subject. We could have printed this page with magenta ink on blue paper (if those picky editors would have allowed it), and you would know it because the diffuse reflection from the page would tell you.

Notice that diffuse reflection does not tell us very much about what the surface material is. Had we printed this page on smooth leather or glossy plastic instead of paper, the diffuse reflection would still look about the same. (You *could*, however, tell the difference in material by the direct reflection.)

When we copy a painting or another photograph, we are usually not interested in the type of surface on which it was produced; we want to know about the colors and values in the original image.

THE ANGLE OF LIGHT

What sort of lighting might accomplish this? To answer that question, let us begin by looking at a standard copy setup and at the family of angles that produces direct reflection.

Figure 4.1 shows a standard copy camera arrangement. The camera is on a stand and is aimed at the original art on a copy board beneath it. Assume that the height of the camera is set so that the image of the original art exactly fills the image area.

We have drawn the family of angles from which a light, or lights, can produce direct reflection. Most copy arrangements use a light on each side of the camera. We need only one light to see the principle.

Such a diagram makes it easy to light the setup. Once again, any light within the family of angles will produce direct reflection, and a light located outside that family will not. We also know from Chapter 3 that a light can produce diffuse reflection from *any* angle. Because we want *only* diffuse reflection, we place the light anywhere outside the family of angles.

53

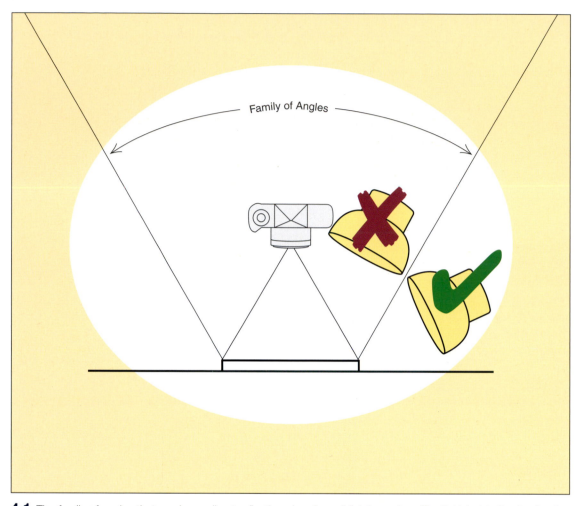

4.1 The family of angles that produces direct reflections in a "copy" lighting setup. The light inside the family of angles will produce direct reflection; the other will not. There is a similar family of angles on each side of the camera.

In Figure 4.2 the cigar box is photographed with the light placed outside of the family of angles. We see only diffuse reflection from the surface, and the tone values in the photograph closely approximate the original.

By way of contrast, in Figure 4.3 the light was inside the family of angles. The resulting direct reflection causes an unacceptable "hot spot" on the glossy surface.

This is all straightforward in the studio or the laboratory. However, photographers are also asked to photograph large paintings in museums or other locations from which they cannot be removed. Anyone who has ever done this knows that museum curators *always* place display cases

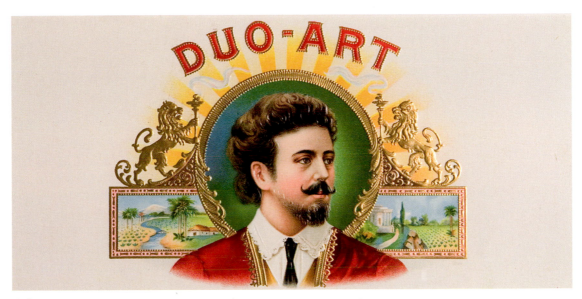

4.2 In a good picture, the box label we see has nothing but diffuse reflections (ignoring, for now, the reflection from the gold foil), and the tones closely resemble those in the original.

4.3 Placing the light inside the family of angles caused an unacceptable hot spot and obscured some of the detail.

or pedestals *exactly* where we want to put the camera. In such situations, we need to place the camera closer to the subject than we might otherwise. We then switch to a wide-angle lens to get the whole subject to fit the image area.

Figure 4.4 is a bird's-eye view of our museum setup. Now the camera has a very wide-angle lens with about a 90-degree horizontal angle of view.

Look what has happened to our family of angles. The family of angles causing direct reflection has grown much larger, and the range of acceptable angles for copy lighting is much smaller. The light now needs to be much farther to the side to avoid unacceptable direct reflections.

Shooting a copy with the camera in this position would yield drastically inferior results if we kept the light where we had it in Figure 4.1. The same lighting angle that works well when the camera is farther away can cause direct reflection if the camera is closer. In this case, we would have to move the light farther to the side.

Finally, notice that in some museum-like situations, the shape of the room may make the placement of the lights more difficult than that of the camera. If it seems impossible to position the lights to avoid direct reflection, we sometimes can solve the problem just by moving the camera farther away from the subject (and using a correspondingly longer lens to obtain a large enough image size).

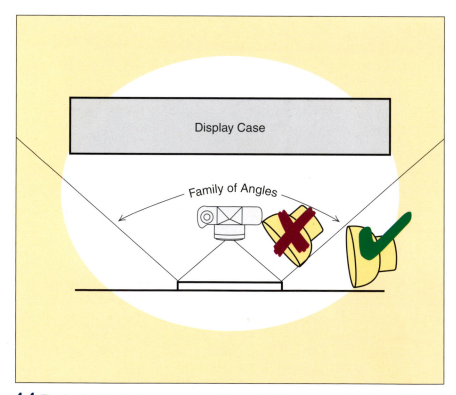

4.4 The family of angles has grown much larger in this arrangement using a wide-angle lens. The result is a small range of acceptable lighting angles. Only the light outside the family of angles will produce glare-free lighting.

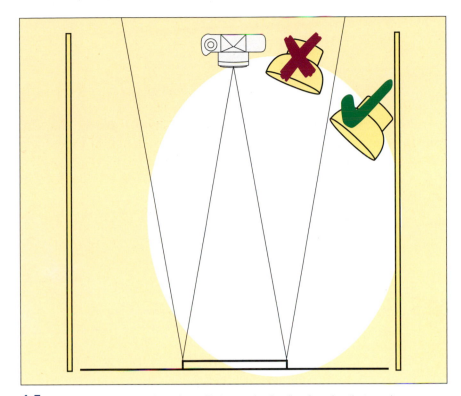

4.5 A copy setup using a long lens. Because the family of angles that produces a direct reflection is small, finding a good place to put the light is usually easy. (Had the wall on the right been a bit closer, however, it would have begun to limit the light placement. We will deal with such a problem in a few more pages.)

In Figure 4.5, the room is too narrow to allow easy light placement, but it is deep enough to allow the camera to be placed at almost any distance. We see that when the camera is farther from the subject, the family of angles that produces direct reflection is small. Now it is easy to find a lighting angle that avoids direct reflection.

THE SUCCESS AND FAILURE OF THE GENERAL RULE

Texts that attempt simply to demonstrate basic copy work (as opposed to general lighting principles) often use a diagram similar to Figure 4.6 to represent a standard copy setup.

Notice that the light is at a 45-degree angle to the original. There is nothing magic about such an angle. It is a general rule that usually works—but not always. As we saw in the previous example, a usable lighting angle depends on the distance between the camera and the subject and the resulting choice of lens focal length.

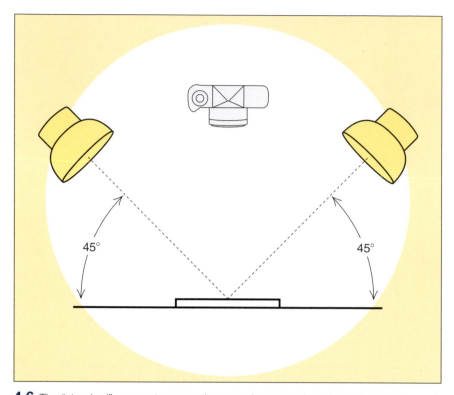

4.6 The "standard" copy setup sometimes produces good results and sometimes does not. A usable lighting angle depends also on the distance between the camera and subject and the choice of lens focal length.

More important, we need to notice that this rule may fail to produce good lighting if we do not give attention to the distance between the light and the subject. To see why, we will combine the principle in Figure 4.1 with that of Figure 4.6.

In Figure 4.7, we see two possible light positions. Both lights are at a 45-degree angle to the subject, but only one of them will produce acceptable lighting. The light that is closer to the subject is within the family of angles that produces direct reflection and will cause a hot spot on the surface. The other light is far enough away to be outside the family of angles and will illuminate the surface nicely.

So we see that the 45-degree rule will work fine if the photographer gets the lights far enough away from the subject surface. In fact, the rule often does serve well because photographers generally do move the lights farther away from the subject for yet another reason, to obtain even illumination.

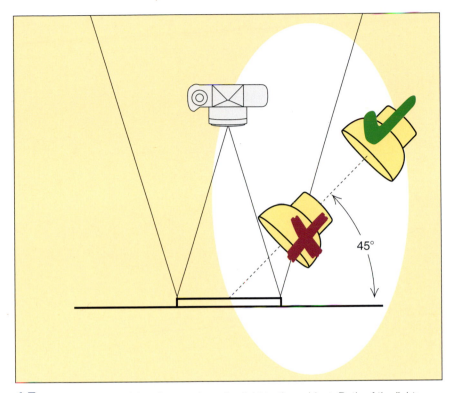

4.7 The importance of the distance from the light to the subject. Both of the lights shown are at 45 degrees to the center of the subject, but only one is satisfactory. The light inside the family of angles will produce direct reflection.

THE DISTANCE OF LIGHT

Up to now we've only considered the angle of the light, not its distance. But clearly that's important too, because we know that diffuse reflections get brighter as the light gets closer to the reflecting surface. Figure 4.8 revisits an earlier arrangement, now emphasizing the distance of the light.

Once again, we are using a wide-angle lens to photograph the subject. Remembering that such situations leave a very small range of angles of illumination that do not cause direct reflection, we have positioned the light at a very shallow angle to the surface. But the edge of the subject that is closer to the light receives so much more light than the edge farther away that uniform exposure is impossible.

Figure 4.9 shows the resulting exposure. The shallow lighting angle avoids direct reflection, but the diffuse reflection on one side of the image is so bright that the consequences are almost as bad.

59

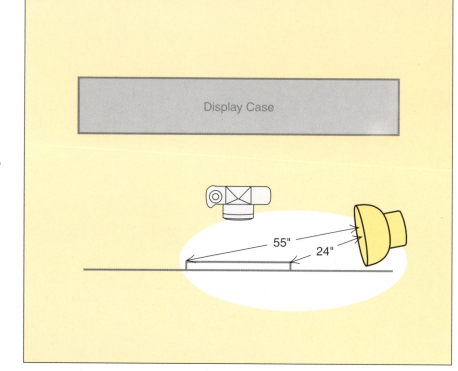

4.8 The shallow angle that avoids direct reflection is also more likely to cause uneven illumination if we don't take care to avoid it.

4.9 A possible consequence of the situation shown in Figure 4.8. Although the light placement avoided direct reflection, the illumination is too uneven to preserve detail on both the left and right sides.

60

Obviously, a second light on the other side of the subject would help provide more even illumination. (This is exactly why most copy setups do, indeed, use two lights.) With extremely shallow lighting angles, however, the second light still does not provide uniform exposure. We simply get two overexposed areas instead of one, with a dark area in the center.

One solution to this problem is to move the light closer to the camera. (An extreme example of this is a flash mounted directly on the camera.) Then the light is roughly the same distance from all points on the surface, and the illumination is more even. But this solution is also likely to place the light in the family of angles that cause direct reflection, which is a worse problem.

The only solution to this problem that always works is to move the light farther away from the subject. In theory, a light that is an infinite distance away will produce exactly equally bright diffuse reflections at all points on the surface, even at the most shallow angle. Unfortunately, a light an infinite distance away is also likely to be infinitely dim. (We will not even begin to deal with the problems of finding a light stand that high.)

In practice, we do not usually need to get the light quite that far away to obtain satisfactory results. We just need to get the light far enough from the subject to produce *acceptably* even illumination, but we need to keep it close enough for acceptably short exposure times.

We could offer you mathematical formulas to calculate an acceptable distance between the light and the subject at any given angle (and for any given acceptable side-to-side exposure error), but you would not use the formulas because you do not need them. The human eye is good at judging the acceptable compromise distance, provided the photographer is aware of the potential problem from the start. Place the lights so that the illumination looks reasonably even; then double-check that judgment by measuring various points on the surface with a light meter.

DOING THE IMPOSSIBLE

The preceding examples tell us that even illumination and glare-free illumination can be mutually exclusive goals. The closer the light source is to the camera, the more directly it lights the subject and the more even the illumination becomes. However, the farther the light is to the side, the less likely it is to be within the family of angles that causes direct reflection.

We have also seen that the usual solution to this dilemma requires more working space in any direction. Here is why:

- Moving the lights closer to the camera axis, for example, means moving the camera farther away from the subject (and using a correspondingly longer lens to get a similar image size). This creates a smaller family of angles that causes direct reflections and allows more freedom in choosing the angle to light the subject.
- Conversely, if circumstances dictate that the camera be very close to the subject, we must light the subject at a very shallow angle to keep the light source outside the family of angles. We must then place the lights much farther from the subject to achieve even illumination.

Unfortunately, we sometimes lack the working space we need for either of these solutions. A photographer may have to photograph a rare document in a storage area so filled with filing cabinets that there is almost no room to work. Even in a gallery area, there may not be enough floor space to properly light a really large painting.

Figure 4.10 shows such an "impossible" lighting problem. The camera could be on a tripod aimed at a document on the floor, the

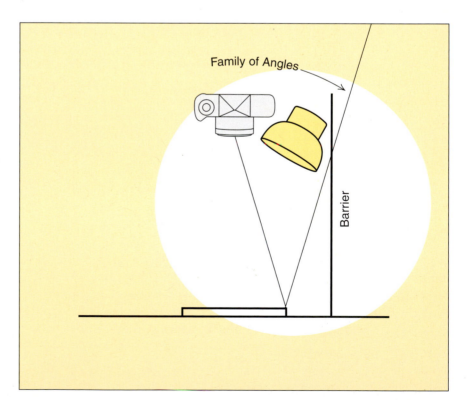

4.10 An "impossible" lighting situation: we cannot position the camera and lights to provide uniform, glare-free illumination.

obstacles on the sides could be filing cabinets, and the ceiling could set the restriction on camera height. Or the camera could be focused on an 8-by-10-foot painting on a wall with other walls or display cases presenting the obstacles. Either way, we cannot position the camera and lights to provide illumination that is both uniform and glare-free.

At a glance we predict that the photograph made with such an arrangement is useless. Figure 4.11 confirms the prediction. The solution is easy when we remember that (1) the "glare" we see on the surface of the original is a mixture of direct and diffuse reflection, and (2) a polarizing filter on the lens can eliminate *polarized* direct reflection.

4.11 One result of the "impossible" situation shown in Figure 4.10. This picture is, as you can clearly see, useless. Because of the way in which we were forced to set up our lights, the original was partially obliterated by the direct reflection from its surface.

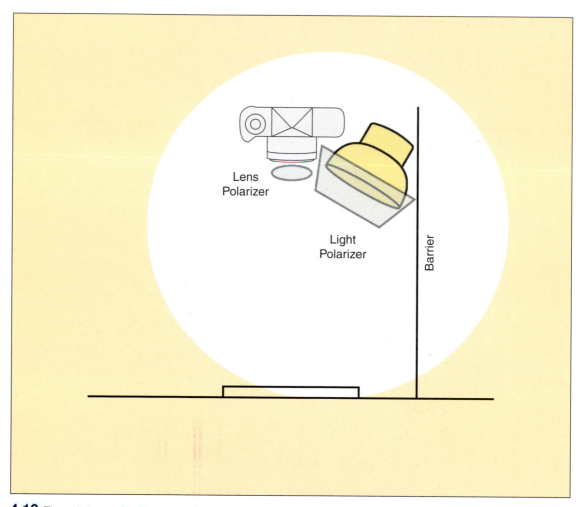

4.12 The solution to the "impossible" lighting requires placing the lights for even illumination and using polarizers to prevent glare. The axis of the light polarizer points to the camera; the axis of the lens polarizer is perpendicular to that.

Figure 4.12 shows how. We first position the lights for even illumination, without concern about whether we are creating direct reflection. Then we place polarizing filters over the lights with their axes oriented toward the camera. This assures us that the direct reflection is polarized. Next, a polarizing filter on the camera, with its axis oriented 90 degrees to those on the lights, eliminates that polarized direct reflection.

In theory, this arrangement allows the camera to see only the diffuse reflection. In practice, we may still see some polarized reflection because no polarizing filter is perfect. However, the defect is negligible in all but the worst cases. Figure 4.13 proves it. Neither the camera nor the light has been moved, but the improvement is dramatic.

4.13 A good photograph despite "impossible" circumstances, using the solution from Figure 4.12. This picture shows the same subject lit by the same light in the same position as in Figure 4.11. Compare the two pictures.

Using Light-Polarizing Filters

Polarizing the light source has serious drawbacks and is a solution to avoid whenever possible. Fortunately, understanding and controlling the size and angle of the light source makes polarizing the light source itself unnecessary in most situations. Some photographers go for years without needing to use light-polarizing filters.

We have deliberately conceived the "impossible" copy problem to be one of those rare cases in which polarizing the light is the *only* solution to the problem. Photographers whose specialty routinely requires highly controlled lighting will occasionally encounter these cases. Because awareness of a problem is the first step toward the solution of the problem, we want to list the possible difficulties now.

In theory, the combined effect of a "perfect" polarizing filter on the light and another on the lens should cost a total of two stops of exposure. Real polarizers are far from perfect, though. In practice, because polarizers have a lot of neutral density, the actual exposure reduction is likely to be four to six stops.

(Continued)

Using Light-Polarizing Filters (Continued)

The problem gets even worse in noncopy situations, where we are likely to lose additional light through diffusion materials. The consequent aperture may be too wide to maintain adequate depth of field, or the exposure may be so long that reciprocity failure becomes difficult to calculate and camera or subject movement is increasingly difficult to avoid.

The ideal solution to this problem is to use the most powerful lights that our budget and the available electrical current allow. If that is not enough, we treat the problem as we would any other low-light-level scene: we use a camera support that is as sturdy as possible and focus the camera as carefully as possible to make maximum use of what little depth of field we have.

The second problem is that polarizing filters are vulnerable to damage by heat. Remember that the light absorbed by the polarizers does not simply disappear. It turns into heat and threatens to cook things!

Photographers using strobes often leave the polarizers off the lights until they are ready to shoot. They turn off the modeling lights before attaching the polarizing filters. The brief flash of the flash tube presents minimal heat danger.

Polarizing filters used with incandescent lights need to be attached to a bracket or a separate light stand a distance away from the light. The exact distance depends on the wattage and the reflector design of the light. It is worth cutting a small piece of the polarizing material and deliberately burning it in front of the light to determine a safe distance.

Finally, we must remember that polarizing filters can have a minor effect on color balance. If you are shooting film and can't adjust the color balance in the camera, it is wise to shoot and process a color test and adjust the color-compensating (CC) filtration before exposing the final film.

USING DIFFUSE REFLECTION AND SHADOW TO REVEAL TEXTURE

In any discussion of surface definition, we must talk about texture. (This is why we promised at the beginning of this chapter that all examples would be *nearly* two-dimensional.) We will first look at a photograph that fails to reveal the texture of the subject. This will help us analyze the problem and come up with a better solution.

We photographed the detail on the glove's surface shown in Figure 4.14 with a portable strobe mounted on the camera. If the object is to show texture, the picture is decidedly unsatisfactory.

The light color of the glove contributes to the problem. We know that *all* light subjects produce diffuse reflections, and we know that the brightness of a perfect diffuse reflection does not depend on the angle of illumination. For this reason, light striking the side of a particle of texture reflects back to the camera almost as brightly as light striking the top of the particle.

The solution is to move the light to a very shallow angle to the surface so that it skims across, as seen in Figure 4.15. This gives each particle of texture a highlight side and a shadow side.

Notice that this arrangement may produce uneven illumination, just as it did when we moved the light to a shallow angle in the copy setup

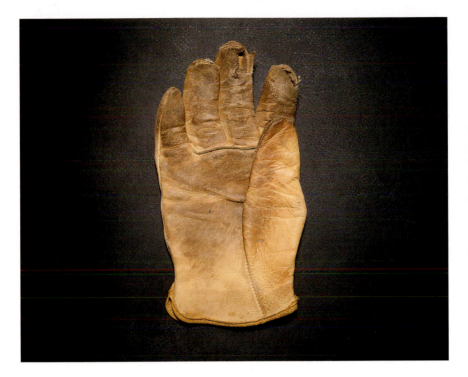

4.14 A glove photographed with the light mounted on the camera. With no contrasting highlights and shadows, much of the glove's surface detail is invisible.

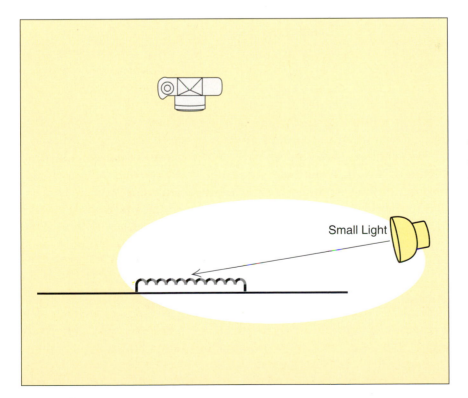

Small Light

4.15 A small light at a very low angle to the subject produces the contrasting highlights and shadows needed to reveal texture in medium- and light-toned subjects.

67

4.16 The same glove we used in Figure 4.14. Only this time we photographed it with raking light such as shown in Figure 4.15.

in Figure 4.8. The solution is the same: move the light farther from the subject.

The texture in this type of surface can be helped still more if we use as small a light source as possible. This is because small light sources produce sharply defined shadows.

If the particles of texture are tiny, their image may be too small to resolve sharply. If the shadow itself is as sharp as possible, then the image of the shadow is more likely to survive the optical limitations. Figure 4.16 is the result.

Lighting for texture in this manner is so easy to understand that it is almost intuitive. Novice photographers sooner or later learn this with no help from us. We are not trying to point out the obvious. Instead, we want to contrast the lighting of this cloth with another, less obvious, example in which the same technique does not work at all.

CAPITALIZING ON DIRECT REFLECTION

Figure 4.17 was produced by the same lighting as the successful photograph of the leather glove's texture that you saw in Figure 4.16. It shows how applying a good technique at the wrong time can produce a bad picture. The lighting that revealed the texture so well in the glove loses

4.17 The same lighting that revealed texture in the brown glove loses most of the detail in the black leather book cover.

almost all detail in the notebook's cover. You have to take our word that the texture exists.

The raking light we used on the light-brown glove revealed detail by placing a shadow on one side of each particle of texture and a diffuse highlight on the other side. The same shadow exists on one side of each particle of texture in the black leather notebook cover (although you cannot see it), but the diffuse highlight on the other side of each particle is gone. The problem with this photograph is caused by the subject itself. It is black, and black subjects, by definition, produce little diffuse reflection.

We know that increasing exposure would enable the weak diffuse reflections on the leather to record, but an exposure increase is rarely an available option because important light-toned areas also exist in

69

most scenes. If we increased the exposure, the highlight detail in the lighter subject matter might be hopelessly lost. Besides, this is a book about lighting, and we are honor bound to deal with the problems without exposure modification, using lighting technique alone.

If we cannot get significant diffuse reflection from the leather surface, we will try to produce direct reflection instead. This seems to be our only remaining option. Because direct reflection can only be produced by light coming from a limited family of angles, our first step is to see where that family of angles might be.

Figure 4.18 shows where the light *must* be if the camera is to see direct reflection on the surface. Furthermore, to produce direct reflection across the *entire* surface, the light must be large enough to *completely fill* this family of angles. Therefore, we need a light of at least the size and in the position shown in the diagram. The light source for this picture could be an overcast sky, a soft box, or a reflector card illuminated by still another light source. All that matters is that the light be the right size and in the right place.

Notice that this arrangement could not be more different from the one that worked well for the white cloth. Instead of raking the light

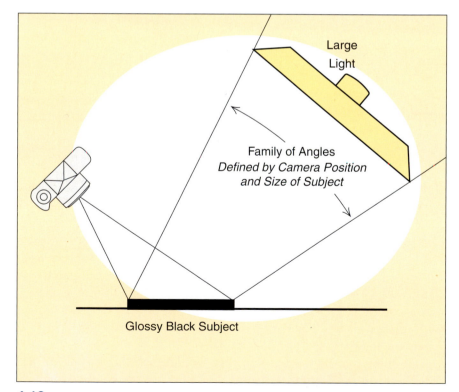

4.18 A light filling the family of angles defined by the black leather book.

from the side, we have put it above the subject. This nearly eliminates the small shadows that defined the cloth texture. Instead of a small light source, we have a large one. This means that whatever slight shadows do remain in the texture will be too soft to define the texture clearly.

In other words, the theory that predicts the best way to light the cloth also says that our new lighting arrangement is the worst possible way to light the leather! This apparent contradiction is caused by the earlier theory neglecting one consideration: direct reflection.

The large light above the table produces the magnificent texture visible in Figure 4.19. No exposure increase was necessary. The amount of light falling on the leather is the same as that in Figure 4.17. Nevertheless, the highlight in the leather texture has moved up the tonal scale from near black to middle gray.

4.19 Using the lighting diagrammed in Figure 4.18 maximizes direct reflection and reveals texture in the leather.

The apparent increase in illumination comes from good reflection management. The leather surface can produce little diffuse reflection but a great deal of direct reflection. By capitalizing on the type of reflection appropriate to the surface, we have recorded the subject as well as possible.

COMPETING SURFACES

Photographers would have less gray hair, and less income, if all work were as easy as the examples we have seen so far in this chapter. Some surfaces are rendered better by capitalizing on diffuse reflection; others are depicted best by capitalizing on direct reflection. We've seen that the best lighting for one can be the worst for the other. When we have both in a single scene, our job gets harder.

Too often, however, to be completely legible, some parts of the scene require diffuse reflection, whereas others need direct reflection. In many of these cases, we can simply deal with the more important part of the scene. If we get that right, viewers do not notice minor defects in the lighting of the rest of the surface. On other occasions, however, several entirely different parts of the surface are all important, and those different parts of the picture absolutely must have different lighting.

This does not require any new principles. It does mean that we have to apply more than one principle to light a single scene. As we saw in the photographs of the white cloth and the black leather, the technique that produces one effect often excludes another. In extreme cases, this means that the problems presented by competing surfaces can't be solved. When that happens, we shoot more than one picture, each lit differently, and then we combine them digitally. Whether to get the picture right in the first place or to fix it later is entirely a matter of choosing, on a case-by-case basis, whatever takes less time.

Commercial photographers sometimes work out the composition of a photograph before beginning to perfect the lighting. After all, if the relationship of the angles between the light, the subject, and the camera is critical, it makes no sense to carefully position the light before knowing the orientation of the subject.

Figure 4.20 is one such preliminary composition. One small light to the right of the camera illuminates this collection of surfaces. The position of the light is similar to the single-light copy setup shown in Figure 4.1. For now, the only purpose of that light is to light the subject well enough to see it in the camera.

Before lighting a scene well, we have to decide what is important in it. This picture is intended to produce interest in a music CD scheduled to be released. Almost any advertising image needs to carry the message as strongly as possible and as independently of the text as possible.

4.20 Lit by one small light to the right of the camera, this photograph was exposed only by diffuse reflection.

(A reader may continue turning pages without bothering to read the copy if the photograph, by itself, does not create enough interest in the product.) With that in mind, this photograph must make the disc and its packaging immediately visible. At the same time, the stick-on label is essential to the ad concept.

Of the important competing surfaces, only the type on the label is adequately recorded in the first photograph. We would expect that because the lighting resembles copy lighting and there is no technical difference between photographing a label and copying a painting. But the black disc in its black envelope and black case does not have enough shadow detail to survive even the reasonably good reproduction in this book. Had this shot been used for the intended ad in a trade newsletter, on newsprint paper, the result would have been even worse.

73

4.21 Direct reflection alone produces good detail in the black subjects, but the black type on the label is too weak.

Because the test shot suffers from the same problems we saw in the black leather, we decided to try the same solution diagrammed earlier in Figure 4.18. We used a light large enough and positioned to maximize the direct reflection on the black surfaces.

Figure 4.21 is the result. Predictably, the detail in the black disc and packaging are good. Equally predictable, the direct reflection that brightens the black plastic has the same effect on the black type in the label. The type is too weak to look good. Unless your eyes are good, it is not even legible.

Thus, each basic lighting technique is good for one type of surface but bad for the other. Still, both surfaces are important. This complicates life considerably. Fortunately, several possible solutions are available. We will present four of the more promising ones.

Try a Lens Polarizing Filter

Try this solution first; it's the least likely to work, but it's the easiest. On some surfaces, the direct reflection we do not want will turn out to be polarized direct reflection. If this is the case, we can eliminate the offending reflection with a polarizing filter on the lens. If we are lucky, the direct reflection we want to keep will be unpolarized and will not be significantly affected by the filter.

More likely, however, the direct reflection will be polarized on both surfaces or on neither. So if the polarizer eliminates the undesirable reflection, it also filters out the direct reflection we do like.

Use a Still Larger Light

Figure 4.22 shows a light large enough to fill the family of angles causing direct reflection, plus a large range of angles that do not. The light coming from the family of angles causing direct reflection lights the

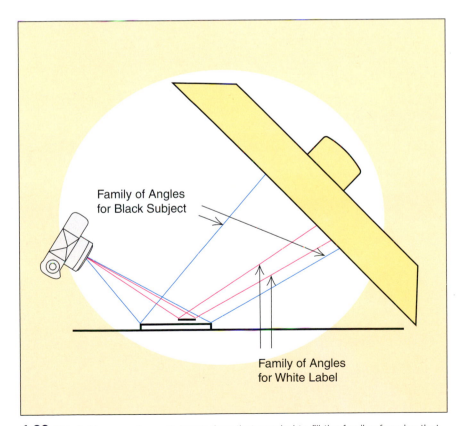

Family of Angles
for Black Subject

Family of Angles
for White Label

4.22 This light source is much larger than that needed to fill the family of angles that causes direct reflection.

black plastic well. The rest of the rays from this source strike the surface from angles that can only produce diffuse reflection and, therefore, light the label well.

This solution is especially effective using a light, plus an independently supported diffusion sheet, rather than a soft box. Then we can light one part of the diffusion sheet more brightly than another to place slightly more direct reflection on the black plastic than on the label.

Unfortunately, this approach is a compromise, not a complete solution. The type will not be quite as black as it was in the first photograph of this scene, and the plastics will not have as much detail as they did in the second picture. Both types of surfaces might be lit adequately but not as well as possible.

Use More Than One Light

We could also combine the lighting used in Figure 4.20 with that in Figure 4.21. Such a two-light arrangement is shown in Figure 4.23. In principle, this solution is the same as using a single very large light: some

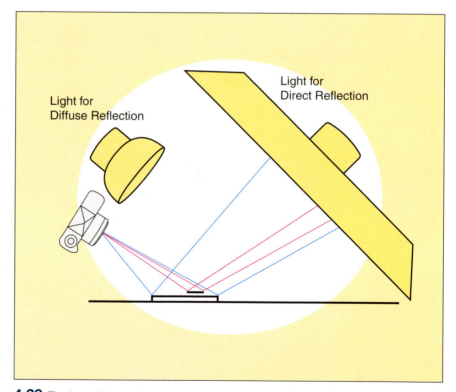

4.23 The large light produces direct reflection, whereas the small one near the camera produces only diffuse reflection. The result is a compromise.

of the rays come from angles that cause direct reflection, whereas others come from angles that can only cause diffuse reflection. Using two lights may be easier to control, however, because we can adjust the power in each light independently.

Like a single very large source, the multiple-light solution is also a compromise. It's a better compromise, but neither the diffuse reflection nor the direct reflection will look as good as it might if we had to light for only one of the two.

The size of the subject often determines whether to use multiple lights or a single very large one. All other things being equal, smart photographers do whatever requires the least work. In this case, it is easy to come up with a single source that is very large compared with the size of the subject. If the subject were larger, it might be easier to use two lights.

Use a Gobo

We have been careful to point out that the preceding techniques are compromises. They work for many, but not all, competing surfaces.

If the stick-on label is not very glossy, and if we know the photograph is going to be well reproduced, the compromise is often adequate. If the label is glossy, however, none of the lighting solutions we have seen so far will be adequate. If there is enough direct reflection for the black surfaces, there will be too much direct reflection on the label. Furthermore, if the advertisement is to be used in a newspaper or printed on other inferior paper, the defect is magnified.

The only remedy for this problem is a small gobo that fills the family of angles that causes direct reflection on the label but that is not large enough to extend into the family of angles that produces direct reflection on the rest of the subject. (Gobo is photospeak for anything that *goes between* the subject and the light source specifically to block part of the light.) Figure 4.24 shows the position and size of a gobo that could accomplish this.

Although the gobo is large enough to block all direct reflection on the label, notice in the diagram that it does not block much of the total surface of the light source. We still obtain a lot of light from those angles that cause diffuse reflection on the label. Therefore, the total exposure is not significantly affected.

Getting the gobo to be the right size and at the right distance is not always easy. Notice that the *closer* the gobo is to the light source, the larger it needs to be to fill the same family of angles; also, the larger the gobo is, the more it blocks the total illumination and the more likely it is to affect exposure. This seems to suggest that we might want the gobo as close to the subject as possible so that a smaller one will do the job.

77

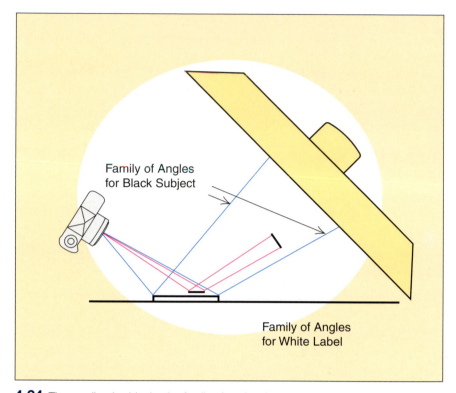

4.24 The small gobo blocks the family of angles that causes a direct reflection on the label but not the one that causes direct reflection on the rest of the subject.

But a gobo closer to the subject is more likely to cast a visible shadow on the tabletop. This is because moving the gobo farther from the light makes the light effectively smaller *compared with the gobo*. Because smaller light sources produce harder shadows, we are more likely to be able to see the shadow.

So the gobo needs to be far enough from the subject to avoid casting a visible shadow, yet far enough from the light to be small enough to block as little total illumination as possible. It also needs to be exactly large enough to block the direct reflection on the label but not on the rest of the subject. This is why we saved the gobo for the last solution to the competing-surfaces exercise. It is the most effective solution, but it requires the most work and the most time. On the first occasion you attempt it, you may find positioning the gobo with precision to be a bit tedious. Fortunately, it soon gets easier with a little practice.

We can usually support the gobo on a thin wooden dowel clamped to a nearby light stand. This arrangement provides plenty of freedom to move the gobo in any direction until we get it right. However, if anything in the scene is mirror-like, then the wooden support becomes a

4.25 The result of the technique illustrated in Figure 4.24: detail in the blacks, plus legible type on the label.

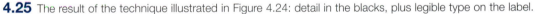

visible reflection in the picture. In those cases, we tape the gobo directly to the diffusion material above the subject. Then we can move the light itself until the gobo is properly positioned.

Figure 4.25 is the result of this arrangement. The direct reflection is gone from the label but not from the disc or its packaging.

COMPLEX SURFACES

In this book we will use the term *complex surface* to mean a *single* surface that requires both diffuse and direct reflection to define it properly. Glossy wood is a good example. Only direct reflection can tell the viewer that the wood is glossy, but diffuse reflection is essential to reveal the color and the grain of the wood beneath the gloss.

Figure 4.26 is a piece of highly polished wood lit to produce both direct and diffuse reflection. A medium-sized light source has been

79

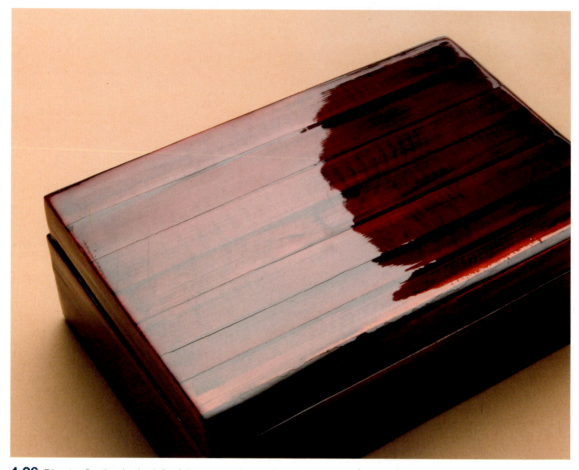

4.26 Direct reflection in the left of the scene shows the gloss, whereas diffuse reflection at the right reveals the wood grain.

positioned to reflect in the lower portion of the wooden surface to show the glossy finish. Notice that the slight physical texture in the surface is also revealed by the direct reflection.

The light was large enough that it filled the entire family of angles required to produce direct reflection over the whole surface. However, we blocked part of the light with a gobo so that the right part of the surface produces only diffuse reflection, which allows us to see the color and grain structure in the wood. Notice that the right area is the only area in which the true color of the wood would be clearly apparent. Figure 4.27 diagrams the lighting method.

Notice especially the transition zone between the areas of diffuse and direct reflection. This area has some of each type of reflection, which often reveals the surface better than either diffuse or direct

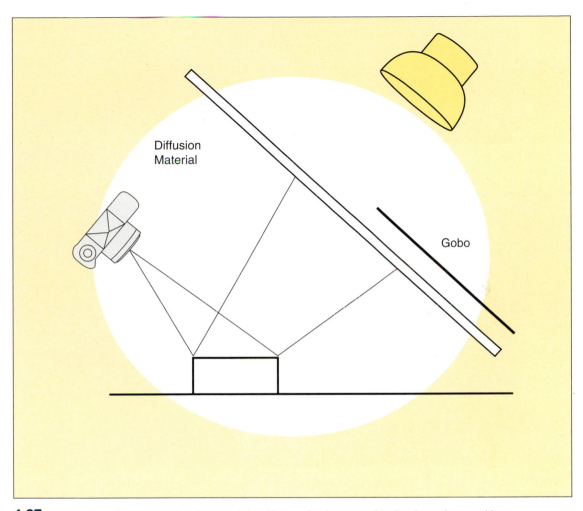

4.27 Lighting to produce both the direct and the diffuse reflections, used to illuminate the wood box in Figure 4.26.

reflection alone. If you want to capitalize on this effect, you can enlarge the transition zone to fill more of the surface. Just move the camera farther from the subject and use a longer lens to keep the subject a similar size, or move the gobo closer to the light so that it casts a softer shadow on the diffusion material.

Finally, see how much easier this exercise becomes if we do not restrict ourselves to a two-dimensional surface. Look at what happens in Figure 4.28 if we put a three-dimensional object on the wood surface. The reflection of the glasses in the wood tells the viewer that the wood is glossy. Adding a secondary subject reveals the wood better than we are likely to be able to render the wood alone.

81

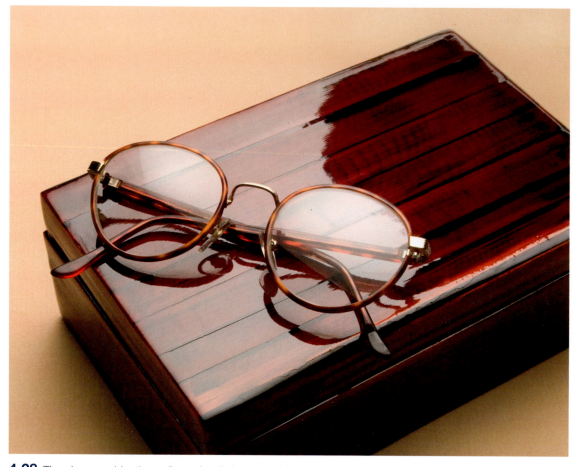

4.28 The glasses add a three-dimensional element, which provides additional visual clues (the reflection of the glasses) to prove the surface is glossy.

Adding a three-dimensional subject to this kind of scene often makes the lighting easier. We cannot pursue this approach very far, however, because we promised that this chapter would be about two-dimensional and nearly two-dimensional subjects. In the next chapter we will see what happens when those surfaces face three different directions at once.

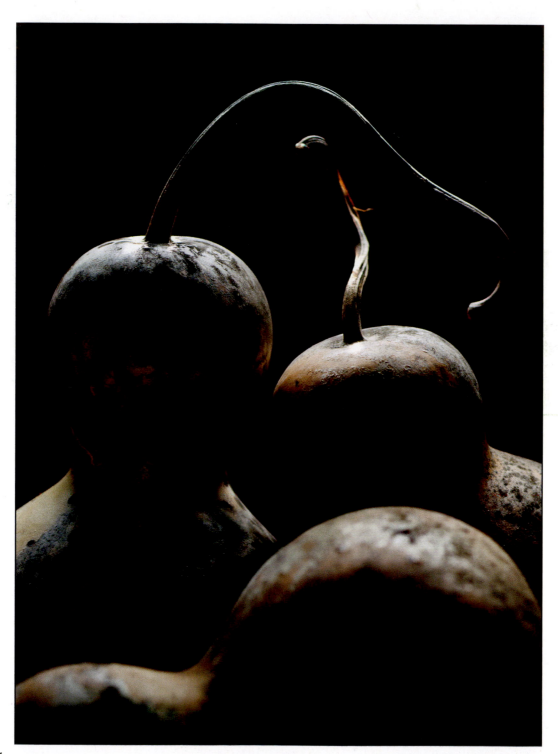

84

Revealing Shape and Contour

In the previous chapter, we dealt with the problems and opportunities for lighting objects that are flat, or nearly so—things that are visually defined only in terms of length and width. In this chapter we add the third dimension—*depth*.

A box, for example, is a group of only three visible surfaces. Because we know how to light *any* of the surfaces well, we can also light all of them well. Does this mean we can light any of these surfaces using *only* the principles described in the previous chapter? Usually not. Lighting each visible surface well is not usually enough. We also have to think about how those surfaces *relate* to one another. Then we have to light and compose to add depth, or at least the illusion of depth, to the picture.

Three-dimensional subjects require their own lighting techniques. The lighting techniques that we are going to demonstrate are designed to produce the visual clues that our brains need to interpret depth.

Interpreting *visual clues* is the key concept on which this whole chapter hangs, so we will begin by describing what some of these visual clues are. It is difficult to make a photograph with absolutely no visual clues to represent depth. However, it is easy to draw such a picture. Figure 5.1 is an example. No one can say for sure what this drawing is intended to represent. We say that it is a cube, but you could just as reasonably insist that it is a hexagon with a "Y" drawn in the center.

Figure 5.1 fails to supply our eyes with the essential visual clues that our brains need to process the information coming from our optic nerves and to decide, "This is a three-dimensional scene."

The only way we can be sure that a viewer can understand that an object is a cube is to add these visual clues. Figure 5.2 has exactly the visual clues the brain is looking for. Compare it with Figure 5.1.

5.1 This diagram fails to provide any visual clues that would make us perceive it as a three-dimensional object.

5.2 Here we have added those visual clues that the brain needs to see depth.

DEPTH CLUES

Why does the second picture look more three-dimensional than the first? A look at the drawings gives us two immediate answers. The first is *perspective distortion*: some edges of the cube seem to be longer than others, and some seem to be shorter, even though we know they are all the same length. The corners all appear to join at different angles, even though we know they are all 90 degrees.

Besides perspective distortion, there is a second clue that our brain uses to perceive depth: *tonal variation*. Each face of the cube is the same color as the others, but some look lighter and others appear darker.

Notice that these visual clues are so powerful that the brain perceives depth that does not and never did exist! This is not really a cube; it is only a bit of ink on paper. Photographers record real subjects with real depth, but that depth is lost in the picture. A photograph on paper or on a monitor is as two dimensional as these drawings. Photographers who want to maintain a sense of depth need to use the same techniques that illustrators do. Our job is often easier than theirs because nature does the job for us by providing the right lighting and perspective, but not always.

Both perspective distortion and tonal variation influence lighting decisions. Lighting *produces* highlights and shadows, so its effect on tonal variation is obvious. The relationship between lighting and perspective distortion is less obvious, but it is still important. Viewpoint determines both perspective distortion *and* the family of angles that causes direct reflection. Changing viewpoint to control that family of angles also alters perspective distortion; changing viewpoint to control perspective distortion also alters the family of angles.

PERSPECTIVE DISTORTION

Subjects appear smaller when they are farther away. Furthermore, if the subject is three dimensional, the part of the subject that is farther away appears to be smaller than the closer part of the same subject. Similarly, the closer part of the same subject appears to be larger. We call this effect *perspective distortion*.

Some psychologists believe that infants perceive more distant subjects to be actually smaller. No one is sure about this because by the time we are old enough to talk about the matter, our brains have learned to interpret perspective distortion as depth. We do know that learning is involved, however; people raised in primitive societies, without buildings that have right-angle corners, are less likely to be fooled by the illusion in Figure 5.3.

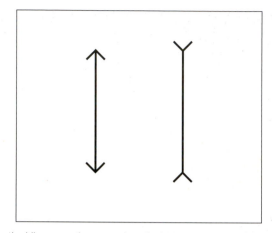

5.3 The two vertical lines are the same length, but to most people one looks longer than the other.

Distortion as a Clue to Depth

Our eyes deceive us when we look down railway tracks, but our brains do not. The rails appear to converge in the distance, but we know that the rails are parallel. We know that they are the same distance apart a mile down the track as they are where we are standing, so the brain says, "The tracks only *appear* to converge because they are distant." But how does the brain know that the tracks are distant? The brain answers, "They *must* be distant because they appear to converge." (The flow of this logic must shock computer programmers, but they are accustomed to the limitations of inferior hardware.)

We assume the brain actually uses a more complex process, but the effect is the same: perspective distortion is one of the major visual clues that our brains use to perceive depth. Controlling this perspective distortion allows us to manipulate the illusion of depth in the picture.

Conventional photography is two dimensional. (Few photographers shoot holograms.) Viewers notice the length and width of a printed picture but not the thickness of its paper. We perceive depth in the photograph despite the fact that it does not really exist. Figure 5.4 proves it.

The foreground chess pieces clearly appear to be in front of those in the background. But the "foreground" and "background" existed only in the scene, not in this picture. This image is printed on a flat paper surface. Perspective distortion is critical to this sense of depth that photography conveys.

One of the main reasons we know that this scene has depth is that the lines that delineate the square shape of the chessboard—and, to a

5.4 Although this photograph is a flat, two-dimensional representation of the scene, we perceive depth in it.

lesser extent, the squares on it—look distorted. In reality, those lines are parallel to each other. That, however, is, as you can see, not the case in the picture. Like the railroad tracks we discussed earlier, these lines converge at a point on an imaginary horizon. This distortion gives the brain a strong visual clue that it is seeing length, width, *and* depth.

Manipulating Distortion

Within great limits, we can increase and decrease the amount of perspective distortion in a photograph. This means that we can control the sense of depth our pictures give to viewers.

Controlling the degree of perspective distortion in a picture is simplicity itself. The *closer* we move the camera toward the subject, the *greater* the distortion will be. Conversely, the *farther* the camera is from the subject, the *less* it will be distorted. It is that easy.

In Figure 5.5, we see the effect of the first half of the rule. It is the same chessboard, but the camera has been moved much closer to it. (Of course, changing the camera distance also changes the size of the image, but we cropped the pictures to keep the same subject size in all of them.)

See that the closer viewpoint increases the distortion. The lines that define the chessboard appear to converge much more radically than they did in the first photograph.

Exactly the reverse takes place in Figure 5.6. This time we moved the camera back. Notice how there is less distortion in this picture. The

89

5.5 Moving the camera closer increased perspective distortion and made the parallel lines that run toward the horizon appear to converge. This is one of the visual clues that the brain uses to perceive depth.

5.6 With the camera farther away, parallel lines appear to converge less.

lines in it converge far less obviously than they do in either of the two previous illustrations.

TONAL VARIATION

The second major depth clue is tonal variation. Tonal variation means that there are light areas and dark areas in the subject. If the subject is a cube, ideal tonal variation means that the viewer sees a highlighted

Do Lenses Affect Perspective Distortion?

When most photographers first use a wide-angle lens, they decide that the lens introduces a great deal of distortion. This is not quite accurate. Camera position determines perspective distortion, not the lens.

To prove this, we made every picture of the chessboard with the same wide-angle lens. This means that we had to enlarge the image made at an intermediate distance somewhat, and we had to greatly enlarge the image made at a greater distance. Those enlargements produced images whose sizes match the one made with the camera closer. Had we used longer focal length lenses, we would not have had to enlarge those two images, but the shape of the chessboard would have been the same as the shapes in the three pictures we show.

Choosing a lens of the appropriate focal length does allow us to control image size to make it fit the sensor size. Assuming we want the usable image to exactly fill the sensor, a short focal-length lens allows us a viewpoint that produces perspective distortion. A longer lens allows us to get far enough from the subject to minimize perspective distortion without having to greatly enlarge the image later. In each case, the viewpoint determines the distortion, not the lens. Extremely wide-angle lenses and inferior lenses may produce their own other types of distortion, but not perspective distortion.

side, a shadowed side, and a side that is partly shadowed. (We use "side" for convenience. One of these sides could be the top of the cube, or even the bottom, if the cube is suspended above us.) Good lighting does not always require this ideal, but the ideal is still the standard we use to evaluate whatever lighting exists.

These highlights and shadows are determined by the *size* and *position* of the light used. We treat size and position as two different concepts, but they are not mutually exclusive. One can greatly influence the other. A large light, for example, illuminates the subject from many different "positions" at the same time. In the rest of this chapter, we will see how these two variables relate.

THE SIZE OF THE LIGHT

Selecting the size of the light is one of the most important steps in studio lighting. Time of day and weather determine the size of the light outdoors.

The previous chapter discussed how adjusting the size of the light makes the edges of the shadows harder or softer. If two shadows record as the same gray, a hard shadow will be more visible than a soft one. For this reason, a hard shadow often increases the illusion of depth more than a soft one. When we understand this concept, we have another way to manipulate the tonal values, and thus control the sense of depth, in our pictures.

91

This seems to say that hard lights are better lights, but depth alone does not make a good picture. A shadow that is too hard can be so visible that it competes with the primary subject. Because we cannot offer firm rules about what size light is always best, we will explore the general principles in more detail.

Large Lights versus Small Lights

In Chapter 2 we discussed the following basic principles: a *small* light source produces *hard*-edged shadows, and a *large* one produces *soft*-edged shadows. Most of our lights are small. Portability and cost require it. Therefore, photographers more often need to enlarge a small light than the reverse.

Diffusing screens, umbrellas, and bounce cards all increase the effective size of any light. The effect of any of these is about the same as that of another. Because all of these devices can produce identical pictures, we pick the one that is most convenient. Thus, if the subject is small, we are more likely to use a framed sheet of diffusion material because we can place it close to the subject for brighter illumination. It's harder to construct a very large diffuser, so we are more likely to bounce the light from a white ceiling to light a large subject.

Outdoors we can achieve the same effect by waiting for an overcast day. Clouds make excellent diffusion material, effectively increasing the size of the sunlight source. Depending on the available time and the accessibility of the site, some photographers wait for a day with the right amount of cloud cover.

Lacking the time to wait for the best day, the same framed diffusion material we use in the studio is also good for small outdoor subjects. Alternatively, we can keep the subject in the shade. Then the large open sky, instead of the small direct sun, serves as the primary light source. (Although, without compensation, a subject lit only by the open sky can be quite blue.)

Distance from the Subject

You may have been surprised that in the preceding section we referred to the clouds and the sky as larger light sources than the sun. A corollary to the effect of the size of the light relates to the distance between a light and the subject it illuminates. The closer a light is to the subject, the softer the shadows are; the farther a light is from the subject, the harder the shadows become. The sun behaves as a small light source to people on earth because it is so far away.

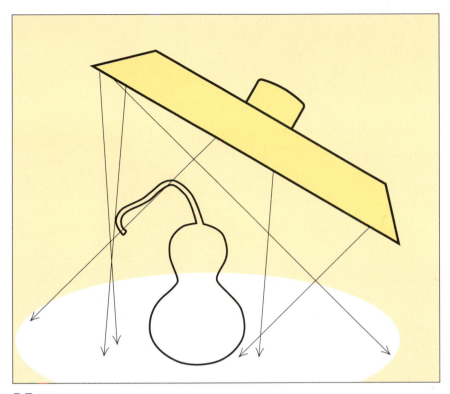

5.7 When close to a subject, the light rays from a large light source strike the subject from many angles. The closer the light is, the softer its shadows are.

Remember that large lights produce soft shadows because they illuminate the subject from more different directions. Figure 5.7 shows this, but look at what happens in Figure 5.8 when we move the same light source farther away. The light still emits rays in many directions, but only a narrow range of these rays strikes the subject.

Moving a light farther from the subject increases its contrast by reducing the range of angles from which the rays can strike the subject. This is just another way of saying that large lights produce soft shadows and small lights produce hard ones. The *closer* we move a light to a subject, the *larger* that light source becomes in relation to it.

Photographers using portable strobes in small rooms sometimes insist that the opposite is true. They know that moving the light farther from the subject softens the shadows, rather than making them harder. This is because moving the light farther away reflects more of the rays from the surrounding walls. The room itself becomes a more important component of the lighting. The room is larger than the strobe, so the principle is not contradicted.

93

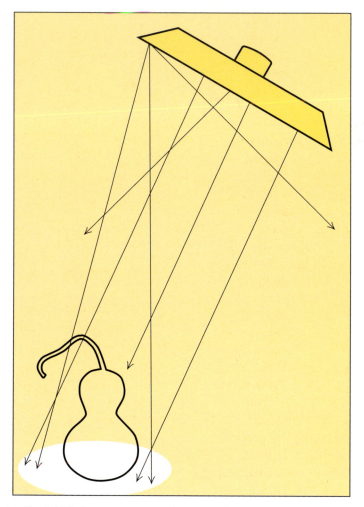

5.8 Moving the light farther away causes the rays striking the subject to be more parallel. This produces harder edged shadows.

THE DIRECTION OF THE LIGHT

The direction of the light relative to the subject determines what part of the subject is highlighted and where the shadows fall. Light from any direction may be good in any particular case, but only a few of them are good for emphasizing dimension.

Light coming from the direction of the camera is called *front lighting* because primarily the front of the subject is illuminated. Front lighting shows the least possible depth because the visible part of the subject is entirely highlighted. The shadow falls behind the subject where the camera cannot see it. The camera sees no tonal variation and, therefore, no depth. For this reason, front lighting is often called *flat*

lighting. However, the apparent lack of depth is not always a deficiency and, in fact, can sometimes be a virtue: front-lit portraits can be flattering by minimizing skin texture.

Backlighting also fails to reveal the depth of an object. Coming from behind the subject, backlighting puts the visible part of the subject in shadow. This can add drama, but without other lights, it will not add dimension.

Because the perception of depth requires both highlight *and* shadow, a lighting direction between front and backlighting maximizes that perception. Such lighting is called *side lighting.* Most good lighting is, at least to some extent, side lighting.

Still life photographers often use *top lighting* for tabletop subjects. Top lighting represents depth to the same extent as side lighting because it gives the subject the same proportion of highlight and shadow. We base our choice between them entirely on taste. This is a question of where we want the highlight and shadow, not of how much of each.

Light directly from the side or the top often conceals too much of the subject detail in shadow. So photographers may pull the light toward the camera to a position between those of side lighting and front lighting. This compromise is called *three-quarter lighting.*

You can justifiably decide to use any of these lighting directions for any subject. The thinking process you use is more important than whatever rules we offer. Your decision will almost always be good, as long as you consider what each direction accomplishes and how well it fulfills your objective for a particular subject.

Now we will look at a real subject and decide on one good way to light it. The subject will be a dried gourd, and our objective will be to light it to emphasize depth.

Light on the Side

One way of producing the shadows that we need as depth clues is to position the main light on one side of the subject. We tried this in Figure 5.9, using a small, high-contrast light so that you could see the shadow easily.

This is a potentially good approach, but it is usually not the best one for tabletop subjects. The combination of highlight and shadow does show dimension, but the hard shadow, located where it is, distracts from the primary subject. We could improve this photograph with a larger light. That would soften the shadow, making it less noticeable. However, the position of the shadow would still cause it to compete. (The gourd is the subject, not the shadow. On any other day we might decide the shadow is the subject, or at least an important secondary subject. Then we would light and compose the picture to capitalize on that shadow.)

95

5.9 The shadow helps the brain perceive depth, but in this case the shadow is obtrusive.

The only way to keep this particular shadow from drawing the eye away from the subject would be to soften it so much that it would not exist at all. But notice that the shadow also proves that the subject is sitting on a table. Without the shadow, the brain would have no way of knowing whether the subject is on the table or floating above it.

The relationship of the subject to the background tells the viewer an essential message about the depth in the scene. Conveying that message requires keeping the shadow. Because we must not get rid of the shadow, then we have to put it somewhere else.

Light above the Subject

The least distracting place for the shadow in most compositions is directly under and in front of the subject. This means placing the light above and slightly behind the subject. Figure 5.10 was shot with such an arrangement. Now the shadow gives the subject a "ground" on which to sit.

Although the placement of the shadow is improved, the picture still has two problems. The first is that the subject still does not have as much depth as it needs. The top of the subject is highlighted, but either side is about the same gray as the other. The lack of tonal distinction between the left and right sides detracts from the illusion of depth. The second problem, to many photographers, is that the shadow under the

5.10 With a small light above the subject, the shadow is small enough to be less obtrusive and it gives the gourd a "ground" on which to sit. However, the shadow is still too hard.

gourd is too hard. Being so hard makes it obtrusive, too much of an element in the picture.

We will first deal with the hard shadow. We used a small light in this example to make it easier to see where the shadow falls. Now that you have seen the shadow clearly, we will soften it. We will substitute a large soft box for the earlier small light. Figure 5.11 is a diagram of the lighting. Figure 5.12 is the result.

Notice in the lighting diagram that the soft box is angled slightly toward the camera. This tilt is not essential, but it is common. The tilt keeps the seamless background evenly illuminated. Notice that the light is closer to the top part of the background and that keeping the light level could light that area too brightly. The other reason for tilting the light is to cast more light on any reflector cards we might decide to use for fill light.

Fill Light

Sometimes a single large overhead light is sometimes all we need, but not always. This lighting fails if the subject is tall and thin or has very vertical sides. The tonal variation produced by the single overhead light

Seamless
Background

5.11 Lighting with a soft box makes the shadow much softer and unobtrusive.

5.12 The result of the lighting shown in Figure 5.11.

may be too extreme and, compared with the top of the subject, the front and side are too dark. This can even happen for a shallow, flat subject (such as an audio amplifier) if the detail in its front is highly important and what's on top is not. Figure 5.12 shows a bit of this problem; it's not terrible the way it is, but a little more light on the front of the gourd would be nice.

The most obvious solution to this problem is to add another light to fill in some of the shadow. This is not always the best solution, nor is it always necessary. Placing the fill light to one side may cause competing shadows, such as those shown in Figure 5.9. But placing the fill light over the camera may light the subject too evenly. That costs the very depth we are trying to achieve.

We can avoid adding problems by using a fill light that is as soft as possible and as dim as possible, provided it is still bright enough to do its job. If the fill is soft, the additional shadow will be too poorly defined to compete. If the fill is dim, a competing shadow will not be dark enough to be visible.

Keeping the fill soft means using a large enough source. A *very* rough rule is to use a fill light near the subject that is about half the size of the main light. Brighter fill lights usually need to be larger, but weaker ones can be smaller without creating noticeable extraneous shadows.

Sometimes a simple reflector card provides enough fill. We can add reflector cards on each side of the subject or directly under the camera. The amount of fill light affects both the brightness of the subject and the amount of the ground shadow lost. Our choice of fill card will vary with both the subject and the background.

Figure 5.13 was made with a silver reflector card to the right of the gourd. The light gray background reflected enough light to eliminate any need for a fill card to the left of the subject.

A white background might have reflected so much light that we would have needed no reflector cards at all. A black background would have reflected so little light that we would have needed stronger fill.

We can use any combination of reflector cards and additional lights, depending on how much fill the specific subject needs. The least amount of fill we are likely to use is the light reflected from a light background surface on which the subject sits. In those cases we may also decide to put a black card on one side of the subject so that both sides do not get equal fill. (We will show an example of this with the white-on-white subject in Chapter 9.) The most fill we are likely to need is a light behind a large sheet of diffusion material on one side of the subject, plus a smaller silver card or a white one on the other side.

5.13 A fill card lightens the front of the gourd by reflecting some of the light from the overhead soft box.

The physical arrangement of the apparatus used in the photograph influences how much freedom we have in positioning the reflector card. Sometimes we can put the card wherever we please, but on other occasions there is only one possible position that is close enough to the subject but still out of the image area. This may require using a white card when we might otherwise prefer a silver one.

A silver card usually reflects more light onto the subject than a white one, but not always. Remember that a silver card produces direct reflections. For this reason, the silver card has its own limited family of angles from which reflection can occur. In a crowded arrangement, the only possible position of a silver card may be at an angle from which it can reflect no light to the subject. In contrast, most reflection from a white card is diffuse. Because the angle of a white card is less critical, from some positions it will reflect more light to the subject than a silver one.

Notice that the size of the main light also influences our choice of reflector cards. A bright, smooth silver card produces a mirror image of the main light. Therefore, if the main light is large, then a large silver card will serve as a soft fill light. A small silver card will behave as a hard

fill for the same reason any other small source is hard. If the main light is small, however, a silver card reflecting that light will always be a hard fill, regardless of its size. A white reflector card is the only reflector that can provide soft fill light from a small main light.

Finally, even though the background surface often provides adequate reflected fill, beware of colored backgrounds, especially if the subject itself is white or pastel. Fill reflected from a colored background can color the subject. Sometimes we have to add more fill from a white light source to overcome the color cast caused by the background surface. We may also need to cover part of the background surface with black cards to get rid of off-color reflected fill.

Adding Depth to the Background

In Figure 5.11 we used a curved paper background called a *sweep*. Hung in this manner, the background covers the table on which the subject sits and also conceals whatever might be behind the table. The camera sees no horizon, nor is the gentle curve of the paper visible as long as we do not let the shadow of the subject fall on that part of the background. The brain thinks the entire surface is horizontal and extends a possibly infinite distance behind the subject.

So far, we have used simple, single-tone backgrounds for the sake of simplicity in our examples. Not only can this produce boring pictures, but such lighting also fails to capitalize on the illusion of infinite depth in the background. We can greatly enhance this illusion by illuminating the background unevenly.

We call this uneven illumination *falloff*. As we are using the term, it means a transition in the scene from light to dark. Falloff can occur in any area of the picture. Photographers more commonly use falloff at the top of the picture; it looks good there and happens to be the easiest place to put it without interfering with the lighting of the primary subject.

Look at Figure 5.14. Notice how the background tone falls off from light green in the foreground to black in the background.

The difference in the tonal value of the foreground and background tones provides another visual clue to suggest depth.

Figure 5.15 shows how we produced the falloff. All we had to do was aim the light more toward the camera.

This simple change in our set allowed less of it to fall on the seamless paper at the back of the set.

Notice that we added a gobo over the lens. It was important because the more we aimed the light toward the camera, the greater was the possibility that we would produce serious camera flare.

101

5.14 The uneven illumination of the background, called falloff, adds depth to a picture and helps separate the subject from the background.

5.15 Aiming the light toward the camera produced the background falloff. The gobo is often essential to prevent flare.

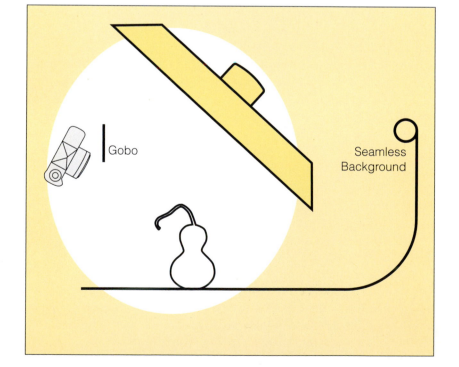

Gobo

Seamless Background

Stopping Flare

Flare, also called *nonimaging light*, is the scattering of light so that it goes where we don't want it. It exists in every picture, usually to an unnoticeable and harmless degree. However, the lighting in Figure 5.15 is likely to produce enough flare to degrade the picture. Sometimes flare looks like a uniform gray fog over the entire image; other times it appears as the uneven streaks we show later in Figure 7.17.

There are two different kinds of flare: lens flare and camera flare. The effect of these two can look the same. The difference between them is where the light gets scattered. Lens flare, thanks to modern optics, is rarely a problem if the lens is kept clean. Camera flare, on the other hand, is relatively unimproved by optical advances, and it remains a serious problem.

Figure 5.16 shows what causes camera flare. Light from just outside the field of view enters the lens and reflects from inside the camera to the sensor, degrading the image. All cameras have black interiors and all professional cameras have ridges inside to absorb as much of this extraneous light as possible, but no camera design eliminates it entirely.

The whole purpose of a lens hood is to block light coming from outside the scene before it enters the lens. Lens hoods, unfortunately, sometimes do not extend far enough forward to be of any help in preventing camera flare. This is particularly true of view cameras because a lens hood deep enough to be effective can block part of the scene when the lens is tilted or shifted. The solution is to use opaque cards as gobos, as in Figures 5.15 and 5.16.

5.16 Camera flare is caused by light from outside the field of view passing through the lens and reflecting from the inside of the camera. Blocking the light before it reaches the lens is the only way to prevent it.

(Continued)

> ## Stopping Flare *(Continued)*
>
> If the light source is hard, we can position the gobo so that its shadow just barely covers the lens. However, placing the gobo is more difficult if the light source is soft. The shadow of the gobo may be so soft that we cannot tell when it adequately blocks the light falling on the lens.
>
> Because we normally compose and focus with the lens opened to its maximum aperture, there is little depth of field in the image we see in the camera. This lack of depth of field may make the image of the gobo so unsharp that it is impossible to see it even when it is intruding into the picture area. It can be difficult to place the card close enough to the field of view to be useful without blocking part of the scene.
>
> Remember, however, that the glass lens reflects like a mirror. With the camera on a tripod, you can look into the front of the lens and see the reflection of any light source likely to cause flare. Move the gobo in front of the lens just far enough that you can no longer see the light source reflected in the lens. Then pull the gobo back slightly for safety. A gobo in that position eliminates almost all flare without extending into the image.

HOW MUCH TONAL VARIATION IS IDEAL?

We have said that a box with three visible sides needs to have a highlight side, a shadow side, and a side whose tone is between those two. Nowhere have we said how bright the highlight must be or how dark the shadow should be. In fact, we never specify lighting ratios in this book because the decision has to be based on the specific subject as well as personal taste.

If the subject is a simple cube with no important detail on any of its sides, we can make the shadow black and the highlight white. However, if the subject is the package for a product we want to sell, there may be important detail on all sides. This requires keeping the highlight only slightly brighter, and the shadow only slightly darker, than the third side.

Let's look at two more examples, an office building and a cylinder, one case in which photographers are very likely to want less tonal variation, and another in which we tend to prefer more variation.

Photographing Buildings: Decreasing Tonal Variation

The same techniques apply to photographing the building in Figure 5.17 as to making a picture of a brick. Both cases need those visual clues that add the illusion of depth.

However, special considerations apply to the building. The first is that we are likely to prefer a smaller light source for the architecture than for the brick. This does not suggest that architecture does not photograph beautifully on an overcast day. The opposite is true. Architectural photography almost always includes the sky, however, and

clean blue skies are usually more pleasing than dingy gray ones. Furthermore, a blue sky probably has a hard, undiffused sun in it.

Choosing a day with harder light has further implications about where we "position" that light. The harder shadow is more visible and, hence, more likely to compete with other detail. The undiffused sunlight also causes brighter highlights and darker shadows. Unfortunately, such highlight and shadow are more likely to obscure details.

Because of the need to minimize shadows to increase the legibility of the architectural detail, many photographers prefer to take pictures that are lit much like that shown in Figure 5.17. They like to work with

5.17 This building is the same basic shape as the other boxes shown in this chapter. The sun was in a position to produce relatively even illumination. (Copyright 2007 by Dan Cunningham.)

the sun behind them, slightly to the side that the building faces, and low in the sky. Not only does such lighting produce a less distracting shadow, but because it occurs just after sunrise or just before sunset, the sunlight often warms the color pleasingly.

We know that less tonal variation produces less sense of depth. But remember also that more perspective distortion increases the depth illusion. So as we opt for more even illumination, we are also likely to locate the camera closer to the subject. (Architectural photographers use shorter-focal-length lenses to make this possible.) The consequent increase in perspective distortion regains some of the lost depth.

Photographing Cylinders: Increasing Tonal Variation

Now we are going to look at cylinders and the special problems they can present. Figure 5.18 is basically a cylindrical object, but the tonal variation does not reveal the shape very well. Because the lighting is so even across the entire surface of the wooden bowling pin, it is difficult to tell whether the object is three dimensional. The photograph does not contain enough visual clues for our brains to make an informed decision.

The problem is caused by the fact that the "sides" of the cylinder are not separated by any clearly defined edge. The shadow blends so gradually into the highlight that some of the dimensional distinction is lost. The solution to this problem is to build more tonal variation into the scene. Cylinders usually need a brighter highlight side or a darker shadow side than boxes do. Figure 5.19 shows what happens when we modify the lighting to achieve this.

There are two good ways to obtain this increased tonal distinction. One is to keep the basic lighting similar to that in the gourd examples but to use a brighter reflector on one side. Then we use no reflector or, if necessary, a black card on the other side.

We could also produce Figure 5.19 by putting our main light beside instead of above the subject. By lighting one side of the cylinder more than the other, enough variation from highlight to shadow supplies the illusion of depth.

Unfortunately, placing the light to one side of the subject creates a potential problem. The shadow of the subject falls on the table surface beside it. As we saw earlier, the shadow is least likely to become a strong compositional element if it falls at the bottom of the picture, under the subject.

If we do place our main light to the side of a cylindrical subject, we usually use an even larger light source. This further softens the shadow and makes it less likely to compete for attention.

5.18 This subject is basically cylindrical, but the flat lighting does not give enough visual clues to show it.

5.19 Lighting the pin from the side gives pronounced tonal variation—just the clue that the brain needs to perceive depth.

Remember Surface Detail

Finally, remember that surface detail, subtle variations in both color and texture, are most visible in the mid-ranges. Look again at Figure 5.19, the bowling pin, with this in mind. The "B" logo is large and graphic enough to hold up under almost any lighting, but if we want to get picky about it, we have to admit that the center of that logo is rendered better than its left and right edges. The logo is somewhat less visible where its black edge meets the shadow and where the gloss of its highlight turns the black to a color similar to that of the wood. Furthermore, if we were the manufacturers of the pin, instead of photographers wanting a good picture, we would probably object to the near-loss of the "g" in the "score-king" part of the label.

Some digital cameras compound this loss by abruptly clipping the detail at absolute black and absolute white. Photographers who shot film, especially negative film, usually had some additional detail in both the highlight and the shadow that could be enhanced in the darkroom.

So knowing that tonal variation is a good thing, we still don't usually maximize it. We judge each subject individually, considering what else is important about that subject, who is going to use the picture, and how they intend to use it.

THE GLOSSY BOX

In Chapter 4 we saw that good lighting requires distinguishing between diffuse and direct reflection and making an informed decision about which we are going to use. Everything we said about lighting a simple, flat surface applies equally to the group of surfaces that makes a three-dimensional object.

In this chapter we have discussed perspective distortion, light direction, and light size. These all determine whether the camera can see a light source within the family of angles that produces direct reflection. Now we are going to talk about some of the special techniques that are helpful when photographing a glossy box.

Look at Figure 5.20, a diagram showing a glossy box with two families of angles, one that produces direct reflection from the top of the box and one for the front. (Most camera viewpoints require photographers to deal with three families of angles, but it is easier to see them in a diagram showing only the top and front.)

Our first lighting decision is whether to produce direct reflection or to avoid it: whether to place the light within or outside the family of angles.

Figure 5.21 shows a box with a very glossy finish. Because it is so shiny, much of the detail of the wood in its top is obscured by direct reflection.

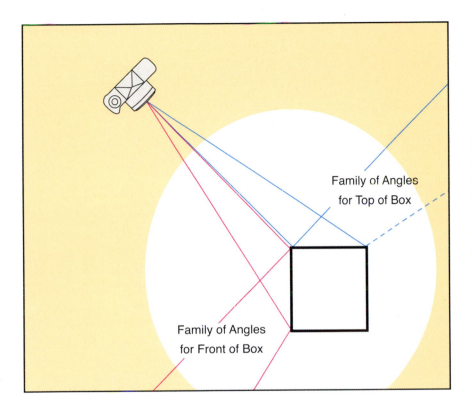

Family of Angles
for Top of Box

Family of Angles
for Front of Box

5.20 Here are two of the families of angles with which we must contend when shooting a box. A light source in either of them will produce direct reflection.

5.21 Details on the top of this box are largely obscured by direct reflection. We could remedy this by keeping light sources out of the family of angles producing that reflection.

We should be able to remedy the loss of detail by keeping light sources out of the family of angles that produces such reflection. The following is a series of steps that can accomplish this goal.

Use a Dark Background

First, use a dark background if possible. As you can see from Figure 5.20, one of the ways in which glare-producing light gets to the subject is by reflecting from the background. Light from the tabletop can cause direct reflection on the sides of the box. If we are using a sweep, light from its upper part can reflect on the box top. The darker that background is, the less light reflects from it. This step alone may be adequate for some subjects.

Sometimes you may not want a dark background. On other occasions, you will find that light that produces direct reflection comes from someplace other than the background. In either case, the next step is the same: find the light creating the direct reflection and get rid of it.

In the examples that follow, we deal with the family of angles defined by the top of the box with one set of techniques. We then use another, slightly different procedure for the families of angles associated with the sides.

Eliminate Direct Reflection from the Box Top

There are three effective ways of eliminating direct reflection from the box top. We can use one, or we can use a combination of them, according to the other requirements of the picture.

Move the Light Source toward the Camera

If the camera is high, then an overhead light can reflect in the top of the box. This is particularly true of a bank light. Such a light is so large that at least a part of it is very likely to be within the family of angles. This causes direct reflection to be brighter and worse than if a light background reflects in the top of the box.

One remedy is to move the bank light toward the camera. Doing so, as shown in Figure 5.22, clearly reveals the detail on the box top.

Raise or Lower the Camera

Moving the camera also changes the family of angles. If an overhead light source reflects in the box top, lowering the camera moves the family of angles so that the light is no longer in it. If the top of a sweep is reflecting in the top of the box, raising the camera causes the studio

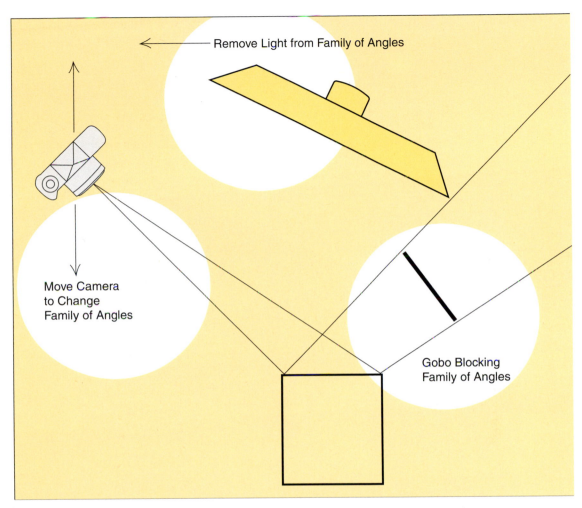

5.22 Here are some of the different ways to eliminate direct reflections from the box top. You can use any one or a combination of them.

area above and behind the background to reflect instead (Figure 5.23). Fortunately, it is usually a simple matter to keep that part of the studio dark.

Use Falloff

If it is not possible to use a dark background, we may at least be able to darken that part of the background that causes direct reflection on the top of the box. Falloff accomplishes this. Keep as much light as you can from the background. The less light hitting the box surface, the less that will reflect from it.

111

Eliminate Direct Reflection from the Box Sides

It is relatively simple to get rid of most of the direct reflection from the top of a glossy box. Things get more difficult when we start trying to eliminate it from the sides. In Figure 5.24 we have turned the box top on edge to show an exaggerated example of the problem that can occur on the sides of the box.

5.23 Here we see the results of moving the bank light forward. The detail on the box top is now clearly visible.

5.24 For this picture, we turned the box's top on edge to give an exaggerated example of the problems that can occur on the box's sides.

112

Put a Black Card on the Tabletop

This will darken part of the surface and eliminate direct reflection from part of the subject. Figure 5.25 shows the result.

This is a particularly useful technique when we want to eliminate some direct reflections but not others. For example, direct reflection can obscure the plastic dial on a stereo receiver while at the same time making the aluminum faceplate look bright and clean. In such cases, cutting the black card to fit just the family of angles that produces direct reflection on the plastic can solve one problem without creating another.

If you look again at Figure 5.20, you will see that if the box side is perfectly vertical, the black card cannot fill all of the family of angles unless it is close enough to touch the bottom of the subject. Nevertheless, getting the card as close as possible without intruding into the image area is often a good start before going on to the next technique.

Tip the Box

Sometimes you can remove a good bit of the offending glare by tipping up the front of the box. The suitability of this tactic depends on the shape of the subject.

5.25 Using a dark card to the right of the box gets rid of unwanted direct reflections on its side and restores detail.

113

For example, subjects like computers and kitchen appliances often sit on their own small feet a small height above the tabletop. Hiding a small support in the shadow under such a subject is simple. Once the camera is tilted to make the subject appear level, the trickery is undetectable.

If the box is supposed to be flush on the tabletop, it is easier for the camera to see that the box is not level. We may be able to tilt the box less, or not at all. Even a slight tilt can be helpful, however, especially along with the following technique.

Use a Longer Lens

There are times when a longer lens can come to the rescue. Figure 5.26 shows how a longer lens allows us to place the camera farther from the subject. As we see, the family of angles is smaller than it was in Figure 5.20. This means less of the tabletop reflects in the subject.

Finish with Other Resources

If some direct reflection is still obscuring detail, the following techniques can eliminate it completely.

Try a Polarizer

If the direct reflection is polarized, a lens polarizing filter will get rid of it. We suggested this as one of the first remedies to try for the competing surfaces presented in the previous chapter.

If, however, the subject is a glossy box, we more often save the polarizer as a next-to-last resort. The glossy box usually has polarized reflection on more than one side. Unfortunately, the reflection from one side is likely to be polarized in a direction perpendicular to the polarization of the other side. This means that as the polarizing filter eliminates one polarized reflection, it effectively increases another.

Therefore, we first try the preceding steps. Then, whatever direct reflection is left is that which is the most difficult thing to eliminate. Then we use the polarizer to reduce that reflection. If the other remedies have been successful, the slightly increased direct reflection on the other sides will not be any trouble.

Use Dulling Spray

Yes, there are times when the dragon wins! There are times when Mother Nature, physics, and viewpoint produce reflections that cannot

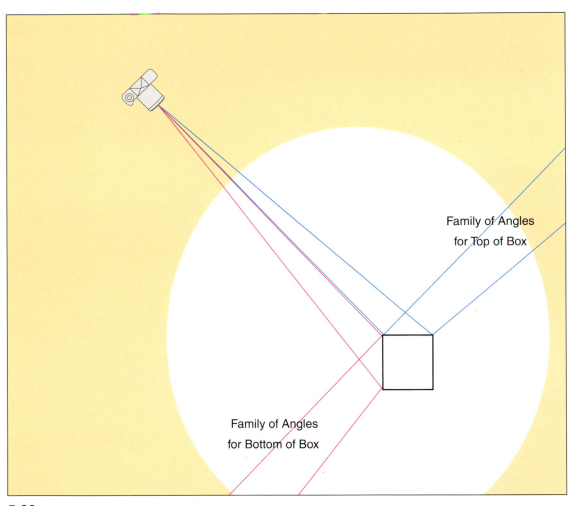

Family of Angles
for Top of Box

Family of Angles
for Bottom of Box

5.26 Using a long lens sometimes helps get rid of unwanted reflections. Comparing the more distant viewpoint in this diagram with that in Figure 5.20 shows that the farther we move the camera, the smaller the family of angles gets.

be eliminated with any of the techniques we have described. Then we use dulling spray. It may make an otherwise unacceptable picture work.

Be aware, however, that dulling spray can reduce the sharpness of the very detail you are trying to preserve. If that detail happens to be fine type or the like, the loss of sharpness may be more damaging than a loss of contrast caused by direct reflection.

In addition, there is always the chance that the chemistry of the dulling spray will not get along well with that of the subject upon which you are spraying it. So be careful. Always test a little bit of spray on a small, and hopefully insignificant, part of your subject. Not to take this precaution is to court disaster!

115

Use Direct Reflection

We chose the glossy box example to be one in which direct reflection is obviously offensive. But if direct reflection does not obscure detail, we are usually more likely to try to maximize it rather than to avoid it. After all, if direct reflection is essential to the surface, capitalizing on that reflection produces an image of the subject that looks as much like the real thing as possible. We will discuss the specific technique in the next chapter.

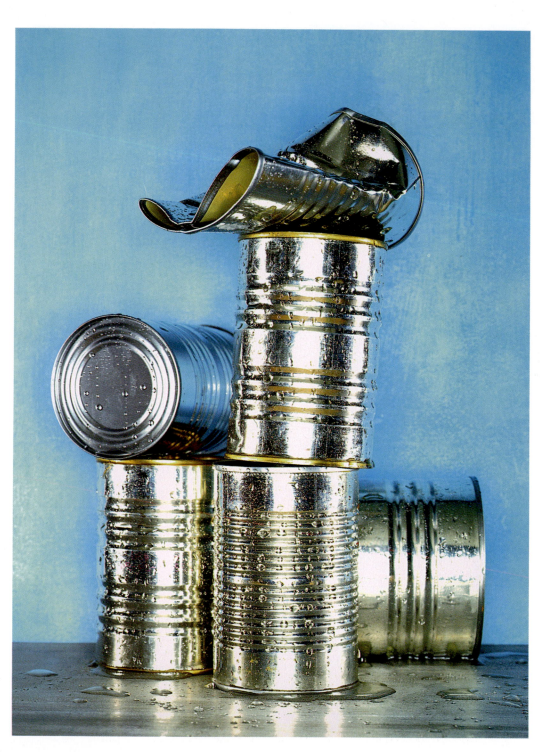

118

6

Metal

Many student and apprentice photographers think metal is one of the most difficult photographic subjects and consider assignments that require them to photograph metal to be nothing less than cruel and unusual punishment. However, when they master the assignment, they discover that nothing could be further from the truth. Metal is not difficult, and photography teachers have slightly less than sadistic motives when they require such work.

There are about a half dozen classic subjects that all photographers are supposed to encounter as they learn lighting. These subjects teach basic techniques that enable us to light anything. Metal is one of the classic subjects for good reason. Brightly polished metal produces almost nothing but unpolarized direct reflection. This constancy makes metal a real joy to photograph. It is predictable. It plays by the rules. We can tell before we begin to light the scene what size the light needs to be.

Moreover, when it does turn out to be impossible to position the light source where it needs to be to light the picture well, we can also see the problem early in the process. We seldom invest a lot of time, only to find that what we are attempting cannot be done and that we have to start the lighting arrangement over from the beginning.

In addition, because the direct reflection in metal is largely uncontaminated by other types of reflections, it is easy to see how this reflection behaves. Therefore, learning to photograph polished metal helps give one the capability to see and to manage direct reflection whenever and wherever it occurs, even when other kinds of reflections compete in the same scene.

We will introduce new concepts and techniques in this chapter. The most important subject matter is the simplest: flat, brightly polished metal. A flat piece of metal, without any other objects in the scene, is easy to light, even without much thought or understanding of the

119

relevant principles. But such simple subject matter can demonstrate the most sophisticated techniques—techniques that can eventually make even the most difficult assignments possible.

Much of what follows is based on the family of angles that causes direct reflection. We introduced this family in Chapter 3. We have used the concept in each succeeding chapter, but in none of them was it as vital as it becomes when dealing with metal.

FLAT METAL

Brightly polished metal acts like a mirror: it reflects whatever is around it. This mirror-like quality means that when we photograph metal, we do not make a picture of just the metal itself. We also make a picture of its surrounding, or environment, as it is reflected in the metal. That means that we must prepare a suitable environment before we photograph the metal.

We know that direct reflection can be produced only by a light source that is within a limited family of angles, relative to the subject and to the camera. Because the metal reflects its environment, it makes sense that the smaller that family of angles is, the less of the environment we have to worry about. A small piece of flat metal has only a small family of angles from which direct reflection can be produced. This makes such a piece of metal the simplest example we can use to talk about the general principles of lighting any metal.

Figure 6.1 is a diagram of a piece of flat metal and a camera. Note that the camera position is essential in any lighting diagram involving metal. This is because the family of angles depends on the position of the camera relative to the subject. Therefore, the relationship between the camera and the subject is at least as important as the subject itself. We know that direct reflection can be produced only by a light located within the limited family of angles we show here.

Bright or Dark?

One of the first decisions that we have to make when we photograph a piece of metal is how bright we want it to be. Do we want it to be bright, dark, or something in between? The answer to this question determines the lighting.

If we want the metal to appear bright in the photograph, we make sure our light source fills that family of angles that produces direct reflection on the metal. If, however, we want the metal to be dark in the picture, we put the light anywhere else. Either way, the first step in lighting metal is to find that family of angles. After that, the task is straightforward.

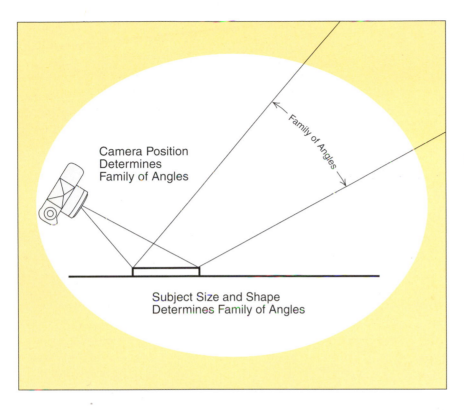

Camera Position
Determines
Family of Angles

Family of Angles

Subject Size and Shape
Determines Family of Angles

6.1 The family of angles that produces direct reflection depends on the position of the camera relative to the subject.

Finding the Family of Angles

Practice makes it easy to anticipate where the family of angles will be. Experienced photographers usually get the light so close to the ideal position on the first try that only minor adjustment needs to be made after the first look in the camera. However, if you have never before tried lighting metal, it may be difficult to visualize where the family of angles exists in space.

We are going to show you a technique that always finds exactly where the family of angles is. You may decide to use it often or you may decide to use it only for more difficult setups, depending on your need. Either way, an abbreviated version of this routine is adequate for most photographs. If this is the first time you have tried to light metal expertly, it is probably worth trying the entire following sequence of steps at least once as an exercise.

Position a White Target Where You Think the Family of Angles Will Be

This white target can be any convenient large surface. The easiest will be whatever large piece of diffusion material you might eventually use

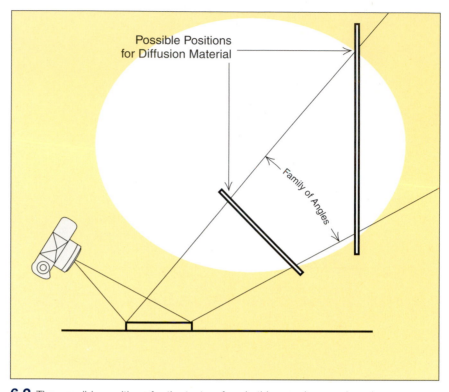

6.2 The possible positions for the test surface in this exercise are also where we might suspend diffusion material if we wished to light the metal brightly.

to light the metal. Figure 6.2 shows two possible positions where we might suspend a large diffusion sheet over the metal.

You do not know exactly where the family of angles is at this point. Use a larger white surface than you think you need to fill those angles. The less sure you are of where the angles are, the bigger the surface needs to be.

Place a Test Light at the Camera Lens

We call this a "test" light to distinguish it from whatever light we eventually use to make the picture. The test light needs to have a narrow enough beam to light the metal without illuminating the surrounding area. A small spotlight is ideal, but a flashlight is adequate if you can keep the room dark.

If you are photographing a small piece of metal from a close working distance, the test light must be exactly at the lens position. This may require temporarily removing the camera from the tripod. Alternatively, if the camera is a view camera, you may be able to temporarily remove both the lens and the camera back and aim the test light through the

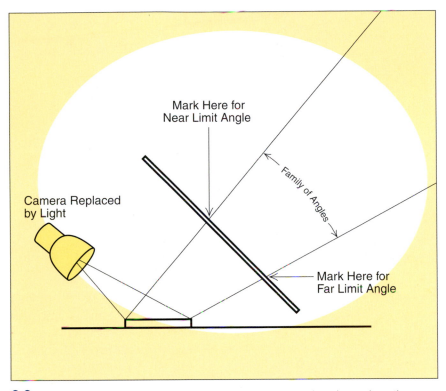

Mark Here for
Near Limit Angle

Family of Angles

Camera Replaced
by Light

Mark Here for
Far Limit Angle

6.3 A test light in place of the camera reflects from the metal to show where the family of angles is located. News flash: Since the last printing of this book, a clever reader has suggested using a laser pointer as the test light. Should work well!

camera. Be careful of this tactic! A photographic light too close to a black camera can quickly heat up the camera enough to cause very expensive damage.

When the camera has a long lens and the distance to the subject is great, it is usually not necessary to place the test light at exactly the lens position. Positioning the light as close to the lens as possible approximates the ideal well enough for more practical purposes.

Aim the Test Light

Aim the test light at the point on the metal surface that is nearest to the camera. The light will reflect off the metal and onto the test surface. As we see in Figure 6.3, the point at which the beam strikes the test surface marks the near limit of the family of angles. Use removable tape to mark the spot.

If the beam of light is broad enough to cover the entire metal surface, you can leave it in position without moving it for the rest of this

exercise. If, however, the test light illuminates only part of the surface, aim it now at the farthest point on the metal. The light reflected from that point on the metal will strike the test surface at the far limit of the family of angles. Once again, mark the test surface with tape.

Similarly, mark as many points as you need to see where the family of angles lies. The shape of the metal subject determines the necessary number of points. At the least, you will probably decide to mark the near and far limits of the family of angles. If the metal is rectangular, you may decide to mark the points at which the corners reflect light onto the test surface, instead of the edges.

Study the Position and Shape of the Area Marked on the Test Surface

You will almost never need a light source or a gobo that *exactly* fits the family of angles. Nevertheless, this is good practice, so use this opportunity to examine exactly where those angles are. A little extra time invested now will pay back dividends later. Precisely locating the family of angles now will allow you to guess its position more quickly in a future project without going through this whole measurement procedure again.

Note especially that the point reflecting in the metal edge at the *bottom* of the image corresponds to the limit marked at the top of the test surface and vice versa. Remembering this will make it easy to find the source of glare or hot spots on any type of subject from now on.

The relationships you prove in this exercise apply to other camera and subject orientations. The diagram here represents a side view of a camera photographing a small piece of metal on a table. Of course, it could just as easily be a bird's-eye view of a camera photographing a building with a mirrored glass front. Then the area marked on the test surface might correspond to the portion of the sky reflected in such a building.

Lighting the Metal

Using the foregoing test, experienced judgment, or a combination of the two, we find the family of angles from which a light can produce direct reflection in the metal. Next, we have to decide whether we want the metal to be bright or dark in the picture. This is a critical step because it leads to two exactly opposite lighting setups.

In some photographs, the metal needs to be absolutely white while the rest of the scene is as dark as possible. On other occasions, we decide to keep the metal black in an otherwise high-key scene. More often we like to see something between these extremes, but learning to produce the extremes makes the compromise easier to obtain.

Keeping the Metal Bright

Because photographers usually choose to make the metal in their pictures look bright, we will deal with that case first. If we assume that we want the entire surface of the metal to photograph brightly, we then need a light source that at least fills the family of angles that produces direct reflection. Note that because polished metal produces almost no diffuse reflection, light coming from any other angle will have practically no effect on the metal, regardless of how bright it is or how long the exposure.

It is also important to realize that a light that just fills the family of angles is the *minimum* light size we can use. Later, we will show you why we routinely use a light larger than the minimum. For now, we will assume that the minimum size is adequate.

Figure 6.4 shows one possible lighting arrangement. We have used a light on a boom above a diffusion sheet and have adjusted the distance from the light head to the diffusion material so that the beam approximately fills the family of angles that we marked earlier.

We could use an opaque white reflector card instead of the diffusion sheet. Then we would use the alternative lighting shown in Figure 6.5.

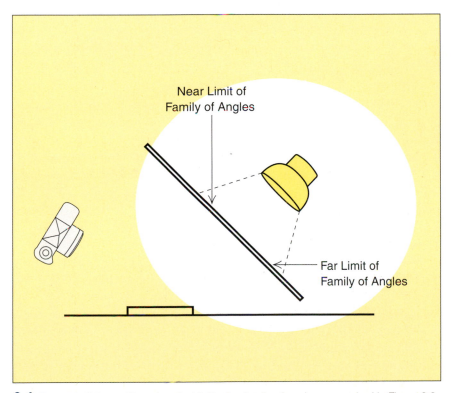

Near Limit of Family of Angles

Far Limit of Family of Angles

6.4 The main light positioned so that it fills the family of angles we marked in Figure 6.3.

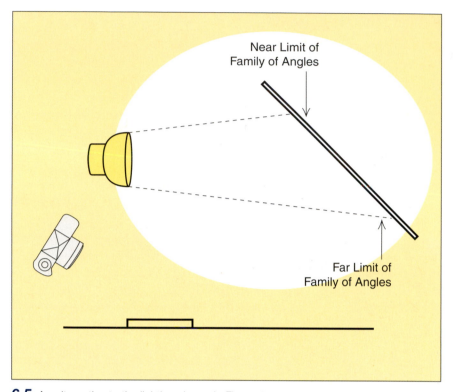

6.5 An alternative to the lighting shown in Figure 6.4 uses an opaque white reflector card and a spotlight focused to fill the family of angles.

A spotlight near the camera, with the beam of the light focused to approximately fill the family of angles, would light the subject identically to the light through the diffusion sheet.

Most soft box arrangements do not allow adjustment of distance of the head to the diffusion material on the front. The light is fixed inside the box to illuminate the entire front of the box as evenly as possible. However, we can achieve a similar effect by attaching black cards to the front of the soft box to limit its effective size, as shown in Figure 6.6.

We used the first of these three alternatives to photograph a brightly polished metal spatula on a white paper background. Figure 6.7 is the result.

As we expected, the metal is a pleasing light gray. If you have never lit a scene this way, you might not have expected the photograph to render the "white" background so dark! This is a necessary consequence of the lighting. The exposure is "normal" for this scene.

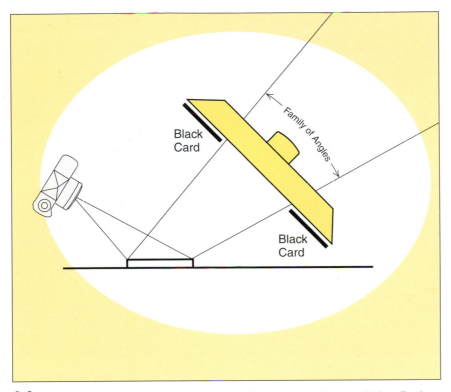

6.6 A third alternative to the lighting shown in Figure 6.4: a soft box, with its effective size adjusted by black cards.

What Is a "Normal" Exposure for Metal?

Because the metal was the important subject matter in Figure 6.7, we exposed to get it right and ignored the background. How might we expose the metal to "get it right"? One good way is a spot meter reading on the metal, remembering to expose two to three stops more than the meter indicates. (The meter tells us how to expose the metal to be an 18% gray. However, we want it brighter than that. Just *how much* brighter is a creative decision, not a purely technical one. Two to three stops is a reasonable range.)

Keep in mind that in the preceding example, we lit the metal to be as bright as possible without bothering with any other considerations. Because the metal produces almost nothing but direct reflection, its brightness in the image approximates that of the light source. A gray card reflection reading of the scene will probably not predict an acceptable exposure *if the metal is the important subject*. The general rule that tells us to place the middle grays accurately, letting the extremes fall

127

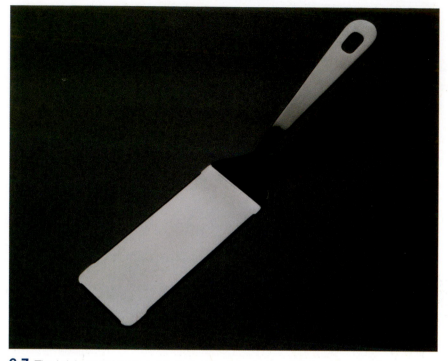

6.7 The bright metal spatula blade is placed against a white background. Do you know why the white background looks so dark?

where they may, fails when the important subject happens to be very much brighter than an 18% gray card. Thus, the "proper" exposure for this scene renders the white background as a dark gray.

Suppose, however, that the metal is not the only important subject. This could happen even in this simple scene. There are no other important objects here, but the white background could be critical in an advertisement requiring legible black type in the image area.

In that case, a gray card reading would give an excellent exposure of the white background but at the expense of hopelessly overexposed metal. There is, unfortunately, no "normal" exposure that works for both. If the metal and the white paper are both important, we have to relight the scene. We will soon see several ways to do so.

Keeping the Metal Dark

In the previous section, we talked about how to photograph metal to appear bright. Now we will relight the scene to keep the metal as dark as we can. In principle, nothing could be easier. All we have to do is to light the metal from any direction we please, other than from within

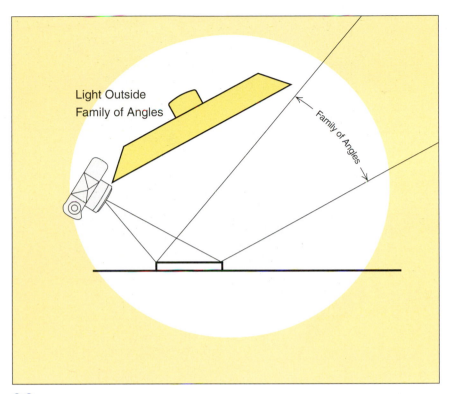

Light Outside
Family of Angles

Family of Angles

6.8 This light position is one of the many that would work if we want to keep the metal dark. The important point is to keep the light outside the family of angles.

that limited family of angles that produces direct reflection. One simple way to do this is to put the light near the camera. We will start by showing what happens when we do.

The light position shown in Figure 6.8 is one of many that would work. Note that the same family of angles we determined earlier now marks the positions where we must not place the light if we want to keep the metal dark.

Although the family of angles is still in the diagram, notice that the white test surface on which it was marked is gone. Had we left it in place, it would have reflected some of the general illumination, behaving as an additional light source.

Figure 6.9 proves the theory. It shows graphically what happens when we place the light source outside the family of angles that produces direct reflections on the metal spatula. The lighting setup in Figure 6.8 can cause only diffuse reflection. Because the metal cannot produce much diffuse reflection, it is black. The paper can produce diffuse reflection from a light from any direction, so it is rendered white.

129

6.9 The light is outside the family of angles reflected by the spatula. With no direct reflections on the metal surface, it is black in this picture.

An incident reading, a gray card reading, or a reading of the white paper (with the appropriate compensation) would all be good exposure indicators. This is true of almost any scene with reasonably even illumination and little or no direct reflection. With neither direct reflection nor important dark subjects in shadow, we do not have to think about the extremes. Getting the middle grays exposed properly is all we need to worry about.

We are unlikely to use the lighting in Figure 6.8 as the principal lighting of a scene except to demonstrate the principle. The position and the hardness of the shadow are too displeasing. With that in mind, we will move to a slightly more difficult variation on the same theme. We will keep the metal surface black but remedy the objectionable shadow.

Assume the test target we used to find the family of angles was much larger than the minimum needed to fill those angles. If we light the subject with every point on the surface except the marked family of angles, we will have a large, soft source that still keeps the metal black. Figure 6.10 shows how we can accomplish that result.

Notice that we have backed up our light to illuminate the entire diffusion sheet as evenly as possible. Then we have attached a gobo cut

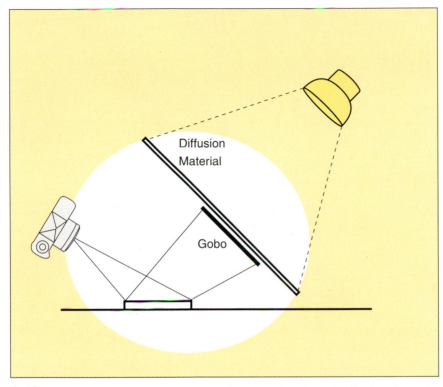

6.10 The large light lights the scene softly, but the gobo fills the family of angles and keeps the metal dark.

to a size and shape that barely fills the family of angles. Figure 6.11 is the result.

This technique would also work very well using a soft box instead of a framed diffusion sheet and a light on a boom, but it would be less effective using an opaque white reflector card. The light illuminating the reflector card would also illuminate the gobo brightly. The gobo would behave more like a reflector than a light-blocking device, even though it might be black. Because that black gobo would absorb some photons and reflect others, it would not be a good way to demonstrate either bright-metal or dark-metal lighting. However, it might be the most pleasing compromise of all.

The Elegant Compromise

We almost never use the bright-metal or the dark-metal lighting techniques by themselves. More often we prefer a combination of the two, a compromise between the extremes.

131

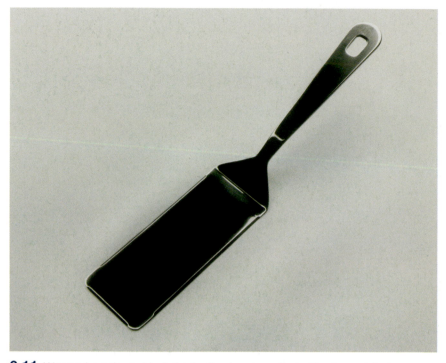

6.11 We used a gobo to block the family of angles reflected by the metal when we took this shot. This darkened the spatula.

Figure 6.12 is a compromise. It was made with light filling the family of angles that produces direct reflection from the metal *plus* illumination from other angles to produce diffuse reflection from the background.

Figures 6.13, 6.14, and 6.15 show some possible lighting arrangements that could have produced the photograph. Every arrangement uses light from within the family of angles *and* from other directions. We used the lighting in Figure 6.15, but any of these lighting arrangements could produce equivalent results. The best way is whatever suits the equipment you have on hand.

The most important point behind this demonstration is not to convince you that the compromise lighting makes the best picture, but to get you to understand the *thinking* that leads up to the compromise.

We can *decide* exactly where we want to place the metal on the grayscale. The precise tone of the metal is fully controllable, independently of the rest of the scene, and it can be any step between black and white that the photographer's creative judgment determines.

If we had used the lighting in Figure 6.13, for example, we could have made the metal brighter by increasing the power of the light above the diffusion material, or we could have made the paper background

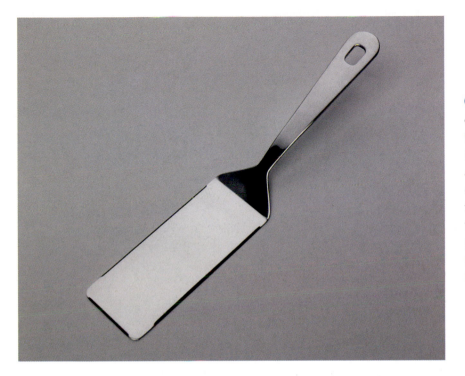

6.12 An elegant compromise between Figures 6.7 and 6.9. Light fills the family of angles that produces direct reflection from the metal, and light from other angles produces diffuse reflection from the background.

Fill Light

Main Light

Diffusion Material

6.13 One way to light the spatula shown in Figure 6.12. The main light is positioned within the family of angles to produce the large, bright, direct reflection on the spatula. The fill light brightens the background.

133

6.14 Another way to light the spatula shown in Figure 6.12. The gobo partly blocks the light from the part of the reflector within the family of angles, marked A, but not from the rest of the reflector card, marked B.

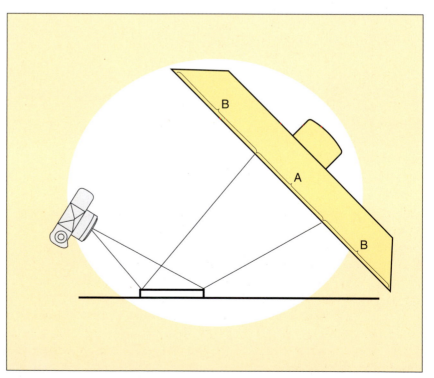

6.15 The part of the soft box, B, outside the family of angles, A, lights only the background, not the metal.

brighter by placing a more powerful fill light near the camera. Using two lights in this manner gives infinite control of the relative brightness of the metal and the background.

Even a single light provides excellent control if it is large enough. Look again at the single soft box in Figure 6.15. Notice that the entire light source produces diffuse reflection from the paper, but only that portion that covers the family of angles produces direct reflection on the metal. Having more of the surface of the soft box within the family of angles makes the metal brighter. However, if the soft box is large enough to have very little of its surface within the family, then the background will be brighter.

The distance between the light source and the subject determines how much of that source will be within the family of angles.

Controlling the Effective Size of the Light

In previous chapters, we have seen that control over the size of the light source is one of the most powerful manipulative tools a photographer has. We have also seen that the physical size does not necessarily determine the effective size. Moving a light closer to the subject makes it behave like a larger one, softening the shadows and, for some subjects, enlarging the highlights. Moving the light farther away does the opposite. This principle is even more significant if the subject is bright metal.

In Figure 6.16 we see the same camera and subject relationships used earlier. Now there are two possible positions for the same soft box. One position is much closer to the subject than that used in the previous example, whereas the other is much farther away.

We expect the closer light to illuminate the background more brightly, but the brightness of the metal does not change because the brightness of direct reflection is not affected by the distance to the source. Figure 6.17 confirms that expectation. Moving the light closer has greatly lightened the background without affecting the brightness of the metal. Compare it with Figure 6.12, made with the same soft box farther away. Similarly, moving the light farther from the subject would darken the background, still without affecting the brightness of the image of the metal.

Changing the distance of the light source changes the brightness of the background but not of the metal. This seems to give us nearly infinite control of the relative brightness of the two. Sometimes it does, but not always. This is because the focal length of the lens can also indirectly influence the effective size of the light. This is often surprising, even to highly experienced photographers, but the diagrams in Figure 6.18 show how it can happen.

135

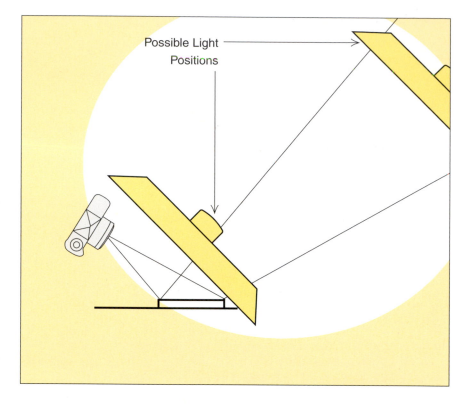

6.16 Two possible positions for a soft box. Either position lights the metal identically. However, the closer we move the light to the subject, the brighter the background becomes.

Possible Light Positions

6.17 Compare this photograph with Figure 6.12. Moving the soft box closer has brightened the background but not the spatula.

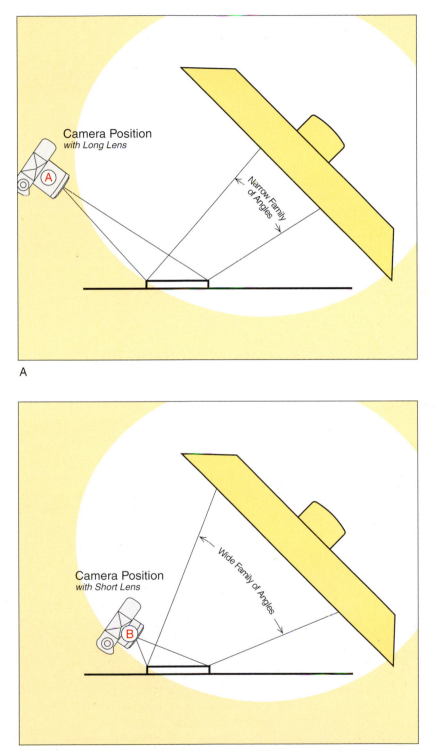

Camera Position
with Long Lens

A

Narrow Family
of Angles

A

Camera Position
with Short Lens

Wide Family of Angles

B

B

6.18 The distance from the subject to the camera affects the effective size of the light. Camera B is close, and the resulting family of angles is large. Camera A is farther from the subject than B, and the resulting family of angles is much narrower. If the metal is exposed identically in the two scenes, the background will be brighter in arrangement A and darker in B, despite the fact that the actual incident light is identical in both scenes!

In Figure 6.18A, the camera farther from the subject has a long focal-length lens, and the closer camera (B) has a short lens. Therefore, the image will be the same size in either photograph.

To camera A, farther from the subject, the soft box is much larger than the family of angles that produces direct reflection. We could move the light much closer or much farther away without affecting the lighting of the metal. The longer lens, by allowing a more distant viewpoint, offers a more flexible choice of places to put the light. Thus, it maximizes the control over the relative brightness of the subject and the background.

But look at the difference in the effective size of the light seen by camera B. The soft box just fills the family of angles defined by the close viewpoint. We cannot move the light much farther away without the edges of the metal becoming black.

In Chapter 5 we saw that camera viewpoint also determines perspective distortion. Sometimes there is not much choice about where to put the camera. In other scenes, there is a wide range of satisfactory camera positions. In those cases, if the subject is bright metal, we recommend using a longer lens and getting the camera farther away to allow more freedom in lighting.

Keeping the Metal Square

In none of the preceding examples was the camera perpendicular to the metal surface. Sometimes we need a photograph in which the camera viewpoint appears to be perpendicular to the metal and centered directly in front of it. Because the metal is a mirror, the camera is likely to reflect in the subject. Now we will see several ways of dealing with this problem. You will probably use each of them at one time or another, depending on the specific subject and the available equipment.

Use a View Camera

This is the best solution. (If everyone used view cameras, we might not even mention any other techniques.) As long as the camera back is parallel to the reflective metal, the metal will appear to be centered in front of the camera to most viewers.

In Figure 6.19, we positioned the camera off center so that it does not reflect in the metal. The image plane is still parallel to the subject so the viewpoint does not introduce perspective distortion. We then shifted the lens to center the subject in the image area, just as it would be if the camera were directly in front of the subject. Notice that this places the family of angles to one side of the camera.

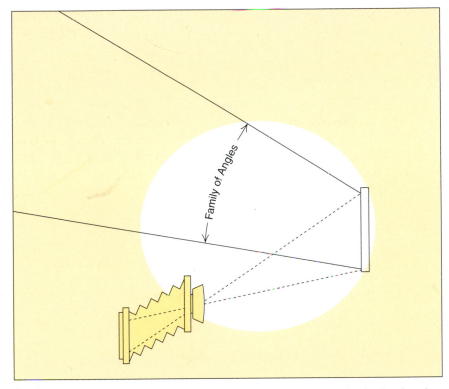

6.19 The camera will not reflect in the metal because it is outside the family of angles. The metal will not be distorted because it is parallel with the image plane.

All lighting tactics discussed earlier are applicable: we use a light large enough to fill the family of angles, keep the light out of the family of angles, or use a combination of the two, depending on how bright we want the metal to appear.

If the camera position requires shifting the lens a great distance off center, we may encounter two special problems. First, the lens may begin to vignette the image. This creates black corners at the edge of the picture. Second, viewing the subject too far off center can produce geometric distortion or reveal the slight distortion that can be present even in good lenses. Keeping the camera as far from the subject as possible, and using a correspondingly longer lens, minimizes both of these problems.

Aim the Camera through a Hole in the Light Source

Assuming we want to keep the metal bright, we sometimes position white seamless paper to light the metal. We then cut a hole in that light source that is just large enough for the lens to see through it (Figure 6.20). This solution minimizes the problem of camera reflection,

6.20 The camera will not reflect in the metal, but the hole in the paper will.

but it does not get rid of it. Although the camera is not visible in the subject, the hole in the light source is.

This technique works fine if there is enough irregularity in the metal subject to camouflage the offending reflection. If, for example, the subject is a machine with a complex control panel, reflection may be invisible among the knobs and meters.

Whether the light source is a reflector card or a diffusion sheet, we have to be especially careful in lighting the area near the camera. A light aimed at a reflector card can cause flare if the rays fall directly into the lens. Lights projecting through a diffusion sheet can cause a shadow of the camera on the diffusion sheet that reflects visibly in the subject.

Photograph the Metal at an Angle

Keep the camera as far from the subject as possible to minimize perspective distortion. Then correct the distortion in postproduction. Digitally removing the distortion is not an ideal solution. This sort of image manipulation always results in some quality loss.

Keep these solutions in mind as an available option if circumstances force it upon you. A bad remedy may be better than no remedy. If you use this alternative, be sure to compose your picture with a generous amount of extra space around the subject. You will have to crop the trapezoidal projected image to fit the rectangular print.

Retouch the Reflection

Shoot the metal straight on, let the camera reflect, then remove the reflection digitally. This is not a lighting solution, so we will not discuss it in detail. Nevertheless, for some subjects, especially large ones, retouching is so much easier than any of the lighting solutions that we should not forget the option. Spending half a day lighting instead of spending half an hour at a computer makes no sense. Furthermore, this solution, unlike the immediately preceding one, loses no image quality.

METAL BOXES

A metal box presents the viewer with up to three visible sides. Each side needs a treatment similar to that of any other flat piece of metal. Each surface has its own family of angles to consider. The difference is that each family of angles faces a different direction and we have to deal with them all at once.

In lighting a metal box, we need to deal with some of the same considerations involved with lighting a glossy box made of any other material. (If you are browsing through this book without reading the chapters in sequence, you may want to look at the section on glossy boxes in Chapter 4. However, although this theory is identical to that applied in the earlier picture, the difference makes us likely to apply it the opposite way from that in the earlier example.)

Figure 6.21 is identical to Figure 5.19, repeated here so that you don't have to keep turning back to it. Now, however, the box is made of metal, not wood. There are two families of angles, one for the top and one for the front of the box. We may place light within these families of angles, or not, depending on whether we want the surfaces to be bright or dark. If the box were turned to show the camera three sides, the same principles would apply—but they would be harder to see in a drawing. The family of angles defined by the front of the box would then fall below *and* to the side of the box. The other visible side of the box would produce a similar family of angles on the other side of the scene.

A glossy nonmetallic box that is not black produces both diffuse and direct reflection. We often avoid direct reflection on a glossy box to avoid obscuring the diffuse reflection. A polished metal box produces only direct reflection. Without direct reflection, we see the metal box as black.

141

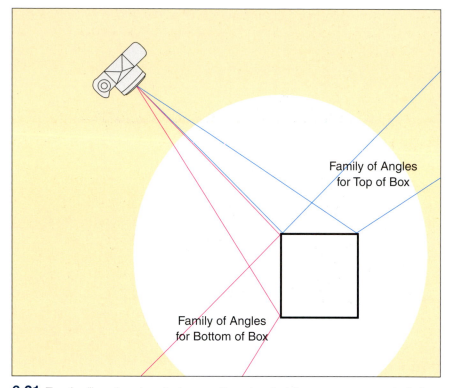

Family of Angles
for Top of Box

Family of Angles
for Bottom of Box

6.21 Two families of angles of a box positioned so that the camera can see both its top and front.

Because we more often like to render metal bright, we usually want to *create* direct reflection rather than to avoid it. This means that we need to fill each family of angles with a light source.

The family of angles defined by the top of the box is easy to light. We treat it just as we did the flat metal in our earlier examples.

The sides of a metal box are more difficult. If we position the camera and subject as in Figure 6.21, then at least one of the light sources *must* be in the picture. The family of angles defined by the front of the box falls on the table where the box sits. That means the table surface is the light source for the front of the box, whether we like it or not.

We cannot use a reflector card, or any other light source, for the sides of the box without it showing in the scene. The closer to the box we can crop the picture, the closer we can put the reflector. Even so, some of the bottom of the box will still reflect the table.

If we do not want to crop the bottom of the box out of the image, and if the box is truly mirror-like, the line where the reflector meets the table will be visible and objectionable. Figure 6.22 shows the problem. We have left the picture uncropped so that you can see the reflector card.

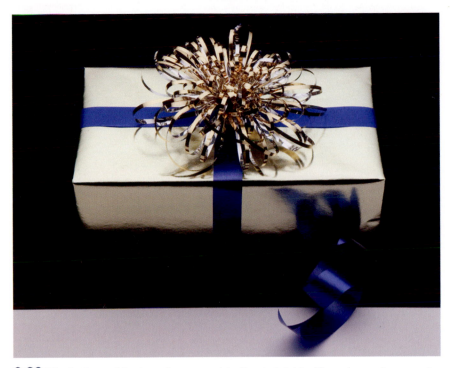

6.22 The bottom of the box disappears into the dark table. The only way to prevent this would be to place the reflector so that it touches the front of the box.

Brightly polished metal boxes almost always present this problem. Fortunately, it is usually the only major problem; the remainder of this section is a collection of techniques for dealing with it. Pick the one you need according to the circumstance.

A Light Background

By far the easiest way to photograph a three-dimensional metal subject is to use a light-gray background. The background itself is the light source for much of the visible metal. As soon as we place the subject on such a surface, much of the work is done and we need only a few adjustments to perfect the lighting.

To produce Figure 6.23, we began with a background surface larger than we needed to fill the image area. Remember that the background needs to fill the family of angles reflected by the metal, not just the area the camera sees. Then we lit the top of the metal box with a soft box, just as if it were any other piece of flat metal.

That was almost all we had to do. The setup was completed by silver reflectors on each side of the scene to fill the shadow in the ribbon.

143

6.23 The light gray surface on which we photographed this box acted as a light source for the front of it.

If good lighting for the metal box were the only objective, we would *always* use a light-toned background. Art and emotion often impose other requirements, however, so we will look at some other techniques.

A Transparent Background

The only way in which we can orient a metal box as we did in the previous examples *without* having a light source in the scene is to put the box on a transparent surface. When we do that, the camera sees the reflection of a light source (in this case, a white card) in the metal without having that light source in direct view of the camera. Figure 6.24 shows how.

This arrangement allows us to position a dark card large enough to fill the background but small enough that it stays out of the family of angles that lights the front and the side of the metal box. The photograph in Figure 6.25 was made this way. Notice that the background is dark, but not black, and that the table surface has a reflection in it. From this viewpoint, any light source producing direct reflection on top of the metal will also create direct reflection on the glass surface supporting it.

The picture is good. But suppose we disliked the reflection in the glass and wanted the background to be absolutely black. We could

White
Card

Transparent Sheet

Dark
Background

6.24 One way of lighting the front of a metal box without having a light source in the scene. Placing the box on a sheet of clear glass allows reflecting light through the glass to the box.

eliminate the reflection of the box by using frosted glass, but that would make the background lighter instead of darker.

Fortunately, most of the direct reflection from glass viewed at this angle is polarized, so we were able to eliminate that reflection in Figure 6.26 by putting a polarizing filter on the lens. The glass is now black. Remember, too, that direct reflection from metal is never polarized unless the light source itself is polarized. So the polarizing filter did not block the direct reflection from the metal.

A Glossy Background

If the metal is on a glossy surface, it is possible to have the light source in the image area *without* the camera seeing it! We call this technique *invisible light*. Here is how it works: look back at Figure 6.21, but this time assume the subject is sitting on a glossy black acrylic sheet. The family of angles defined by the front surface tells us that the *only* possible place from which the metal could get light would be from the black plastic

145

6.25 The result of the lighting shown in Figure 6.24. Whether the dark reflection under the box is objectionable depends on the specific subject and your opinion of it.

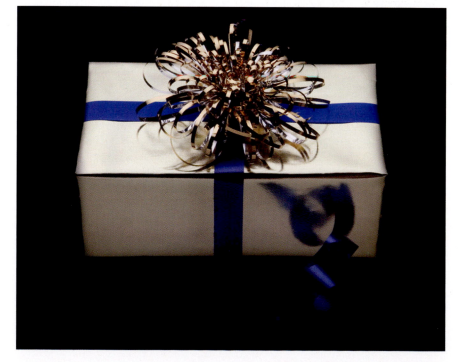

6.26 The same scene as in Figure 6.24, but with a lens polarizer removing reflection from the glass. The polarizer does not affect the metal.

146

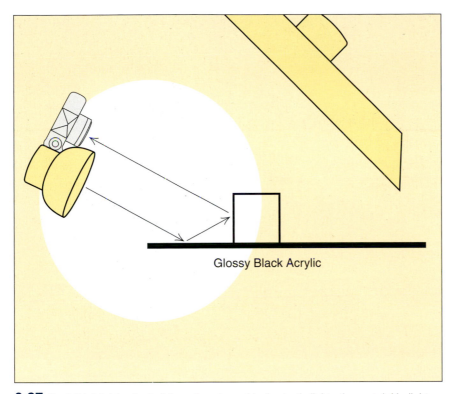

Glossy Black Acrylic

6.27 "Invisible" light reflected from the glossy black plastic lights the metal. No light reflects directly from the plastic to the camera, so the camera cannot see the light source for the metal.

surface, but "black" is a short way of saying that the plastic reflects no light. Together, these facts suggest that the front of the metal cannot be lit.

However, we have also said that the black plastic is glossy. And we know that glossy things *do* produce direct reflection, even if they are too black to produce diffuse reflection. This means that we can light the metal by bouncing light off the plastic surface as in Figure 6.27.

If you examine the angles, you see that a light under the camera can bounce light from the glossy plastic to the metal. That light strikes the metal at such an angle that it then reflects back to the camera to record on film. The metal is lit, and the bright metal in Figure 6.28 proves it. As far as the metal can tell, it is being lit by the plastic surface in the scene. However, the camera cannot see that light is reflecting from the black plastic; the family of angles defined by the plastic makes it impossible.

Like the earlier glass surface, the acrylic surface will reflect the overhead light source. Once again, we used a polarizing filter on the lens to eliminate the glare.

6.28 The result of "invisible" light. The light source for the box is in the scene—the black plastic directly in front of it.

Finally, notice that the front of the box now shows a texture not seen in the earlier examples. This is because invisible light is only effective in a small area on the tabletop.

When metal is not absolutely flat, the family of angles required to light it becomes larger. Next we'll examine an extreme example of that circumstance.

ROUND METAL

Lighting a round piece of metal begins, like any other metal shape, with an analysis of the family of angles that produces direct reflection. Unlike any other metal shape, the family of angles defined by a piece of round metal includes practically the whole world!

Figure 6.29 shows the relevant family of angles for a camera photographing a round metal object at a typical viewing distance. Remember, lighting metal requires the preparation of a suitable environment. Round metal requires a lot more work to light because it reflects so much more of that environment.

Notice that the camera will always be in the environment the metal sees. There are no view-camera tricks to remove the camera from the

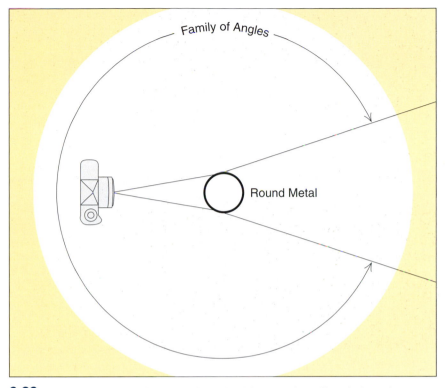

6.29 The family of angles for a round metal subject consists of its whole environment, including the camera.

family of angles reflected by round metal. Furthermore, the reflection of the camera will always fall exactly in the center of the metal subject, where it is most noticeable to the viewer.

For this exercise we will use the most difficult example possible: a perfectly smooth sphere. Figure 6.30 shows the problem.

The first step in fixing this problem would be to get rid of unnecessary objects. However, the camera is the one offending object that no cleanup effort can remove. There are three ways to eliminate the camera reflection: we can camouflage the reflection, keep the camera in the dark, or put the subject in a tent.

Camouflage

For our purposes, camouflage is any desirable clutter that helps make unwanted reflections less obvious. Sometimes the subject provides its own camouflage. If the surface is irregular, the camera reflection may fall between the cracks.

Additional subjects in the scene can also provide camouflage. The reflection of surrounding subjects in the metal can break up other

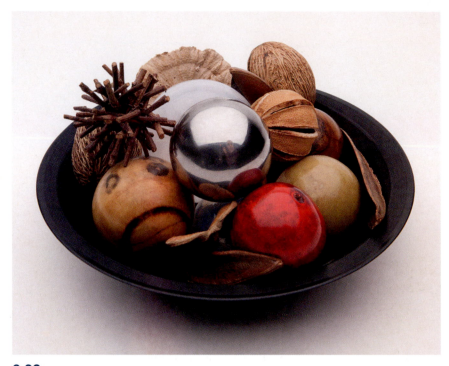

6.30 The common problem presented by a shiny sphere.

reflections that we do not want the viewer to see. If the surrounding objects in Figure 6.30 were items appropriate to the scene, instead of studio tools, they could make good camouflage. Small subjects can be put directly on top of a reflection of a larger one.

Keeping the Light off the Camera

If the camera is kept in the dark, then it cannot see itself reflected in the subject. Whenever possible, confine the lighting to the subject. Long lenses help. A camera farther from the subject is less likely to have extraneous light falling on it.

If it is impossible to keep the light off the camera, covering it with black material can work as well. A few pieces of black tape could have covered the bright parts of the camera in Figure 6.30. Black cloth or a black card with a hole in it can conceal the camera entirely.

However, this works only in a studio large enough that the surrounding walls do not reflect. In a smaller room, building a tent may be the only solution.

Using a Tent

A tent is a white enclosure that serves as both the environment and the light source for the subject. The subject goes inside the tent and the camera is almost always outside, looking in through a small opening. Tents are often used for subjects such as metal, which produce a great deal of direct reflection, but they are sometimes used simply to produce very soft light for subjects such as scientific specimens and for fashion and beauty.

A tent can be made of opaque white material such as a collection of reflector cards. Then we can put the lights in the tent and bounce them off the inside walls. This produces a very soft light, but the lights themselves reflect visibly in any mirror-like subject. More often we use translucent material such as frosted plastic and project the lights through the tent wall.

An ideal tent would be a translucent white dome with no visible seams. Most photographers approximate this ideal as closely as possible with translucent paper or plastic. Figure 6.31 shows one way to do this.

We do not show any lights other than the soft box that is a structural part of this tent. Additional lights are almost always useful, but their exact positions and sizes are highly optional. Some photographers like to light the whole tent uniformly, whereas others tend to light only a few small areas.

Figure 6.32 was shot in such a tent. This photograph is a good example of the principle, but it is a bad picture. The lighting on the ball is acceptable, except for the dark spot in the middle, which is the hole through which the camera is seeing.

One of the authors once made a picture similar to this one for the cover of a department store Christmas catalog. But the peripheral areas also included bits of ribbon and greenery to camouflage the seams in the tent.

Looping a piece of the ribbon "accidentally" across the front of the ball hid the camera. If the intent of the image had precluded additional subject matter to use for camouflage, the only remedy to the problem would have been retouching.

It is tempting to build a very large tent to keep the camera as far from the subject as possible. Intuitively we know that if the camera is farther from a metal subject, then the reflection of the camera will be smaller. However, the image of the subject also becomes smaller, so we have to shoot with a longer lens. But this "remedy" also enlarges the reflection of the camera back to its original size! The camera itself is the

151

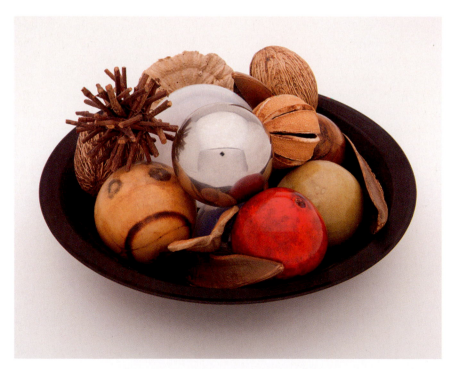

6.31 Building a tent around the subject and shooting through a hole in it is one way of cutting down on unwanted reflections on shiny round subjects.

Diffusion Material

Seamless Background

Round Metal

6.32 A photograph of a shiny sphere shot with the help of a tent such as the one diagrammed in the previous figure. By itself, the tent does not solve the problems. However, it will make any retouching easier.

only reflection whose size cannot be reduced by moving it farther away. It always remains constant, relative to the subject. Resist the temptation; the extra work is always wasted.

OTHER RESOURCES

The basic approach to lighting metal is determined by the family of angles and, therefore, by the shape of the metal. Beyond the basic lighting, there are a few more techniques you may want to try at any time with any piece of metal.

Any of these additional options can be purely creative decisions, but they can serve technical purposes, too. For example, you may find that the edge of a piece of metal is disappearing into the background. Keep in mind, the closer the metal comes to producing *pure* direct reflection, the closer that reflection comes to photographing at the same brightness as the light source. As we have seen, the surface on which the metal is sitting is often the light source. If they are of identical brightness, the camera cannot see where one surface ends and the other begins. This is a case where polarizing filters, "black magic," or dulling spray can add the finishing touches to the lighting.

Polarizing Filters

Metal does not produce polarized direct reflections. Therefore, we cannot usually use a lens polarizer alone to block the direct reflections coming from metal. Remember, however, that the light source may have some polarized rays. If so, they remain polarized as they reflect from the metal. This is frequently the case if the metal is reflecting blue sky. In the studio, the light reflected from the surface on which the metal rests is often partly polarized. In either case, a polarizer on the lens gives additional control over the brightness of the metal. Even if there is no polarized light in the scene, we can put it there by using a polarizing filter over the light.

Black Magic

Black magic is anything added to the basic lighting setup solely to place a black "reflection" in the metal surface. Black reflected in an edge can help to differentiate it from the background. Reflected across the center of a slightly irregular surface, black magic can also add dimension.

Black magic usually involves the use of a gobo. This works especially well with a diffusion sheet. Placing the gobo between the diffusion sheet and the subject makes a hard black reflection. Putting it on the other side of the diffusion sheet from the subject creates a softly

153

graduated reflection. The farther behind the diffusion sheet you place the gobo, the softer it becomes.

Occasionally you may decide to use an opaque reflector (reflecting another light somewhere else in the set) as a light source for the metal. In this case, a gobo cannot produce softly graduated black magic, but a soft-edged stripe of black spray paint across the reflector will create the same effect.

Beware of Blue Highlights

Polarizing both the lights and the lens may create special problems if the photograph is color and the subject is metal. Polarizing filters allow more light from the blue end of the spectrum to pass through than from the red. This makes such a filter behave like a very light blue filter. The effect is so slight that we do not notice the color imbalance in a color photograph unless extremely accurate color rendition is necessary.

Even when there are polarizing filters on both the lens and the lights, the increased blue shift is rarely a problem if the subject produces mostly diffuse reflection. However, if the subject produces much direct reflection, some of the highlights may be offensively blue. Furthermore, because the blue occurs only in the highlights, they can't be fixed by general color correction.

It is easy to overlook these blue highlights if you do not anticipate them, so be warned. If they happen and you decide the sacrifice is worthwhile, budget the time for retouching.

Dulling Spray

Dulling spray creates a matte surface that increases the diffuse reflection and decreases the direct reflection from a piece of metal. This allows a little more freedom to light the metal without strictly obeying the limitations imposed by the family of angles. Unfortunately, metal with dulling spray on it no longer looks brightly polished and may not even look like metal any longer!

Heavy-handed use of dulling spray is a habit to avoid. To an educated eye, it reveals, rather than conceals, a photographer's inability to light metal well. With that said, we should also admit that all of the authors of this book keep dulling spray handy in their studios.

Try to light the metal as well as possible. Then, if necessary, add a little dulling spray just to an overly bright highlight or a disappearing edge. Keep as much of the gleam of the metal as you can, and avoid thickly coating the entire surface.

WHERE ELSE DO THESE TECHNIQUES APPLY?

The techniques we use for metal are good to remember any time direct reflection is important. We will see more of them in the rest of this book. Some of these applications may not be obvious yet. For example,

we will see in the discussion of extremes in Chapter 9 why much of the technique for lighting metal is useful for almost any black-on-black subject, regardless of the material of which it is made.

Other subjects that produce direct reflection are readily apparent. One of them is glass. Glass, however, offers additional opportunities and challenges of its own. We will see why in the next chapter.

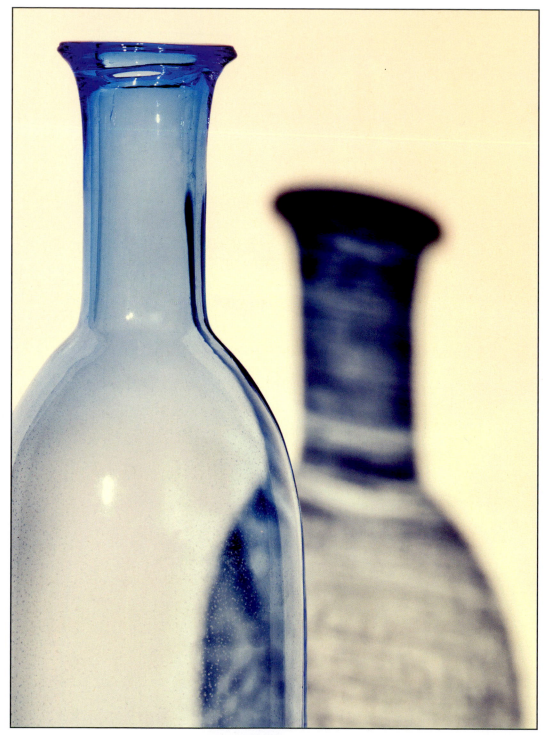

The Case of the
Disappearing Glass

The distant genius who first fused sand into glass has tricked the eyes and delighted the brains of every generation of humans to follow. It has perhaps also grayed the hair and wasted the time of more photographers than any other substance. However, attempting to reproduce the appearance of glass need not lead to the photographic disasters we so often see. This chapter discusses the principles, the problems, and some straightforward solutions to the basic challenges that glass offers.

THE PRINCIPLES

The appearance of glass is determined by many of the same principles we discussed in the preceding chapter on metal. Like metal, almost all reflection produced by glass is direct reflection. Unlike metal, however, this direct reflection is often polarized. We might expect the techniques used for lighting glass to be similar to those used for metal. We might find a polarizing filter useful more often, but otherwise apply the same methods.

However, this is not so. When we light metal, we are primarily interested in the surfaces facing the camera. If they look right, then minor adjustments can usually take care of the details. Lighting glass, however, requires attention to the edges. If the edges are clearly defined, we can often ignore the front surface altogether.

THE PROBLEMS

The problems caused by glassware are a result of the very nature of the material. It is transparent. From most angles, light striking the visible edge of a piece of glassware does not reflect in the direction of the viewer. Such an edge is invisible. An invisible glass has no shape or form. To make matters worse, the few tiny reflections we do see are often too small and too bright to tell the anything about surface detail or texture.

Figure 7.1 shows both problems. The direct reflections of the lights illuminating the scene do nothing but distract from the composition. They are not adequate to define the surface of the glass.

7.1 The problems with this picture are caused by the nature of the glass from which the subjects are made. The glass is both transparent and highly reflective.

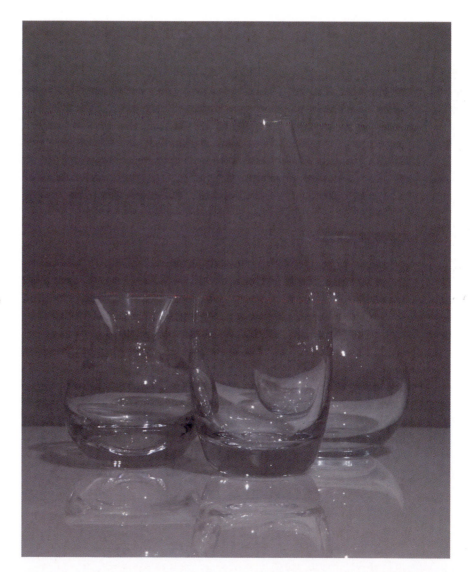

The lack of a clearly defined form is an even more serious problem. With no clear outlines and no marked differences in edge tonality, the glass merges with the background.

THE SOLUTIONS

Having seen what does not work, look now at Figure 7.2. Compare the visibility of the glass shown in it with that shown in the earlier photograph. Both photographs show the same glassware and the same

7.2 Good edge definition is essential to lighting glass.

159

background, and both are made from the same viewpoint with the same lens. As you can see, however, the difference is dramatic.

In the second photograph, strong black lines delineate the shape of the glass. No distracting reflections mar the surface. By comparing these two photographs, we can list our objectives in glassware photography. If we want to produce a picture that clearly and pleasingly reproduces the glassware, we must do the following:

1. *Produce strong lines along the edges of the subject*. These lines delineate its shape and set it apart from the background.
2. *Eliminate distracting reflections* of the lights and other equipment we are using.

Let's look at some of the specific ways we can accomplish these objectives. We will begin by looking at some "ideal" shooting situations. These will help us demonstrate the basic techniques. Later, we will have to go beyond those basics to overcome problems that arise whenever nonglass objects are in the same scene. We will begin by talking about our first objective, edge definition.

TWO ATTRACTIVE OPPOSITES

We can avoid almost all the problems associated with edge definition by using one of two basic lighting arrangements. We will call these the *bright-field* and the *dark-field* methods. We could also call them *dark-on-light* and *light-on-dark* approaches.

The results of these two are as opposite as the terms imply, but we will see that the principles guiding them are identical. Both methods produce the strong tonal differences between the subject and the background that delineate edges to define the shape of glassware.

Bright-Field Lighting

Figure 7.2 is an example of the bright-field approach to lighting glass. The background dictates how we must treat any glass subject. On a bright background, we have to keep the glass dark if it is to remain visible.

If you have read Chapter 2 and the chapters following it, you have already guessed that the bright-field method requires eliminating all direct reflection from the edge of the glass surface. You also should be able to see why we need to begin this discussion by examining the family of angles that determines direct reflection from this particular subject.

Look at Figure 7.3. It is a bird's-eye view of the family of angles that can produce direct reflection on a single round glass. We could draw a similar diagram for each piece of glassware in our example photograph.

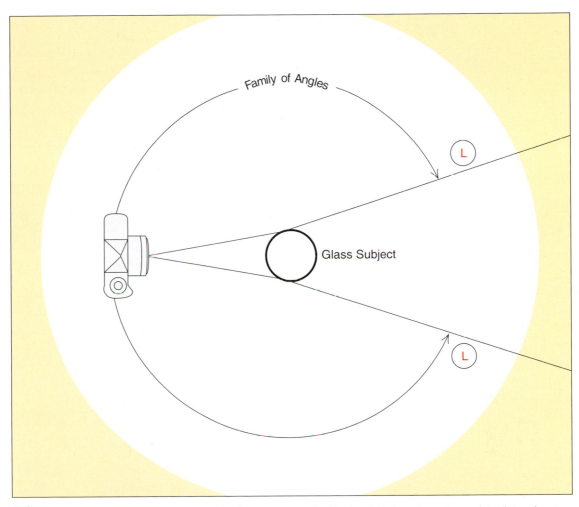

7.3 The limits of the family of angles in this diagram are marked by L. Light from these two points determines the appearance of the edge of the glass.

The family of angles in this diagram is similar to that defined by round metal in the previous chapter. This time, however, we are not interested in most of that family. For now, we care only about the extreme limits of the family of angles, labeled L in the diagram. Light from these two angles determines the appearance of the edge of the glass.

These limits tell us where the light must be if the edges of the glass are to be bright in the pictures or, conversely, where it must not be if the edges are to remain dark. Because in the bright-field approach we do not want the edge of the glass to be bright in the photograph, there must be no light along the lines marked L in the diagram.

7.4 This is one way to produce the bright-field illumination used in Figure 7.2. We would rarely use both lights shown. Either lighting position works, depending on the background.

Figure 7.4 illustrates one good way to produce a bright-field glass photograph. It is not the only way, but it is a good exercise that we suggest you try if you have not done it before. Look at the way the light behaves in each step. This will make it easy to predict what will work and what will not in any variation on this arrangement you decide to try in the future.

These steps work best in the listed sequence. Notice that we do not bother to put the subject into the scene until near the end of the process.

Choose the Background

Begin by setting up a light-toned background. We can use any convenient material. Translucent materials such as tracing paper, cloth, and

plastic shower curtains are a few good materials to try. We might also use opaque surfaces, such as light-toned walls, cardboard, or foamcore.

Position the Light

Now, place a light so that it illuminates the background evenly. Figure 7.4 shows two possible ways to accomplish this; both can produce identical results. Usually the photographer uses one or the other, rarely both.

Figure 7.2 was shot using a light behind translucent paper. This is a particularly convenient setup because it keeps the workspace around both the camera and the subject free and uncluttered.

We can also use an opaque surface such as a wall for the background. If we do, we need to find a place to position the light so that it will light the background without reflecting in the glass or appearing in the image area. Putting the light on a short stand behind and below the glass is one good way.

Position the Camera

Now, place the camera so that the background exactly fills its field of view. This step is critical because the distance from the camera to the background controls the effective size of the background.

The effective size of the background is the single most important consideration when using this technique. For this exercise to be most effective, the background must exactly fill the field of view of the camera, no more and no less.

A background that is too small is an obvious problem: it simply will not fill the picture. A larger background causes a subtler problem. A background too large will extend into the family of angles that produces direct reflection on the edge of the glass. Light from those points eliminates the dark outline that we need to define the edge of the glass.

If the background surface is so large that we cannot keep it from extending beyond the limits of the viewfinder (e.g., the wall of a room), we can also reduce its effective size by lighting only a small portion of its total surface or by covering part of it with dark cards.

Position the Subject and Focus the Camera

Next, move the subject back and forth between the camera and the background until it is the desired size in the viewfinder.

As we move the subject, we notice that the closer it is to the camera, the more clearly the edges are defined. This increase in edge definition

163

is not brought about by the simple principle that larger detail is easier to see. Rather, it is caused by the fact that as the subject moves farther from the lighted background, less light reflects off its edges. The closer the subject is to the background, the more the bright background falls within the family of angles that produces direct reflection to obscure those edges.

Now, focus the camera on the subject. Refocusing will slightly increase the effective size of the background, but that increase will usually not be enough to cause any practical problems.

Shoot the Picture

Finally, use a reflection meter (the one built into most cameras is fine) to read the light on an area on the background directly behind the subject.

Bright-field illumination does not require a pure white background. As long as the background is any tone significantly brighter than the edges of the glass, then that glass will be adequately visible. If the glass is the only subject to worry about, we can control the brightness of the background by the way we interpret the meter reading:

- If we want the background to appear as a medium (18%) gray, we use the exposure that the meter indicates.
- If we want the background to photograph as a light gray that approaches white, we increase the exposure up to two stops more than the meter indicates.
- If we want the background to be dark, then we expose as much as two stops less than indicated. This will produce a very dark gray background.

In this scene there is no such thing as "correct" exposure. The only correct exposure is the one that we like. We can place the tone of the background anywhere we like on the gray scale except black. (If the edge of the glass is black and the background is black, there is nothing left to record!) In practice, the lighter the background, the more graphically the glass is defined.

- If we do expose to keep the background very light, we do not have to worry about extraneous reflection in the front surface of the glass. Whatever reflections exist are almost always too dim to be visible against the background. However, if we decide to expose to produce a medium or dark gray background, surrounding objects may reflect visibly in the glass. We will offer some ways to eliminate these reflections later in this chapter.

In principle, there is nothing particularly complicated about the bright-field approach to photographing glassware. Of course, we have used an "ideal" example to demonstrate the principle as clearly as possible. In practice, complications may occur whenever we decide to deviate from this ideal.

For example, many compositions will force us to keep the glass much smaller, compared with the background, than in our exercise. That will reduce edge definition. Whether the sacrifice will be significant depends on what else is in the photograph.

Of course, understanding the principle and becoming familiar with why the ideal works gives us the understanding that provides the best solution in less than ideal situations. If a composition produces bad lighting, the ideal explains the problem and suggests a remedy. If a particular composition prevents any remedy, then the ideal tells us that, too. We need not waste time trying to accomplish what physics says is impossible.

Dark-Field Lighting

The dark-field method produces the opposite result, illustrated in Figure 7.5.

Review the family of angles that produces direct reflection in Figure 7.3. We saw that in the previous arrangement there must be no light at the limits of the family of angles, L, if the edge of the glass is to remain dark. It makes sense to suppose, then, that the light must come from L if the edge of the glass is to be bright. Furthermore, if we do not want other bright distractions in the glass, then the glass must not see light at any other point.

Figure 7.6 shows the specifics to put the theory to work. Once again, we will present the technique in five steps. Some of them are identical to those used in the earlier bright-field approach.

Set up a Large Light Source

On first examination, the bird's-eye view in Figure 7.3 seems to indicate the need for light at two points. This, however, is a representational defect caused by having to draw in only two dimensions. In actuality, such an arrangement would light only a point on each side of the glass.

To keep the rim bright, a similar light source must be placed above and behind the glass. Furthermore, if the glass is a stemmed glass with a bowl, then yet another light source must be added to illuminate the bottom of that bowl.

165

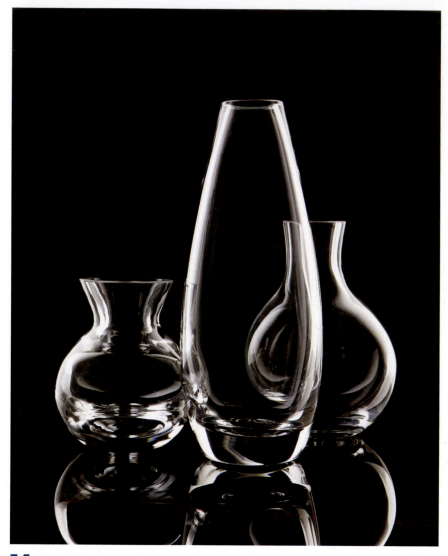

7.5 In dark-field illumination, shape and form are delineated by light lines against a dark background.

So we need four large sources to light just the edges of a single tiny glass! This arrangement would be unwieldy at best. We usually avoid such a complex clutter by replacing all of these lights with a single source large enough to illuminate the top, bottom, and sides of the glass. The exact size of this light source is not critical. Any size between 10 and 25 times the diameter of the subject will work well.

Figures 7.6 and 7.7 show two good ways to create an appropriately large light source. One is translucent and the other is opaque.

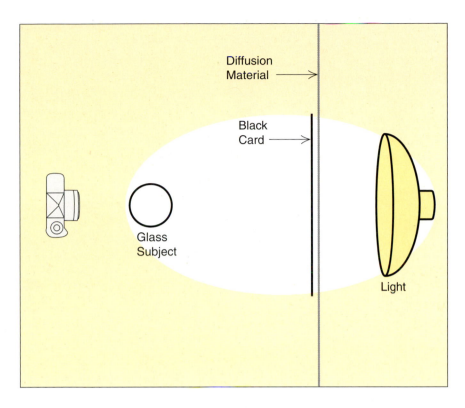

7.6 This is one good way to produce dark-field lighting.

Set up a Dark Background Smaller Than the Light Source

There are several ways to do this. The easiest way, shown in Figure 7.6, is to attach a dark card directly to the translucent light source.

An opaque surface such as a wall can also make an excellent light source. We simply need to illuminate it with reflected light. Such an arrangement may preclude putting the dark background directly on the wall because it may get too much light to photograph as dark as we want.

Instead, we like the setup used in Figure 7.7, which allows lighting the opaque reflective surface as brightly as we like without allowing significant light to fall on the background that the camera sees. Attaching the dark background to a light stand or suspending it from above with string works fine.

The result of both of these arrangements is the same: a dark background is surrounded by bright light.

Like the light source, the exact size of the background is not critical. As with the bright-field approach, we can adjust the effective background size by the camera distance. The only size limitation is that the dark background must be small enough to leave plenty of light visible around it.

167

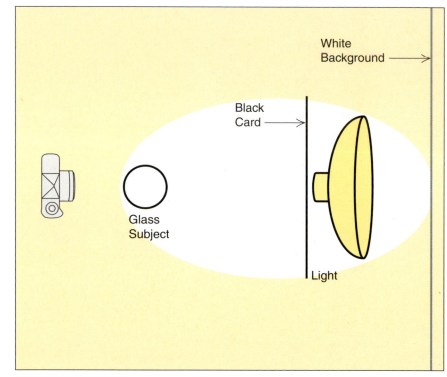

White
Background ⟶

Black
Card ⟶

Glass
Subject

Light

7.7 This setup allows you to light the opaque reflective surface brightly without lighting the part of the background that the camera sees.

Position the Camera

Again, the background should exactly fill the field of view of the camera—no more and no less. This is important for reasons similar to those in the bright-field approach. If the dark background is too large, it will extend into the family of angles that produces direct reflection. That would block light needed to brightly define the edge of the glass and to keep it from disappearing into the dark background.

Position the Subject and Focus the Camera

Next, move the subject between the camera and the background until it is the size we want. Once again, edge definition improves as the subject moves closer to the camera. Finally, focus the camera on the subject. As in the bright-field method, the change in background size caused by refocusing will be too minimal to cause problems.

Shoot the Picture.

Accurate exposure determination with this setup requires the use of a very narrow-angle spot meter to read the highlights on the edges of the glass. In most compositions of this sort, "very narrow angle" means

much less than 1 degree. Almost no photographers have such a meter. Do not despair. Fortunately, any conventional reflection meter (including those in many cameras) can give an acceptably close approximation of the desired exposure with the help of bracketing.

To see why the following method works, we must remember that pure direct reflections from a subject are as bright as the light source that produces them. Those reflections may be too small to read, but the large source is not.

First, place the meter close enough to the light source to read it alone. Read the edge of the light source because that is the part illuminating the glass.

Next, to photograph the glass as near white, expose two stops more than the meter indicates. (This is because the meter thinks it is seeing 18% gray instead of white.) This is a good exposure if the highlight on the glass is perfect unpolarized direct reflection. Such an exposure is theoretically important because it determines the starting point for the bracket. In practice, there is no practical chance that the direct reflection is both perfect and unpolarized, so we may want simply to note this exposure and to move on to the next one. Because perfect direct reflections rarely occur, try additional exposures with one, two, and then three stops more exposure.

All of this assumes the background remains black because little or no light is falling on it. If, however, we desire it to be a lighter value, it will then be necessary to use additional light just for the background. Omitting this additional light and attempting to lighten the background by increasing exposure (according to the metering procedure recommended in the discussion of the bright-field method) will usually overexpose the subject.

Once again, we have used an ideal example that avoids complexities for the sake of simplicity. Deviate from this ideal as much as the composition requires but no more.

THE BEST OF BOTH WORLDS

Bright-field and dark-field methods are easy to learn, but they can be difficult to combine. Most failures in photographing glass result from deliberately or naively using both simultaneously.

For example, we have known some photographers who tried to light glass in a tent like the one described in the previous chapter. They successfully eliminated extraneous reflections, but they equally successfully eliminated the edge of the glass. The part of the tent visible to the camera provided a light background. The rest of the tent lit the glass. The result was the light-on-light approach.

169

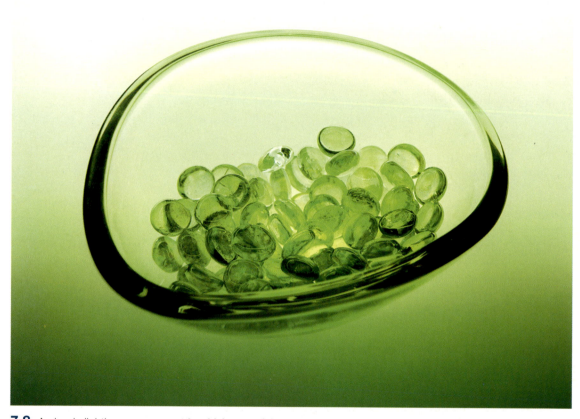

7.8 A classic lighting arrangement in which part of the scene is bright field and the other part is dark field.

Using the two methods together requires that we keep them separate, even in a single picture. We make a mental division of the scene and decide that one part of the picture is to be bright field while the other is to be dark field. We have done this in Figure 7.8, in which the frosted white plastic is illuminated from below by a small light.

Notice that we have not truly combined the two basic methods. Part is bright field and part is dark field. Wherever the two methods remain distinct, the glass is well defined. Only in the transition area do the two methods mix. There can be a noticeable loss there. However, by keeping the transition small this problem can be minimized.

SOME FINISHING TOUCHES

Up to this point we have discussed techniques that define the shape of glassware. As you have seen, we can define the subject shape by using either dark lines against a light background or by using light lines

170

against a dark background. These two techniques are the foundation for lighting glass. However, we often need additional techniques to produce a satisfactory photograph. In the remainder of this chapter, we will discuss some finishing touches. Specifically, we will examine how to accomplish the following:

1. Define the surface of glassware.
2. Illuminate the background.
3. Minimize the horizon.
4. Stop flare.
5. Eliminate extraneous reflections.

Because these techniques are primarily useful in dark-field situations, we will demonstrate them using that approach.

Defining the Surface of Glassware

In many situations, it is not enough merely to define the edges of a subject. It is not enough just to show its shape, no matter how beautifully we do it. Frequently, the photograph must also clearly show the glass surface. To accomplish this, we must carefully manage the highlights that reflect from the surface of the subject.

Large highlights are essential to glass surface definition. To see proof of this, compare the highlights on Figure 7.9 with those seen earlier in Figure 7.1.

The tiny bright spots in Figure 7.1 are harshly distracting at the least and meaningless at best. The opposite is true in Figure 7.9. Instead of competing, the larger highlights provide the viewer with information. Rather than cluttering the other elements of the photograph for the attention of the viewer, it serves the constructive purpose of saying, "This is how this glass surface looks and feels."

Defining a glass surface requires a highlight of the right size in the right place on the surface of the subject. Fortunately, that is not too difficult. Doing it successfully simply requires remembering what the theory of reflection tells us about how direct reflection behaves.

We have seen that almost all reflections from a glass surface are direct reflections and that direct reflections always obey strict rules that predict the angles at which they occur. Now, look at Figure 7.10.

Assuming we want to create a highlight on the area shown on the glass surface, we need to fill the indicated family of angles with light. These are all of the directions and the only directions from which light can produce direct reflection on that part of the glass.

Notice that the rounded glass causes this small subject to reflect much of the studio in its surface. For this reason, lighting for surface definition can sometimes require surprisingly large light sources.

171

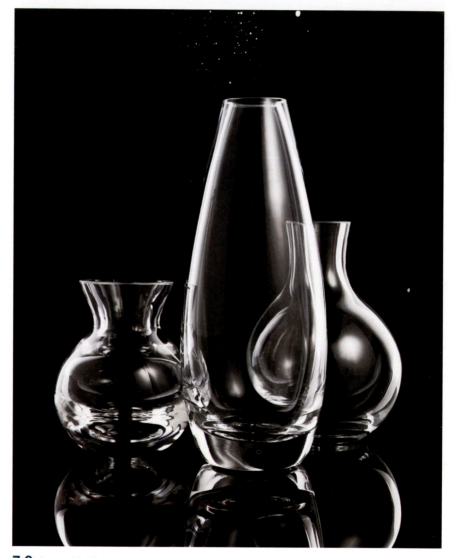

7.9 Large highlights add surface definition to the glassware in this picture.

Figure 7.10 shows two possible ways to provide such a light source. Light sources at either of the two positions would light the glass equally well. However, one needs to be several times the size of the other if it is to cover the required family of angles.

Determining the distance between the photographic light and the diffusion sheet can be an important decision. Notice that in the first photograph in this series, the light was close enough to light brightly only the center of the diffusion material. Figure 7.11 shows an

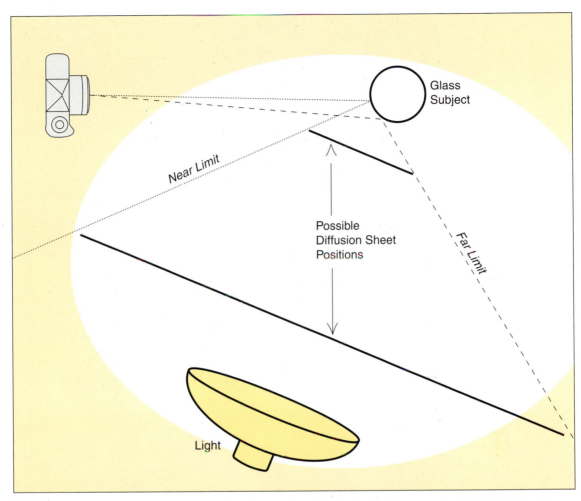

7.10 Creating a highlight on the indicated surface requires filling its family of angles with light. In this diagram, a lighted diffusion sheet reflects on the glass surface to produce the highlight.

alternative method. Here we have pulled the light head farther back. This allows the full rectangle of the diffusion sheet to be lit and to be reflected in the glass surface.

Lighting the whole diffusion sheet more evenly produces a larger highlight, but we usually want to keep that larger highlight dimmer. Had we lit the whole diffusion sheet brightly, it would have reflected in the glass as an obvious hard-edged rectangle. This reflection would have advertised the presence of a studio light and detracted from the reality of the scene.

Regardless of where we put the light, we sometimes minimize the studio look with strips of black tape on the diffusion sheet. Then

173

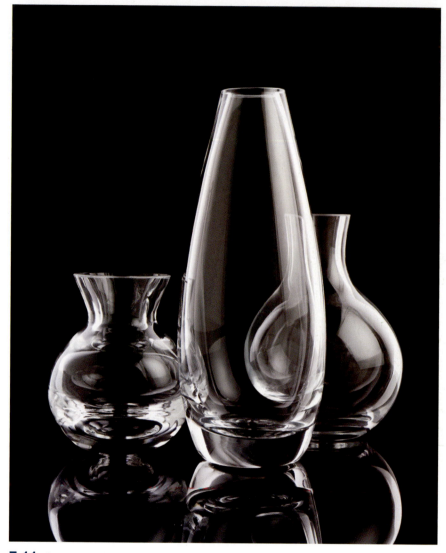

7.11 Compare the large highlight in this picture with that in Figure 7.9. This time we positioned the light far enough away from the diffusion sheet that the entire sheet was lit and reflected in the glass.

the reflection of the light appears to be that of a window, as shown in Figure 7.12.

Before we move on, notice that these are the first examples in this chapter in which the light does not come from behind the glass. This enables us to better define glass that does not have a simple, smooth surface. It is also useful when there are additional nontransparent subjects in the scene. Later in this chapter we will see more examples of this technique.

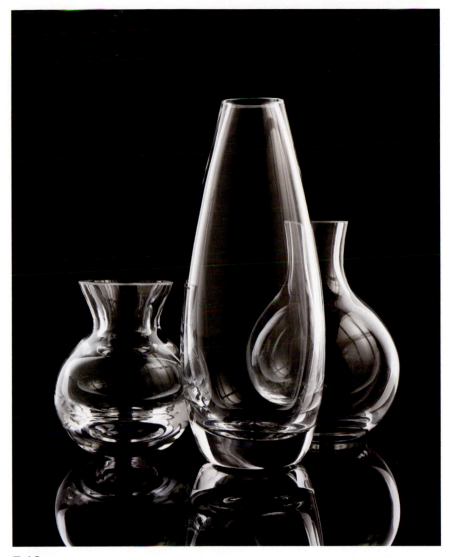

7.12 We used tape to reduce the "studio look" of this shot and to give the illusion of a window being reflected on the glass surface.

Illuminating the Background

The basic dark-field approach produces a picture in which the background appears dark regardless of the actual tone of the background material. Brightening that background material requires an additional light source.

To brighten a dark-field background, we simply put an additional light on the dark background. We position this light similarly to one

175

used to produce bright-field illumination on a white opaque background. Usually, we can even use a light of similar intensity because the darker background material will keep the result from becoming a bright-field photograph.

Figure 7.13 was made this way. Notice that the tone of the background has been lightened to a medium gray and that the glass is free from any extraneous reflections.

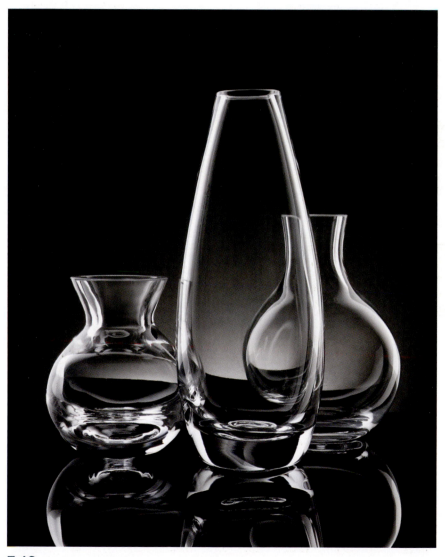

7.13 A light on the background significantly brightened areas of the background in this dark-field shot.

Minimizing the Horizon

Glass things have to be put on tables; tables cause horizon lines in photographs. What can we do if we decide that the horizon is an undesirable distraction?

Eliminating the horizon is easier in photographs of subjects other than glass. Nonglass photographic subjects allow us to use a large enough table to keep the table edge out of the image area. Alternatively, we can use a sweep of seamless paper, raising its top edge high enough to prevent the camera from seeing it. These methods will work for glass subjects too, but not as well.

Remember that the best lighting of the glass requires a background that barely fills the image area. Large tables and paper surfaces interfere with this requirement. If the background is light, we can cover whatever part doesn't show in the scene with anything dark. This produces reasonably good bright-field illumination.

We can also use white or silver reflectors to cover part of a dark table for dark-field illumination. This tends to be somewhat less effective because the light on the reflectors is the same source illuminating the table. The right amount of light on the reflectors may be too much for the table. Therefore, if the table is not an essential element in the composition, we would prefer to get rid of it altogether. We cannot do that, but there are several ways to approximate the effect.

A transparent glass or acrylic table surface resembles a nonexistent table more closely than anything else. In most preceding photographs, we used a transparent table. The background was visible through the table, so the distracting horizon line was minimized. The transparency of the table allowed the background light to pass through and illuminate the scene as if the table did not exist. Figure 7.14 shows light critical to defining this glass, which could pass through a transparent table but would be blocked by an opaque one.

Another reasonable approach is to place the subject on a mirror. The reflection of the background in the mirror shows less abrupt tonal difference between the background and the foreground than other opaque surfaces. Even better, reflection from the mirror surface can light glass surfaces almost as well as light passing through a transparent table. The horizon is likely to be visible but less obtrusive. An interesting variation on both of these approaches is to mist the glass table with water, thus disrupting and camouflaging any potentially disturbing reflections of the subject.

However, even a transparent table or a mirror can produce a slight horizon line, and there are situations when reducing the visibility of the horizon is not good enough. Some pictures require that the horizon be

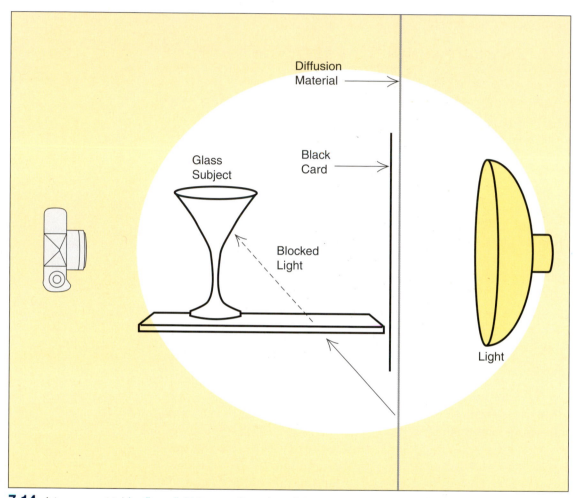

7.14 A transparent table allows light to pass through as if the table didn't exist, but an opaque table blocks light essential for edge definition.

eliminated altogether. In these instances, we can use a paper wedge like the one shown in Figure 7.15.

In this example, the paper wedge is taped directly to a large sheet of diffusion material. A light behind the diffusion material provides illumination. If we cut the paper wedge carefully so that it fits the field of view of the camera exactly, there will be no sacrifice of the lighting quality. Figure 7.16 shows the result of such an arrangement.

Stopping Flare

The basic dark-field approach to photographing glassware is probably the worst flare-producing arrangement that we could encounter.

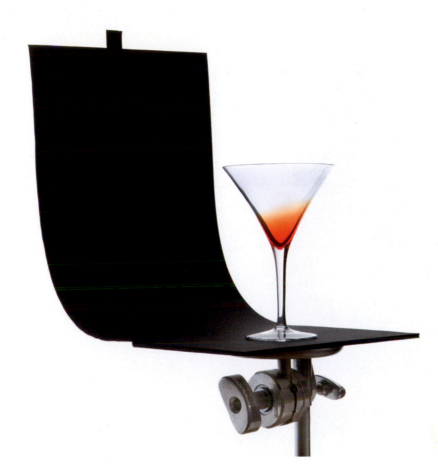

7.15 A paper wedge such as this one will eliminate the horizon but maintain edge definition.

We have discussed the principles of camera flare in earlier chapters. Dark-field lighting exaggerates the problem by giving camera flare the opportunity to occur on all four sides of the image. Figure 7.17 is an extreme example.

Even if the flare is not bad enough to produce a visible fogging of the edge of the image, the general degradation of the image from all sides accumulates. At best, we get a picture with low contrast.

Fortunately, this problem is easy to correct if we understand and anticipate it. We use gobos just as we did earlier in this book, but we have to remember to block the nonimaging light striking the lens from all four sides of the field of view.

We make such a gobo of four cardboard blades or of a single board with a rectangular hole. Then we clamp it to a light stand in front of the camera.

179

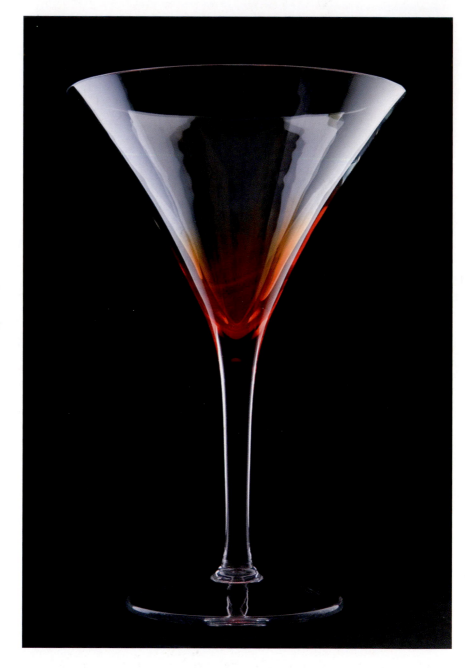

7.16 A photograph made using the paper wedge illustrated in Figure 7.15. The edge definition is good on almost all parts of the glass, and there is no horizon.

Eliminating Extraneous Reflections

Because glass reflects in a mirror-like manner, anything in the room may reflect in the subject. Therefore, after satisfactorily lighting a piece of glassware, we must finish the job by removing any extraneous reflections caused while putting together the setup. This is especially

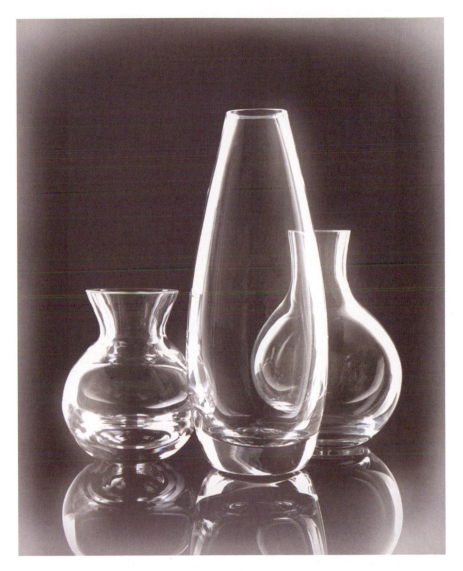

7.17 Because camera flare can occur on all four sides of the image, it is essential to use gobos to prevent it when using dark-field lighting.

true of dark-field lighting because the dark background visible through the glass makes the brighter extraneous reflections particularly visible.

The first step in getting rid of these unwanted reflections is to find which objects in the surrounding area are being mirrored in the glass surface. Once we have done this, there are three basic strategies from which to choose. Often we use a combination of these strategies:

1. *Eliminate objects that create offending reflections.* The easiest way to deal with highly reflective objects such as extra light stands and unused reflector cards is simply to get them out of the room.

181

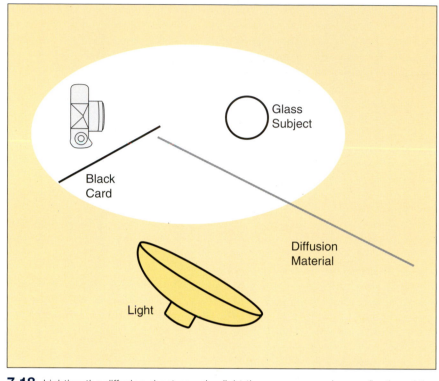

7.18 Lighting the diffusion sheet can also light the camera, causing a reflection of the camera in the subject. In this setup we have used a black card as a gobo to prevent the problem.

2. *Block the light falling on the offending objects.* Notice that in Figure 7.18, the light that is supposed to light the diffusion sheet next to the camera is also falling on the camera itself. A gobo between the light on the camera darkens the reflection of the camera sufficiently that it is no longer visible in the surface of the glass.
3. *Darken the object.* Finally, if the light cannot be blocked from the offending object, we may be able to sufficiently darken the object by covering it with black cards or cloth.

COMPLICATIONS FROM NONGLASS SUBJECTS

The information that we have presented so far in this chapter is all we need to light glass subjects. However, in many cases we need to include nonglass objects in the same picture. The best lighting for the glass may be the worst lighting for the rest of the scene.

As examples, we will look at the two subjects most likely to accompany glass: a liquid in a glass and a label on a bottle. The remedies we propose will be useful for other subjects as well.

Liquids in Glass

We are often called on to photograph glassware filled with liquid. Bottles full of beer, glasses full of wine, vials full of perfume, and bowls full of fish all produce an interesting challenge.

Liquid as a Lens

Optical laws dictate that a round, transparent container filled with a liquid is, in fact, a lens. The troublesome result of this is that a liquid-filled subject may reveal surroundings that we would prefer the viewer not see.

Figure 7.19 is a good example of what can happen. It was made from the same "normal" viewpoint used earlier for the glass without liquid.

7.19 Notice how the "liquid lens" in this wine glass reveals the edge of the background and darkens the apparent color of the liquid.

183

We see that a background large enough to fill the field of view of the camera is not large enough to fill the field of view that is seen through the liquid. The white rectangle in the center of the glass is the background. The dark area around it is the rest of the studio.

Our first inclination might be to use a larger background (or to increase the effective size of the background by moving it closer). However, we have seen that using a background larger than the field of view sacrifices the best delineation of the glass. Such a solution is sometimes practical—but not in a chapter devoted specifically to well-defined glass! For the present need, we will have to think of another technique.

The solution to this problem requires simply moving the camera closer to the subject. Then, if necessary, substitute a shorter focal-length lens to obtain a similar image size. This enables the existing background to fill the area seen through the liquid.

Remember, however, that a closer viewpoint always increases perspective distortion. The increased distortion is apparent in the deeper ellipse of the rim of the glass, as shown in Figure 7.20. Most people would not consider this a defect in this particular photograph, but the distortion could be offensive in another scene with other important subjects or from a higher or lower viewpoint.

Keeping True Color

Suppose a client needs a picture of a glass of light beer in front of a dark background. A liquid in a transparent container always takes on the color of its background. If we are not careful, we will turn the light beer into a dark one! The problem is shown in Figure 7.21.

The solution to this problem is to set up a secondary white or silver background just behind the glass. This secondary background must be the same shape as the subject, even if the glass is stemmed or has an irregular shape. The secondary background must also be large enough to fill as much of the area behind the liquid as possible, without extending far enough to be visible beyond the edges of the glass. All this sounds tedious, but in practice it is not. Figure 7.22 shows one easy way to construct the setup. Here are the steps:

1. *Place a white or silver card behind the subject*. Some photographers prefer a foil with a color similar to the liquid, such as gold for beer. A flexible wire taped to the table surface can make an invisible support for the card, but do not attach the card firmly yet.
2. *Remove the camera, and replace it with a test light aimed at the subject*. This will cast a shadow of the subject on the material from which we cut the background.

7.20 Moving the camera closer to the subject allowed the background to fill the entire area seen through the liquid-filled glass.

3. *Outline the shadow of the subject on the background.* A felt-tip marker is handy for this. After outlining the shadow, remove the card and cut it out.
4. *Reposition the cutout behind the subject.* At this point, we can also remove the test light and replace it with the camera. Look at

185

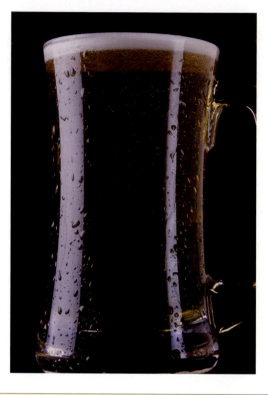

7.21 In this shot, a dark background has turned a light beer into a dark one.

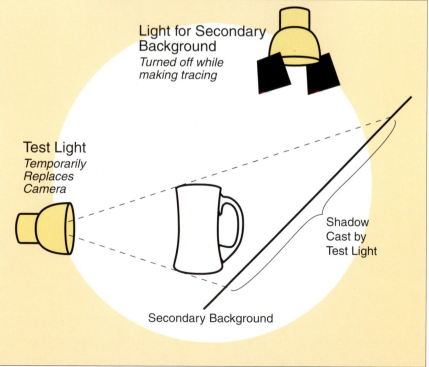

7.22 One setup that uses a secondary background with a light, neutral tone.

Light for Secondary Background
Turned off while making tracing

Test Light
Temporarily Replaces Camera

Shadow Cast by Test Light

Secondary Background

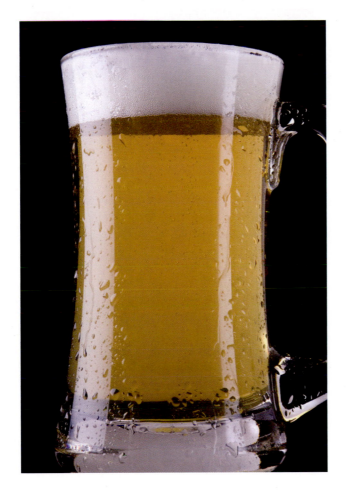

7.23 The beer has the right color this time, thanks to a light-colored secondary background.

the subject through the camera and make sure that the card and the camera are accurately positioned and that the edges of the card cannot be seen.

5. *Place an additional light so that it illuminates only the cutout.* Use barn doors to keep the light off the lens and the subject. Figure 7.23 shows the result.

Secondary Opaque Subjects

A liquid is likely to be the only transparent secondary subject in a photograph of glass. Other secondary subjects are more often opaque and, therefore, more likely to need lighting techniques beyond those adequate for the transparent glass.

The usual lighting for such a scene begins with the lighting arrangement used earlier in Figure 7.10. The same light that produces a

highlight on the front surface of the glass can also give good illumination for an opaque secondary subject. In many cases, this is enough. The next step is to make the exposure.

Unfortunately, other subjects require more work. A paper label is one of the most common examples. Remember that we see neither perfect direct nor perfect diffuse reflection in nature. Although most of the reflection produced by most paper is diffuse reflection, some of it is direct. The lighting that produces direct reflection on the glass surface is also likely to obscure the paper label. Figure 7.24 is an extreme example.

This particular camera position allows two remedies to this problem. One is to move the offending light higher; then any direct reflection from the paper goes downward instead of toward the lens.

7.24 The same lighting that produces direct reflection on glass can also cause it on a paper label. The result is reduced legibility.

If good highlight placement on the glass prevents you from moving the light, use a small opaque card to block the light from just those angles that produce direct reflections on the label. The position and size of this gobo are critical. If it extends beyond the family of angles defined by the label, it will reflect in the glass. We see the resulting photograph in Figure 7.25.

Changing the position of the light or adding a gobo will almost always remove the direct reflection from a secondary subject without harming the lighting of the glass.

We may also consider a polarizing filter as a third remedy. However, this solution is rarely effective because much of the desirable highlight on the glass is usually already polarized. If the polarizer eliminates the offending reflection from a label, it is also likely to interfere with the light the glass needs.

7.25 Here we see the result of using a gobo to block light from those angles that produced the direct reflections on the label in this picture.

189

RECOGNIZING THE PRINCIPAL SUBJECT

In this chapter we have talked about using bright-field and dark-field methods for lighting glass. We have also discussed some remedies to manage complications caused by competing nonglass subjects. However, we have not said very much about when to use which of these techniques.

The nature of the subject determines the best lighting. Deciding which subject is more important is the first step in lighting a scene that includes both glass and nonglass. Should we light the glass as well as possible and then make adjustments to accommodate the rest of the composition? Should we first establish the general lighting, and then add any secondary lights, reflectors, or gobos needed to enhance the glass a bit?

We cannot make these editorial and artistic decisions on a purely technical basis. We might light two identical scenes differently, depending on what is the intended picture caption, on who is paying our bill, or on personal whim.

Seeing how light behaves matters more than the mere ability to make a routine glassware shot look professional. We devote a whole chapter to lighting glass because generations of photographers have found glass to be a classic subject that teaches us to see.

An Arsenal of Lights

Good lighting is one of the most important aspects of portrait making. We can do everything else beautifully, but if our lighting is poor our picture will suffer—often fatally. It is that simple. And with that in mind, we will look at some of the factors that it is important to keep in mind when lighting any portrait.

We will start by explaining the simplest of all portrait lighting; the use of a single light source. We call the light that provides most of the illumination for any portrait the *main* or *key* light, and we generally handle this light the same way. This is true whether we use it alone or with additional lights.

Aside from the main light, this chapter also introduces more complex lighting arrangements than any we have discussed earlier. Such so-called classic portrait lighting requires several lights. Most of these lights could serve similar needs for *any* subject. If you decide not to use all of them for portraiture, you probably will use them for something else later. Therefore, we say more about the fill light than we have before. From there we will move on to explain the use of other lights, such as kickers and hair lights.

THE SINGLE-LIGHT SETUP

Simple, yes. Simplistic, no. A single light is adequate for most portraits; the rest are optional. However, even one light needs to be used well. Otherwise, no amount of additional lighting will salvage the picture.

The Basic Setup

Figure 8.1 is a diagram of the simplest possible setup. In it a single bare bulb that has been placed to one side lights the subject. She is sitting

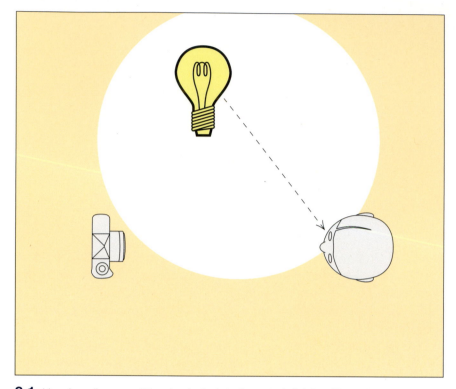

8.1 Here is a diagram of the simplest of studio portrait lighting. The subject is lit by a single bare bulb that is placed to one side.

several feet in front of the plain brown wall that serves as a backdrop. This positioning is important. Were she closer to the wall, her body would cast a potentially distracting shadow on it.

Figure 8.2 is a portrait made with the lighting setup we have just described. In some ways, it is a satisfactory picture. It is sharp, properly exposed, and acceptably composed. However, it suffers from one very serious fault: harsh, distracting, and very uncomplimentary shadows.

Now look at Figure 8.3. It shows the same young lady in the same basic pose. This time the image was made with a single bulb inside a soft box in the same place as before.

But look at the difference between the pictures. The hard-edged, unattractive shadows that produced such an unpleasant picture before have vanished. The softer shadows of this lighting help, rather than detract from, the picture. They help define the features and add an element of depth and interest to the picture. The result is more likely to please most people, especially the subject!

194

8.2 The result of the lighting diagrammed in Figure 8.1. The harsh, uncomplimentary shadows in the portrait distract from the features.

8.3 The softer shadows in this picture are the result of a larger light source. These shadows define the features of the subject and add depth.

195

Light Size

And just what is it that made such a difference between the two portraits we have just seen? Why were the shadows hard and unpleasant in one and soft and flattering in the other? The answer is simple and familiar: light size. The first portrait was made with a single small, bare bulb.

As we have seen, such small sources of light produce hard, sharply defined shadows. The second picture was made with a large light source. The results prove the principle that large light sources produce soft shadows.

In this particular example, we enlarged the light size in the easiest manner possible. We put a translucent lampshade over the bulb. This increased its effective size 10-fold.

The lampshade was a quick and easy solution to the problem of hard shadows, but it was far from the only one available to us. For example, we also could have increased the effective size of our light source by hanging a sheet of tracing paper or plastic diffusion material between the light and the subject. It is worth noting that we could have accomplished the same goal by bouncing a light from an umbrella. These approaches all do the same thing. They make the light size larger and thus the shadows softer.

Skin Texture

The size of the lights also influences the amount of texture we can see in the skin. Skin texture appears as microscopic shadows in the photograph. Such shadows may be either hard or soft, just as the shadows of

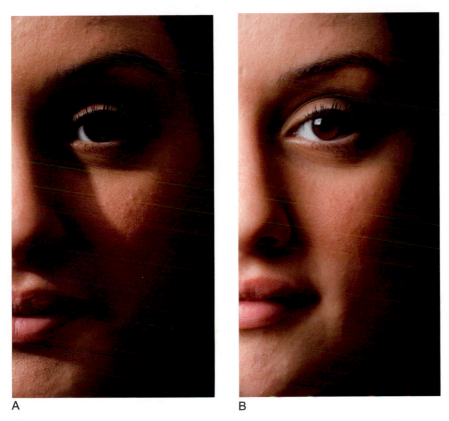

A B

8.4 Compare the skin texture in these enlargements. Picture A was made with a small light. Notice how pronounced the skin texture is. Picture B was made with a soft light and looks smoother.

the general features may be. We can see this clearly in the enlargements in Figure 8.4.

This difference in texture may not matter if the image is reproduced at a small size in a book or magazine, especially if the subject is young. However, people often hang very large portraits on the wall. (Most photographers who do consumer portraiture usually try to sell prints as large as possible to increase their income.) Age and weather add enough skin texture to be visible in even small pictures of many people.

Where to Put the Main Light

Placing the main light is, of course, our first decision. Look at the abstract ball in Figure 8.5. It is the simplest thing we could draw to convincingly represent a ball; without the highlight and shadow, it could

197

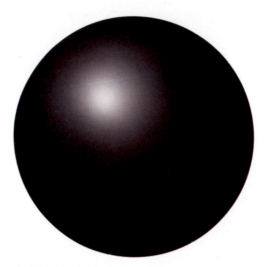

8.5 The placement of the highlight, above and to the left or right of center, simply feels natural.

just as well be a ring, a hole, or a disk. Notice also that the placement of the highlight simply feels more "right" than if we had centered it, say, or put it near the bottom of the sphere.

The most common placement of the portrait main light is about where we have it in the sphere illustration. Faces are more complex. They have noses, eye sockets, mouths, wrinkles, creases, and all the other irregularities that come as part of the human form. Let's look at all of these as we fine-tune the basic light placement.

Generally speaking, we prefer to position the light so that there is a shadow on one side of the face. This, as we have seen, is accomplished by keeping the light to one side. In addition, we want to keep it high enough so that there are similar shadows under the eyebrows, nose, and chin. Having read this, however, you may well ask just *how far* to keep the light "to one side" and *how high* is "high enough." These are valid questions. We begin to answer them with a look at a very useful helper—the *key triangle*.

The Key Triangle

The proper placement of this triangular highlight is the basis of much good portrait lighting. Using the key triangle as a guide to good lighting is simplicity itself.

All we have to do is move the light around until we see a triangular-shaped highlight on our subject's face like the one shown in Figure 8.6. The base of the key triangle should run through the eye, and its point should extend down the cheek approximately to the lip line.

8.6 The key triangle extending from the eye, through the cheek, to the lip line is the starting point for good classic portrait lighting.

The importance of the key triangle is its ability to let us see lighting defects before shooting. Some of the subtleties of good lighting become easy to see when we look at the boundaries of where the key triangle falls.

We will look at the three most common variations and see what might be wrong with them. None of these potential "defects" is an inevitably fatal sin in every picture; every one of them has been used at one time or another to make a good portrait. They are, however, deviations from "standard" portrait lighting, which we should not commit in any picture we intend to sell or submit for a grade until fully mastering the basics.

Key Triangle Too Large: Main Light Too Near the Camera

As Figure 8.7 shows, placing the light too near the camera and in front of our subject lights her too uniformly to show good contour in her face. (The extreme example of such "flat" lighting comes from mounting a strobe directly on top of the camera.)

199

8.7 Flat lighting shows less of facial contours than side lighting. It results from placing the main light near the camera and in front of the subject.

Evaluating whether the lighting is too flat can be difficult for photographers who are just beginning to learn portrait lighting, especially if the picture will be printed in only black ink. Anticipating how color translates to shades of gray takes practice. But the decision becomes simple when we see that such lighting also makes the key triangle so large that it is no longer a triangle.

We can usually improve such lighting by moving the light farther to the side and higher to reduce the size of the key triangle. To maximize contour, we move the light far enough to get the key triangle as small as possible but stop just short of creating either of the following two problems.

Key Triangle Too Low: Main Light Too High

Regardless of whether the eyes are a window to the soul, they are certainly essential to almost any portrait. Keeping the eyes of the subject in shadow can be unsettling to anyone looking at the portrait.

Figure 8.8 illustrates this problem. Notice how the strong eye shadow eliminates the top of the key triangle and produces an unnatural

8.8 The unsettling "raccoon eyes" that we see here come from lifting the main light too high above the model's face.

and ghoulish picture. This shadow is there because we positioned our light too high above the head of the subject. Fixing the problem simply means lowering the light a bit.

Key Triangle Too Narrow: Main Light Too Far to Side

Figure 8.9 illustrates still another potential problem. We positioned the light so that the nose casts a dark shadow across her cheek. This shadow blocks the key triangle.

Once more the cure is simple. To avoid a shadow such as this one, all we have to do is move the light a bit more to the front. When we do this, the key triangle will reappear.

Left Side? Right Side?

Photographers generally prefer to put the main light on the same side as the subject's *dominant eye*, or the eye that appears to be more open than the other. The greater the visible dominance of the eye, the more important it is that we light that side. Of course, some people have very

201

8.9 The result of positioning the main light too far to one side. The model's nose casts a shadow across her cheek, blocking the key highlight.

symmetrical features; then it makes no difference on which side we put the main light.

The other influence on our decision is where the person's hair is parted. Lighting on the same side as the part prevents extraneous shadows, especially if the hair is long.

Some people absolutely insist that we photograph them from one side or the other. Often we should listen to such opinions because they are based on that individual's dominant eye or hairstyle, whether the person knows it or not. Just be sure that the subject has not confused the "good" side with the "bad" side when looking in a mirror!

Broad Lighting or Short Lighting

So far we have made all pictures with the model approximately facing the camera. Whether the light was on the right or the left would have made only a minor difference. However, the difference is major if the subject turns his or her head to either side. Where do we main light then? Figures 8.10 and 8.11 show the options. We either put the light on the same side as the subject's visible ear or on the other side.

8.10 Putting the main light on the side opposite the visible (were it not covered by her hair) ear produces short lighting.

8.11 Broad lighting means putting the main light on the same side as the visible ear.

A main light on the *same* side as the visible ear is called *broad lighting*. Positioning the main light on the side *opposite* from your subject's visible ear produces *short lighting*. (Whether the hair covers the "visible" ear has nothing to do with which side of the face we are talking about.)

If you look at Figures 8.10 and 8.11 again, the reason behind these two somewhat confusing names becomes apparent. First, look at the picture that we made with broad lighting. Notice that a broad, or wide, highlight runs from the back of the model's hair, across her cheek, all the way to the bridge of her nose. Now, look at the portrait that we made with short lighting. This time the highlight is quite short, or narrow. The brightest part of it only extends from the side of the model's cheek to her nose.

There are no firm rules dictating when to use broad and when to use short lighting. Our personal preference, however, leans decidedly to short lighting. It puts the light where it will do the most good, on the front of the face. This, we feel, produces by far the most interesting portraits.

Other photographers have a completely different bias. They feel strongly that the short or broad light decision should be based on the subject's body build. They prefer to use short lighting if their subject has a broad face. Such lighting, they argue, helps make the subject look thinner by putting much of the face in shadow. If, however, the subject is very thin, they like the way that broad lighting increases the amount of the image that is highlighted and makes the subject appear more substantial.

Eyeglasses

Eyeglasses sometimes dictate the position of the main light, regardless of the other preferences of the photographer. Figure 8.12 was shot with short lighting. Look at the resulting direct reflection from the glasses.

It is impossible to eliminate the glare with the light positioned as it was for this portrait. We could, of course, raise it, but depending on the size and shape of the glasses, by the time we get it high enough it might fill the eye with shadow.

Figure 8.13 shows the only solution that always works. It is the same subject shot with broad lighting. Changing from short to broad lighting positions the main light outside the family of angles that produces direct reflection.

Problems with eyeglasses increase with the diameter of the eyeglass lenses. From any particular camera position, the family of angles that produces direct reflection is greater if the glasses have big lenses. If the subject has small eyeglass lenses, we can sometimes keep a short lighting arrangement by using a smaller main light. It is easier to position the smaller light so that no part of the light is within that family of angles.

8.12 Short lighting produces an objectionable glare on the eyeglasses.

8.13 Broad lighting eliminates the glare problem.

Still life photographers exploring portraiture are sometimes tempted to use polarizing filters on the main light and on the camera lens to eliminate reflection from glasses. However, this can cause other problems. Human skin also produces a small amount of direct reflection. Consequently, eliminating all direct reflection in the highlights of a portrait may give the skin a lifeless appearance.

ADDITIONAL LIGHTS

Up to this point, we have shown some of the different ways to position and manipulate highlights and shadows using a single light source. These techniques are powerful because they produce fine work even if we have only one light at our disposal.

Depending on taste, we may be satisfied with the results of a single light and proceed no further with the lighting, even if we have a whole studio full of strobes available. This should be reassuring to anyone not earning a professional income from photography and only able to afford to light a portrait with sunlight.

Still, very few photographers shooting professional portraits use a single light, so this book will discuss what those other lights are and how to use them.

Fill Lights

Shadows are essential to the success of most portraits. Much of the time, however, we prefer to lighten a shadow or even eliminate it altogether. We can do this with a single light source only if we place it near the camera lens. If we want to keep the main light farther from the camera, however, we need some kind of fill light.

Photographers commonly use a fill light that gives the subject about half as much illumination as the main light, but this guideline is by no means absolute. Some photographers like to use a lot of fill in portraits, whereas other equally talented ones prefer to use none. The important thing is not to try to memorize any set of rules; instead, adjust your lighting until it is satisfactory to you.

Some photographers use additional lights for fill, whereas others prefer flat reflecting surfaces. Both methods have their advantages. The most basic multiple light arrangement consists of a main light plus a fill light. An additional light allows good flexibility in fill light placement. We can put the fill light far enough from the subject to be out of the way and still expect it to be bright enough.

Figure 8.14 was made with a single fill light. We turned off the main light so that you could see exactly what effect a fill light has by itself.

Now look at Figure 8.15, in which we turned the main light back on. This is a typical example of the combination of fill light and a main light.

8.14 All we used to make this exposure was the fill light. Notice that it is much dimmer than the main light.

8.15 We used a main and a fill light together to make this exposure.

207

Notice that the shadow under the chin is darker than the other shadows in the face. This area receives little illumination from either the main light or the fill. The shadow is not offensive, but it would be if it were a bit darker or harder. We will talk about how to keep that from happening.

Size is important when you are using fill lights. Generally speaking, the rule is, "the bigger, the better." As you might remember, the larger a light source is, the softer the shadows it produces. The soft-edged shadows produced by a large fill light are less visible and less likely to compete with shadows produced by the main light.

The use of a large fill light allows greater freedom in deciding where to place the light. Because the shadow of a large fill light is not clearly defined, the position of the light is, within a wide range, of no importance. That means we can put it nearly anywhere that we will not knock it over and the lighting differences will be too minor to matter.

Figure 8.16 shows a two-light portrait arrangement including a main light and two possible fill lights, a large one and a small one. We are unlikely to use both fill lights, but we could successfully use either, depending on our preference and available equipment.

One fill light, like the main light, uses an umbrella. This increases its effective size and softens the shadows it produces. Because it is large,

8.16 Two fill light alternatives. Bouncing one light into an umbrella produces softer lighting. The small light, near the camera, produces hard shadows, but they fall mostly behind the subject, where the camera cannot see them.

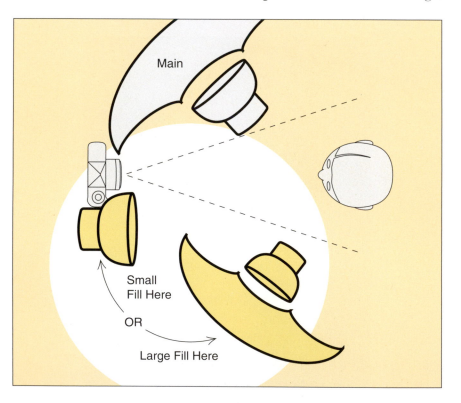

we could move the fill light around a good bit without a major effect on its shadow pattern. Such an arrangement makes it easy to vary the fill light intensity by moving it closer to or farther from the subject.

Alternatively, the fill light can be small if we position it near and slightly above the camera. Notice that the fill light is as close to the camera lens as we can put it. Such a fill light still casts hard shadows, but most of these shadows fall behind the subject, where the camera cannot see them.

Reflector Cards as Fill Lights

One of the simplest and least expensive ways of brightening dark shadows is to use reflector cards to bounce light coming from the main light onto the face of the subject.

Figure 8.17 uses a main light position similar to that in previous photographs, but now a white reflector card has been added to provide fill light.

8.17 In this photograph, light from the main light bounced off a reflector and onto the model's face. There it fills in some of the shadows.

We would like to show you the effect of the reflector fill card alone, but this is impossible. Because the reflector is illuminated by the main light, it has no effect by itself. However, it is useful to compare its effect with that of the additional lamp in Figure 8.15. The reflector fill is dimmer, but the two pictures are more alike than different.

Notice that the dark shadow we saw under the chin in Figure 8.15 has been greatly reduced by the reflector card. The shadow is still present, but it is softer. This is because the reflector card is much larger than the fill light used earlier. We could, of course, have used a fill light as large as the reflector card to produce the same result.

The only common problem with a reflector fill is that it may not be bright enough to suit some photographers' preferences. This is especially likely when we move the camera back to include more than the head and shoulders. The reflector also has to be moved back to get it out of camera range.

The amount of fill light a reflector provides is determined by numerous factors, including the following:

- *The reflector's distance from the subject*. The closer the reflector is to the subject, the brighter the fill light becomes.
- *The reflector's angle*. A reflector card illuminates the subject most when it faces an angle between the subject and the main light. Turning it more to the subject reduces the intensity of the light falling on it. Turning it more to the main light reflects more light in a direction away from the subject.
- *The reflector's surface*. Different reflector surfaces reflect different amounts of light. In our example, we used a white reflector card. If we had wanted more light on the subject, we could have used a silver reflector. Remember, however, that the choice of reflector surface also depends on the size of the main light. A large silver reflector fill can be a soft source only if the main light is also soft.
- *The reflector's color*. When shooting in color, you may also want to experiment with colored reflector cards. At times they are useful for either adding or subtracting shadow color. In a daylight portrait, for example, the sun is usually the main light and, without reflectors, the open sky is the fill. The blue sky adds blue to the shadow. Using a gold reflector warms the shadow, thus eliminating the blue and producing a more neutral color. Using exactly the opposite approach can make a studio portrait resemble daylight. A pale-blue reflector cools the shadow color enough to look more like that in an outdoor photograph. The effect is subtle and few viewers will notice it consciously; still, they are more likely to believe it is an outdoor portrait.

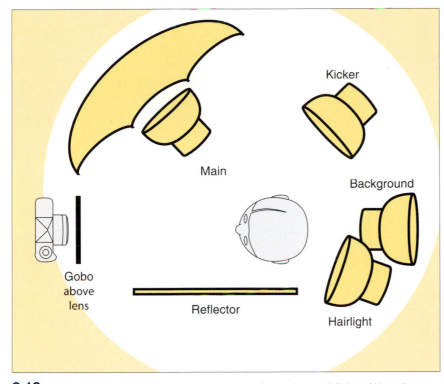

8.18 A main light, reflector fill, plus other commonly used portrait lights. Although some photographers use fewer lights and others use more, this arrangement is common.

Because we personally prefer the reflector to the earlier strobe fill, we will keep it in place for all of the subsequent photographs. Figure 8.18 shows where we placed the reflector in a more complex portrait lighting arrangement.

Now let us talk about the other lights in it.

Background Lights

So far we have talked about lighting the subject. *Background lights* illuminate, as the name implies, the background rather than the person being photographed. Figure 8.19 shows the effect of the background light by itself.

Figure 8.20 was made with a three-light setup. Besides the main and fill lights we used before, we added a background light. Compare it with Figure 8.17, which was made with just a main light and a fill.

As you can readily see, the two pictures are similar, but look at how nicely the back of the model's head and her shoulders are separated

211

8.19 In making this picture, we used a background light to separate the subject's head and shoulders from the background. Notice how this adds depth.

8.20 Adding the background light to the fill and main lights surrounds the subject with a pleasing glow.

from the background in Figure 8.20. That is exactly what background lights do.

They provide a degree of tonal separation between the subject and the background. This separation helps give a feeling of added depth to a portrait and surrounds the subject with what is often a visually pleasing "glow." You can be heavy handed with this, giving the subject a pronounced halo, or you can be subtle, pulling the light farther from the background or using multiple lights to light the background evenly.

Background lights can also add color to portraits. We do this by attaching colored gels, or filters, to the light. Gels are not expensive and they come in a wide range of colors. By using them and a white background, photographers can reduce the number of different colored backgrounds that they need to keep around the studio. Several background lights with filters of different colors can create color combinations impossible with colored seamless paper and white lights.

Figure 8.18 shows one common background light position. The light is placed on the floor and aimed up to lighten the background. This arrangement works well for a head-and-shoulders portrait. Hiding the background light behind the subject is more difficult in a full-length portrait.

Furthermore, lighting the background uniformly, instead of a bright center spot, is almost impossible with the background light in such a position. To photograph the whole body or to illuminate the background evenly, we prefer to use two or more background lights on each side of the subject.

Background lights may be very bright or very dim. Experiment until you come up with the lighting you like. For portraits you intend to later paste into another scene, try lighting a background slightly lighter than pure white (just to be sure). You can then often place the portrait into another scene using the software "darken" mode. In many scenes, this eliminates the need for tediously silhouetting the hair.

Hair Lights

The next light that we are going to discuss is the *hair light*. This light is often used for highlights that separate dark hair from a dark background. However, even if the hair is blond, brightening it with additional light can make the photograph less somber. Figure 8.21 was made with a hair light alone to show the effect.

Now look at Figure 8.22. We made it with a main light, a fill light, and a hair light. This combination has the hair light set at a typical

213

8.21 We made this exposure using nothing but a hair light. Notice the highlights that it puts on the subject's hair.

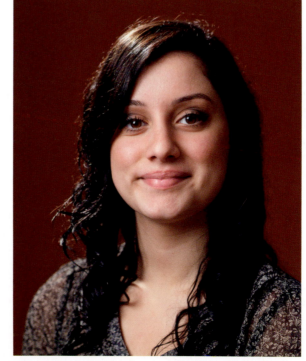

8.22 A hair light used along with the main and fill lights. This one is of typical brightness. Some photographers like brighter highlights, whereas others prefer them dimmer.

brightness. Some photographers might prefer to keep it dimmer, providing separation in the dark areas but attracting less attention to it. Others prefer a brighter hair light for a more theatrical look.

The diagram in Figure 8.18 shows one common position for the hair light, on the side opposite the main light and behind the subject. Alternatively, you can use a boom to suspend the hair light above and to the rear of your subject. The boom allows better freedom to position the hair light without getting the light stand in the picture.

The hair light, like any other light coming from behind the subject, reveals loose strands of hair. Whether this is a problem depends on personal taste and current style. (Some people prefer to look meticulously tidy, whereas others are happy to be absolutely shabby. Either way, their children are probably the opposite!) If we do not want the loose hair, we have to use hair spray, anticipate retouching, or forego the hair light entirely.

It is important to position the hair light so that light coming from it does not produce flare. Remember to look at the lens as you position the hair light to see if the light is falling directly into the lens. If it is, you may be able to move the light a bit. If you do not want to change the light position, block the offending light from the lens with a barn door or a gobo. The gobo above the lens in Figure 8.18 serves this purpose.

Kickers

Along with the different lights that we have talked about so far, some photographers also like to use a *kicker* as a part of their setup. Figure 8.23 was lit by a kicker alone.

As you can see, a kicker adds extra illumination to, or "kicks up," the brightness on part of the face by providing an extra highlight. Kickers are usually about half the brightness of the main light.

Figure 8.24 shows what happens when you use a kicker with a main light and a fill light. Notice how the kicker added an appealing highlight on one side of our model's face.

The position of the kicker is the least standardized of any portrait light. Figure 8.18 shows one possible way to position it. We placed it to the rear of the subject and on the same side as the main light.

As was the case with hair lights, when you are using a kicker you have to be careful that light from it does not spill into the lens. If it does, it will cause flare. The gobo we used over the lens to prevent flare from the hair light in Figure 8.18 will do the same for the kicker.

215

8.23 A kicker by itself. Kickers are lights that are sometimes used to brighten (or "kick up") a small extra highlight.

8.24 The kicker added an appealing highlight down the side of the model's face.

Rim Lights

Some photographers use *rim lights* to illuminate the edges of the subject. Rim lighting is often a combination of hair lights and kickers so similar to the arrangements described in the preceding sections that it makes no difference which terms we use to describe the lights.

However, one variation on rim lighting is different from anything we have seen. This technique places the light directly behind the subject in a position similar to that of a background light but aims the light at the subject rather than the background.

Figure 8.25 shows such a rim light used alone. Figure 8.26 is a combination of the rim light plus other lights, and Figure 8.27 diagrams the setup.

MOOD AND KEY

Mood is one of those subjective ideas hard to discuss and still harder to quantify. It is one of those terms that often has different meanings to different people. At the simplest level, we will all agree that pictures that have a dark and somber lighting evoke a different response from those that are light and brilliant.

To keep from confusing each other with different personal perceptions, photographers talk about the *key* or *brightness key* instead of mood. No one factor determines key. Lighting may be the most essential factor, but subject matter and exposure also greatly influence key.

Low-Key Lighting

Large, prominent areas of dark are characteristic of *low-key lighting*. Pictures made with this kind of lighting tend to be somber—serious, formal, and dignified in mood.

Low-key lighting requires more side and back lighting. Front lighting does not produce enough shadow area to keep the key low. Most of the examples that you have seen so far in this chapter were made with fairly low-key lighting. We did this because it is easier to see the effect of each light in a multiple-light setup using low-key lighting.

High-Key Lighting

High-key lighting is quite the reverse of low-key lighting. Pictures made with high-key lighting are light and bright. They have many white and light gray tones in them. This tends to give them their characteristic upbeat look. For this reason, photographers frequently use high-key lighting to produce a youthful, happy look.

217

8.25 Rim lighting by itself places a bright "halo," or rim of light, around the model's head.

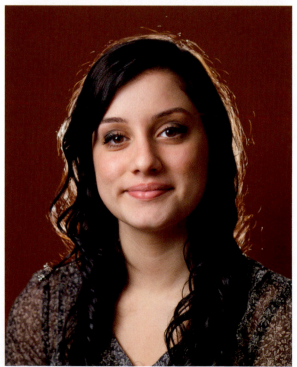

8.26 A rim light along with a main and a fill light. Notice how the rim of light around the model's head separates it from the background.

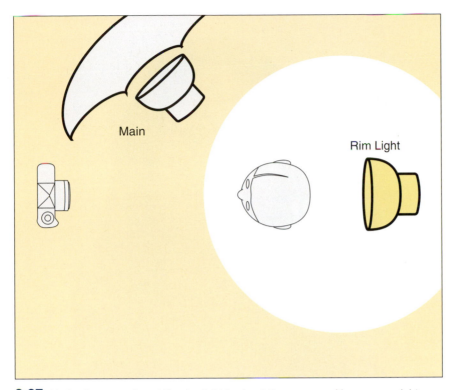

8.27 Notice how we placed the rim light in about the same position as we might have placed a background light, only in this case we pointed the light at the back of the head.

Figure 8.28 is of the same model that we have used so far in this chapter. Look at how different the portrait is when done with a high-key approach. Its mood is completely different from those presented so far. Notice that in this treatment, we have changed more than just the lighting. We have also changed the costume and the background, making them far brighter than in the previous pictures.

Many of the lower-key portraits you have seen in this chapter used lighting that produced highlights of one kind or the other along the edges of the subject. We needed these highlights to delineate the subject's features and to separate them tonally from the background. Without them, the features of the subject would have melted into the background.

High-key portrait lighting always uses a great deal of front light. Edge highlighting is less beneficial in high-key lighting because the edge of the subject threatens to disappear against the light background. Thus, we tend to omit many of the lights that are important in low-key work. It is usually easier to light high-key pictures than it is to light low-key ones.

8.28 The preponderance of light tones gives high-key pictures a fresh and bright look. Such images are common in the fashion and editorial fields.

Figure 8.29 shows how we arranged the lights for the high-key example you have just seen. Notice that all we needed was one large main light, a reflector, and a pair of background lights. We put the main light above the camera but as close to the lens as possible. In this position, it bathed the model in soft and almost shadowless illumination. We placed the reflector under the camera and close to the model. So positioned, it bounced some of the main light illumination back onto her. The two background lights turned the background into one large and evenly lit highlight.

This setup produced a very flat lighting with few shadows to help delineate the features. This lack of shadow is both the advantage and the disadvantage of such lighting.

Because such lighting reduces contrast, it helps to make blemishes and other skin imperfections less noticeable. Most photographers consider this to be flattering and appropriate to young women and children. If you have any doubts about this, just look at the covers of fashion and beauty magazines. Many of the images are made with lighting similar to

Main above lens

Background Light

Background Light

Reflector *below lens*

8.29 A diagram of the lighting used for the previous high-key picture. Both the main light and reflector bathed the model in soft, almost shadow-less, light. Other lights turned the background into a large, evenly lit highlight.

this. However, you should use "beauty" lighting with care. The lack of shadows can also produce pictures that appear flat and formless and seem to be wholly without character.

Staying in Key

Many photographers consider it a good idea to keep a portrait definitely low key or definitely high key whenever possible. They do not mix low- and high-key subject matter and lighting techniques unless there is a definite reason for doing so.

Everyone knows that this rule cannot always be followed. Exceptions include a fair-skinned blonde in dark clothing or a dark-skinned, dark-haired person in light clothing. Professional portrait photographers often discuss wardrobe with the subject in advance, but most nonphotographers would be amazed at how many people agree with the photographer's advice and then show up dressed exactly the opposite.

Unless you crop to include only the face, either one forces you to mix high- and low-key elements in the portrait. On other occasions, you

221

may decide to move the main light more to the side to increase the shadow area in a high-key portrait to emphasize facial contour, or you may decide to minimize shadow in an otherwise low-key portrait to make the skin appear smoother.

Nevertheless, staying in key has some merit. If most of the composition is in the same tonal range, the picture has less clutter to compete with the face. This is especially useful for photographers beginning to learn portraiture who have not yet learned to fully combine lighting, posing, and cropping to unify the composition.

DARK SKIN

We know that photography is most likely to lose detail in the highlights and in the shadows. Few people with light skin are light enough to cost highlight detail, and we rarely encounter such problems. However, a few people with dark skin are dark enough to present potential shadow detail problems.

Some photographers increase the exposure in these cases. Sometimes, and we must emphasize *only* sometimes, this strategy works well. If, for example, the subject is dark skinned and wearing a dark shirt and coat, it is safe to open the lens considerably to compensate for the light lost by skin absorption.

However, if the subject is a bride with very dark skin in a white wedding dress, the preceding strategy could lead to disaster. The face would still be properly exposed and have good shadow detail, but the dress would be hopelessly overexposed. She's been anticipating portraits in a dress with this delicate lace detail for 20 years, and you're in trouble!

Fortunately, there is a better way to approach this problem than just opening the aperture and hoping for the best. The key to successfully dealing with dark complexions is to increase the direct reflections from them.

Human skin produces only a small amount of direct reflection, but as you might remember, direct reflection is most visible on a dark surface. Therefore, capitalizing on direct reflection is one way to lighten dark subjects without increasing general exposure.

Another point to keep in mind is that the larger the light source, the greater the group of angles from which its light will strike the subject. This enables a large light to fill more of the family of angles that causes direct reflection. Thus, in a portrait of a person with dark skin, a larger light produces a larger highlight on the skin without adjusting the exposure at the camera.

Be aware, however, that just a slight increase in the size of the light would offer almost no improvement. Because a human head is roughly spherical, the family of angles that produces a large direct reflection is

also quite large. The larger the light we use, the better the result. We may still have to open the aperture a bit, but not very much, and both the bride's face and her dress will photograph well. (If you are not reading these chapters in order, we suggest you look back at Figure 6.29, round metal, or Figure 7.10, glass, to see the family of angles of direct reflection on a round object.)

AVAILABLE-LIGHT PORTRAITURE

From time to time, you or your client will decide that a portrait needs to be made away from the studio. Location portraiture can be completely frustrating if you are used to the command that the studio gives you. It can also be fascinating and enjoyable. Furthermore, the environment can be an essential part of the person and, therefore, of the portrait.

In Chapter 10 we will discuss the use of minimal lighting gear on location. Those techniques are important, and they apply equally to portraiture as well as to other photographic specialties. Sometimes logistics or other considerations make it impractical to use large, heavy-duty lighting gear. And sometimes we are even more challenged—we cannot use any lights at all. We, in other words, either get the pictures we are after with nothing more than the ambient light present where we shoot, or we don't get them.

With that in mind, we will finish this chapter with a brief look at some useful ambient light and ambient light plus flash portrait techniques. We have omitted a detailed treatment of available-light portraiture because the methods resemble studio portraiture more than they differ.

We will offer just enough examples to illustrate a cardinal rule: location or studio, the guiding principles are the same. It is that simple. No matter where you are, outside or inside, cornfield or studio—light is light. It follows the same immutable laws of physics. In the next few pages, we will light our models according to the same principles as we would in the studio. Only this time we will be looking for Mother Nature to provide most, if not all, of the light.

A Window as a Main Light

Look at Figure 8.30. It is a typical example of a window-lit portrait. This basic picture has been repeated many times by many photographers, and for good reason. As you can see, soft light streaming in through the window gives good contour and depth but none of the harshness sometimes seen in portraits that were made with direct daylight.

As pleasing as this picture is, the lighting involves nothing new. The key to its success is already familiar. Large light sources produce soft lighting. In the studio, we use a large diffuser or an umbrella for a light

223

8.30 Soft light from the open sky streaming in through a window made this portrait. The soft and pleasing light is well suited for the subject.

source. On location, the sky is our large light source. The tools are different, but the result is the same.

You must remember, however, that the window does not have any magic qualities that inevitably make it a soft-light source. Figure 8.31 proves this point. Our model is in the same place, and so is the window, but look at the difference.

In the second picture, hard shadows compete with the subject's features. It could still be a good picture, depending on the intent, but it is not a flattering portrait. What caused the difference? Simply put, the answer is light size. The two pictures were made at different times of day, and the sun had moved during the time between them.

In our first picture, the light through the window was from the open sky. The sky is a large light source. The second photograph was made later in the day, when the sun had moved across the sky. It was lit by

8.31 Later in the day, the sun was lower in the sky, and its direct rays produced the harsh shadows that we see here.

direct sun, and as you know by now, the sun always behaves like a small light source. Direct sunlight always produces hard shadows.

So, once again, we have seen that studio or location, sun or strobe, the results are the same. Light is light. Large lights produce soft shadows, and small lights produce hard ones. The locale may change, but the behavior of light does not.

The Sun as a Hair Light

Figure 8.32 shows an outside setup. We are including it to show how you can duplicate a studio main light and hair light setup in the field.

Figure 8.33 shows how this picture was shot. The open sky serves as a large, soft main light. When we made this picture, the sun was just over the top of the background trees. So positioned, it made a perfect hair light. Notice also how the dark trees in the background contrast well with the brightly lit hair.

225

8.32 Outside natural light and a reflector produce much the same look as do main and hair lights in the studio.

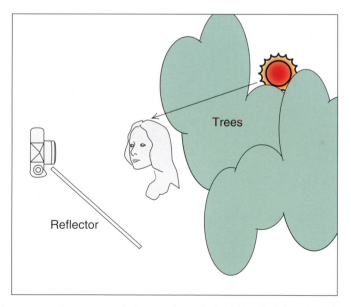

Trees

Reflector

8.33 Here we see how we made the previous shot. Notice that the sky serves as a large, soft main light. The sun was just peeping over the top of a stand of trees in the background, and we positioned the model so that it acted as a hair light.

Once again, the location was different, but the principles that we followed were the same. Once again, light behaves like light!

Combining Portable and Ambient Light

Sometimes ambient light has a beauty totally unexpected because it's nothing we would be able to truly reproduce in the studio. Unfortunately, however, in some of those same cases, the light we encounter on location is not adequate, by itself, to make a fully acceptable picture. We will continue this chapter by examining some such situations.

In Figure 8.34 there was a large, high window that some photographers would be tempted to use as a main light. Instead, we realized that

8.34 In making this picture, we used the natural ambient light that produced both the kicker and the hair light. In addition we added fill light to the scene from a flash-fitted umbrella that we positioned close to our camera.

227

this could be the biggest hair light–kicker–rim light we'd ever had the chance to use and positioned the subject accordingly. A silver umbrella above and to the right of the camera provided fill, but in this case a small strobe on the camera would have worked almost as well.

Figure 8.35 is another, but quite different—and considerably more luminous—example of a portrait shot made using mixed light sources. We made this shot using both portable strobes and the rich, warmly colored ambient light present at the scene. In addition, for this picture, we added a green gel to our bag of tricks. The subject is Miss Prissy Pistol, a burlesque artist in the venue where she performed (Figure 8.35).

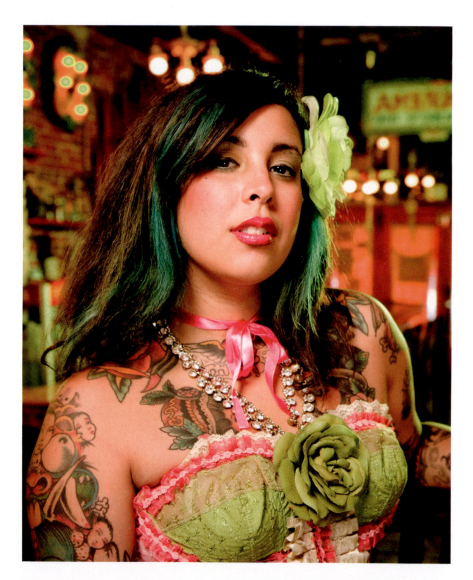

8.35 This portrait is an example of the eye-catching luminosity and "punch" it is possible to achieve by mixing flash and mixed, brightly colored, ambient light sources.

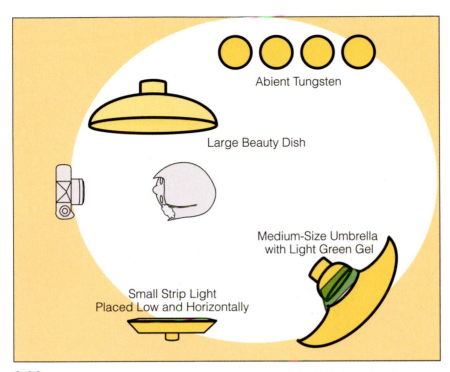

8.36 This diagram shows the setup we used to make Miss Prissy's on-location mixed ambient light and flash portrait.

For our key, or main, light we chose a round 22-inch "beauty dish," or as it's sometimes called, "softlight." We placed this light above, and to camera left, of our camera (see Figure 8.36).

A 32-inch vertical strip box placed to camera right of our camera and aiming up from the floor added a bit of extra fill light to the camera right side of Miss Prissy's face and torso.

For the third light, we taped a green gel over a flash head and aimed into a 36-inch umbrella. We then put this about 7 feet behind Miss Prissy and to camera right. Light from the umbrella added the slight green kick you see on Miss Prissy's camera right arm, shoulder, and hair. It also added some additional light to the back of the bar.

When it came time to shoot, we set our camera aperture at f/5.6 with an ISO of 100. We then—after firing off a number of test shots—selected a shutter speed of 1/6 of a second. At this slow speed, our camera's shutter remained open long enough for the varied and colorful ambient light present in the bar to be recorded by the camera's sensor.

In addition, the flashes we had previously set up also illuminated Miss Prissy. They fired for the briefest moment when the camera's shutter first opened. Called "dragging the shutter," this technique can

229

produce out-of-the-ordinary results and is one with which it is well worth experimenting.

Note: You will need to turn off your modeling light in the flash head to avoid the additional ambient light it produces.

A Reflected Ambient Light Portrait

Working with ambient light can be challenging. And that is putting it mildly! You are never really sure of what it is going to be like until you arrive at your shooting location. In addition, ambient light can, and often does, change in intensity, color, direction, and angle while you are shooting.

With that in mind, we humbly suggest that every photographer who works using ambient light should adopt the following motto: "It's what you do with what you've got that counts." The portrait in Figure 8.37, taken in Savannah, Georgia, is a case in point.

Photography is no different from the rest of life. Sometimes we are lucky—as in very lucky—and everything goes right. It was on one of those all too infrequent days that the reflected ambient light was used in an unusual setting, a bus, to shoot the following eye-catching portrait of the young man sitting across the isle.

8.37 This young man's portrait was made using no other light source but the ambient light that was reflected into the bus from the pavement and the rest of its surroundings.

The morning on which this portrait was made was brilliantly sunny. The bus's interior was awash with light that was being reflected off the parking lot and into the bus through its many windows.

Once inside, this light continued to be reflected and re-reflected from one shiny surface to another. The result was a virtual "sea" of bright ambient light swirling about the bus's interior and wrapping around the young man sitting in his seat.

The result speaks for itself: an arresting, high-key portrait of a young man lit with nothing but the intense sunlight reflected into a bus from the pavement on which it was parked.

APPROACHES WORTH TRYING

Before we end this chapter, we would like to introduce three more techniques we find both useful and interesting. The first involves the use of two lights—one large and one small. The other employs colored gels. And the third relies on motion for its impact. None is particularly complex to execute. All are useful tools worth adding to anyone's lighting arsenal.

Unfocused Spot

When making Figure 8.38, our aim was to create a dramatic portrait in which our subject's face stood out brightly from its somber, almost

8.38 We combined the light given off by a large bank light with that of a seven-inch tight grid spot to illuminate our model generally and highlight her face.

231

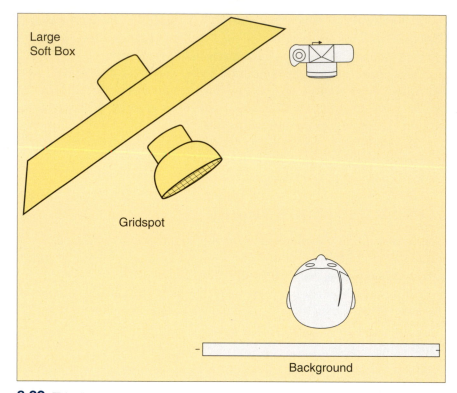

8.39 This diagram shows the "additive" lighting setup we used to make Figure 8.38.

monochromatic, setting. To make the picture we wanted, we decided to use two very different light sources (Figure 8.39). One was a 54-by-72-inch bank light; the other was a tight grid spot fitted to a 7-inch reflector. Prior to shooting, we asked our model, Farrah, to wear a neutral toned gray jacket that would complement the steely blue-toned background we had previously selected.

When time to shoot, we put the large soft box to our camera right, about a foot in front of Farrah. So positioned, it put noticeably more light on the camera right side of her face, thus helping to delineate her features. We then placed our grid spot close to, and directly in front of, the bank light. This produced a closely defined and intense spot of light on Farrah's face.

Once we completed our setup, we made a series of test shots varying our exposure settings and the output of the two lights we were using. After several, we selected the combination that produced the image we have previously shown as Figure 8.40.

For the sake of comparison, in the illustration that follows, we show what Farrah looked like when lit with each of the two lights we used to make her finished portrait.

A

B

8.40 On the left (A), we see Farrah's face lit by the grid spot alone. On the right (B), we see her face lit by only the bank light.

Small Light? Large Light? Why Not Both?

We've seen the advantages of a small light: crisply defined shadow, good texture in subjects, which reveal that texture in mostly diffuse reflection. We've also seen the advantages of a large light: shadows soft enough that they do not distract from the principal subject, the ability to fill a large family of angles to reveal the surface of a glossy subject.

What if we want both at once? We can certainly do this, and there are several ways to accomplish it. One is essentially cost-free, assuming we're already reasonably equipped; another is fairly expensive, but far quicker and easier to reposition. The difference in effect may be fairly subtle, depending on the subject. Try all three, if you can, with borrowed equipment, and then decide which you want to mostly use.

A Small Light Placed Very Close to a Big Piece of Diffusion Material

The light doesn't illuminate the whole diffusion sheet evenly. There will be a hot spot in the center, serving as a fairly hard light. There will also be light scattered to fill the whole sheet; that gives us our soft light. Essentially, we get two different lights from one electronic device and we get very good control: move the light closer to the diffusion material to increase the hard light; move the light farther from the diffusion material to increase the soft light. The disadvantage: we're talking about a pretty bulky arrangement here. There are probably two stands, plus a connecting rod to hold the diffusion material, then another stand for the light.

(Continued)

233

Small Light? Large Light? Why Not Both? *(Continued)*

One photographer can manage all of this with practice, but an assistant speeds things up. The photographer moves the pivotal stand holding the diffuser and then tells the assistant where to put the other stand ("No, not quite, six inches closer to the subject. Yes, there!"). Then we have to reposition the light, assuming we have the diffusion material in the right place. Difficult to learn? No. Practice required? Definitely, but the fact that you have read this far into this book probably proves that you are one of those who intends to put the extra effort into your lighting.

Back up the Light behind the Diffusion Material and Then Put a Second Small Light in Front of It

Nearly the same effect as method 1 but more controllable because we can adjust the power of the two lights independently.

Another Approach Is to Use a Beauty Dish

A beauty dish is a metal reflector similar to many other studio strobe reflectors except they are quite large, usually 20 to 30 inches in diameter. The large reflector acts as a soft light; the smaller flash tube acts as a hard light. A few have optional covers for the flash tube for softer light: sort of a beauty dish–soft box combination effect. They require only one stand instead of the three or four needed by the other methods, so one photographer can easily control them. Sounds like a win-win situation, right? Not quite. They do not fold up for travel like an umbrella or a cloth soft box and they are pretty expensive. Still, if you are already well equipped and you do most of your work in the studio, buying a beauty dish may be the next step for you.

On the left we see Farrah illuminated by just the grid spot. Only the bank light was used to make the image on the right. Referring back to Figure 8.38 we see the impact—the additive effect—that resulted when we combined these two very different lights.

Combining Portable Flash with Color Gels

Our lives are filled with color—a fact that we, as photographers, are all well aware. Much of the time our role as photographers is to record these colors just as we see them. In other words, our purpose is to "get the colors right"—that is, to show them as close to reality as we can. We made Figure 8.41, a portrait of our friend, Tony, with that approach in mind.

To make the picture we had in mind, we used three portable strobes of the "hot shoe" variety made by Nikon, Canon, and other manufacturers. Each of these flashes could be controlled wirelessly, either separately or as a group.

8.41 Tony as seen when lit with "normal" colored lights.

Positioned behind Tony, we used his first portable strobe to light the picture's background. We then placed our second strobe to Tony's camera left and used it as a kicker to add the strong highlight visible on that side of Tony's face.

We then set our last light to fire into an umbrella that we placed on Tony's camera right side. From there it lit much of his face and upper torso with a soft, diffused light.

As you can see, this arrangement produced a classic example of a "naturally" or "faithfully" colored portrait—a portrait that shows Tony as close as possible to the way he actually was when this picture was made. And that's fine if that's the image you want. But what if that is not the kind of picture you want to make? What if, instead, you want to make a portrait that is a bit different? What if you want to add something extra or out of the ordinary to the way you light it?

Well, one thing you can try is to add some color to the light you use. And that is what the next two pictures will demonstrate. We will begin

235

with Figure 8.42. We used exactly the same lighting arrangement to shoot it that we did to take the previous "normal" shot of Tony.

This time, however, we taped pieces of amber filter material—or as it is generally known, "gel"—on both our background light and our kicker. And what a difference that made. This image, while made with exactly the same lighting we used before, sends a very different message. And what is it that produced this very big difference between two almost identical portraits? The answer is simple: color—the color produced by the pieces of amber gel we attached to our lights.

Well, now that we have seen Tony in both his normal and amber modes, let us move on to our final example of color in action. Figure 8.43 kicks Tony's portrait up a notch by adding two colors—green and blue—rather than just one.

We used the same three-light setup that we used before to make this image. Only this time we added both green and blue gels to it. To do this, we gelled both our background light and our kicker with green. In addition, we attached a blue gel to the light that fired into our main light. Together, they produced what I think is an interesting, and eye-catching, mixed color effect.

As we showed in the previous three pictures, using colored gels to add colored lights to otherwise "normally" made shots can produce interesting results. And, fortunately, this is not a complex technique to add to your lighting repertoire. It is, however, one that takes some practice. You can never be completely sure what the exact result is going to be when you use even one gel. Use several, and things get even less predictable.

Then there is the question of exposure. Or to put it another way, just how much light must each of my flashes have to pump out to produce the look I want? Obviously, this can range widely depending on such variables as what colors and how many different ones you use.

Lastly, if you plan on using remote devices to control your flashes, there is the mysterious art of getting them to work properly to be mastered. Their manufacturers will assure you this is pure child's play. Well, don't you believe them for one minute! I have witnessed more than one experienced shooter lapse into fits of rage approaching temporary insanity while trying to get a bunch of remotely connected flashes to work together.

And what does all this mean? Simply put, it means that the key to getting colored lights to produce the results you want is experimentation. In other words, shoot test shot after test shot until you get the results you want. This may sound like a truly primitive way of going about things. And perhaps it is. But it works. Some time ago I had the pleasure of watching Joe McNally, one of the most experienced and

8.42 Tony lit using an amber gel.

8.43 Tony lit using both green and blue gels.

237

sought after photographers working today, make some complex, remotely linked, multilight (several of which were gelled) shots.

And how did he do them? Well, he did just what we suggested here. He set up his gear and then started shooting test shots. After each he would adjust something—be it where a light was, how hot its flash was, the color of a gel—until he was happy with the shot. Now, if that is what it takes for one of the world's most accomplished photographers to pull off a complex shot, do not feel bad if you have to do the same!

Portable Flash with Motion

We have followed a different path in the making of this chapter's last picture. Up to this point, the examples we have shown have been a bit on the serious side; a bit formal and buttoned up. That is definitely not the case with the following portrait, a composite image we should probably call "Vance on a Roll."

Lead singer and front man of the infamous rock band The Factory, our friend Vance is blessed with a seemingly limitless store of raw energy. And that is exactly what we wanted to show when we made this multi-image portrait of him doing his action-packed thing (Figure 8.44).

We shot Vance in a tunnel running between rail stations. We picked this location because of its close-together walls, overall "seedy" look, and the varying color temperatures of the different fluorescent fixtures that provided the ambient light in it.

The approach we used for making this portrait is simple enough. That being said, however, it is also an approach to portraiture that is capable of producing an endless array of wildly different results. The equipment we used was also the soul of simplicity—a camera on which we mounted an on-camera flash to which we had attached a small portable diffusion box.

Our shooting technique was equally uncomplicated. We choose an ISO of 160 and experimented with different apertures ranging from f/6.3 to f/11.

When shooting, we asked Vance move in his usual frenetic, rock-and-roll style. As he did, we made multiple exposures, each time using the flash and with our camera set at very low shutter speeds that ranged from a 1/4 to a 1/2 second.

Sometimes we held our camera rock steady. At other times we moved it about in different ways as we shot.

Each time we pressed our shutter release, the flash we had mounted on our camera fired. The very short burst of light from it *froze* that part of Vance on which we were focused.

8.44 We made the four images in this composite portrait by mixing the light from an on-camera flash with the ambient light present where we shot.

However, because of the slow shutter speeds we were using, the camera's shutter *stayed open* for a brief period *after* the flash went off. It was then that our camera's sensor recorded the ambient light from Vance's surroundings. Because of Vance's movement—or because sometimes we purposely moved our camera in different ways while its

239

shutter was still open—this ambient light was recorded as randomly sweeping swirls of mixed colors.

Needless to say, because several factors are involved in this way of shooting, one can never be sure of exactly what the results are going to be. So shoot, shoot, and shoot some more. Experimentation is the name of the game. The more tries one makes, the better the chances are that at least some of them will work.

This method may sound a bit complex, but actually this kind of shooting is easy to learn. So have some fun and try it. When you do, remember just a couple of things: the *flash* (because it is so brief) *freezes* what it is aimed at, and the *slow shutter speed* allows time for the camera's sensor to *record ambient light from the scene*. Together, these two very different light sources can combine to produce some eye-catching images.

AND FINALLY...

The only occasions when the principles of location lighting and studio lighting differ are when a particular lighting is essential to the environment or the event. A child blowing out birthday candles, a firefighter lit by the harsh red light on the engine, and an orchestra conductor in stage lighting are the worst possible examples of good portrait lighting. However, in none of these cases would we improve the portrait with standard studio lighting. When the light is part of the story, we gain more by capitalizing on it than by tampering with it.

Suggestions Yes—"Rules" No

Everything we tell you in this chapter is true. And it all works. However, that does not mean you should follow our suggestions as though they are the only paths to successful portrait making. Far from it. There is not a single technique here that has not been successfully and pleasingly violated at one time or another.

For example, we repeatedly recommend a large light source for portraiture. Using a large light to soften shadows tends to make people look prettier, but this does not mean that large light sources inevitably produce the best portraits. Less flattering lighting can give the appearance of dignity, wisdom, or endurance.

If the individual we are photographing happens to be the person paying for the portrait, we usually want the person to look as attractive as possible. But we are more likely to please a magazine picture editor with a portrait that shows character and emphasizes whatever personal qualities relate to the text.

The size of the light, along with most of the other suggestions we make, is more than a technical decision. Sometimes it is artistic: How does the maker of the image want to represent the subject? Often it is political: Who is the picture intended to please? Always it is a decision to make rather than a law to obey. The approach to lighting presented in this chapter is a basic approach that most photographers will benefit from learning—not a set of rules that every photographer needs to follow.

9

The Extremes

The extremes are the lightest and the darkest groups of grays or colors in the photograph. For years they were the parts of the picture most likely to lack quality because of the inherent, irremediable defects in film. Good photographers managed to get excellent pictures anyway because they paid a lot of attention to these defects and how to minimize them.

The extremes are a potential problem in any photograph, but in a white-on-white or a black-on-black image, pictures composed entirely of the extremes, little defects can turn into big ones.

Digital technology, lacking some of the film defects, has eliminated some of these problems but revealed a new one: some people *like* these "defects." If we shoot a technically perfect picture and reproduce it well, we think it looks dull and unappealing! Thus, we have to reintroduce the classic defects, the ones we always hoped to someday avoid, just to get a picture that *looks* right.

When we talk about what people like and don't like, it sounds as if we are playing to popular taste—stuff that could reverse itself in a year or a generation—but we're not. These likings seem to be hard-wired into the human brain and will not change without a few more hundreds of thousands of years of evolution or, possibly, the surgical implanting of digital eyes and learning to use them. In this chapter we are going to talk about what those defects are, how we reintroduce them into the digital image, and how we minimize the loss in quality.

THE CHARACTERISTIC CURVE

In this book, we generally keep our attention on lighting and stay away from extensive discussion of basic photography. Nevertheless, the *characteristic curve* dictates some of our technique when we light

243

black-on-black or white-on-white subjects, so we have to talk about it. Other writers have explained this material in more detail. You may give this section as much or as little attention as you need, depending on whose books you have already read.

Characteristic curves are used in many technical fields to plot the response of one variable to another. In photography, the characteristic curve is a graph of the way the brightness of a recorded image varies with different amounts of exposure to light. (We are using the nontechnical term *brightness* to mean both the electrical response of the CMOS [complementary metal oxide semiconductor], CCD [charge-coupled device], *and* the density of film.) For simplicity we will talk about grayscale curves. Whatever we say here also applies to color, except that color requires three curves—one each for red, green, and blue (or, for film, cyan, magenta, and yellow).

The Perfect "Curve"

The characteristics curve is a way to compare two grayscales: one representing exposure steps in the scene and the other representing brightness values in the recorded image.

Note that when we talk about characteristic curves, *exposure* means something slightly different from when we talk about making a picture. Photographers shooting pictures talk about exposure as if the whole image received a single uniform exposure—for example, f/8 at 1/60 second. *Exposure* used this way is convenient shorthand for "How I set my camera for this subject under this lighting condition."

But photographers also know that ideally each shade of gray in the scene is represented by a unique value in the recorded picture. Assuming we are not photographing a blank wall, the recorded image is a *group* of exposures that make an image of the grays in the scene. Therefore, when we talk about exposure steps in the characteristic curve, we mean "the whole scene," and not necessarily a large number of recorded pictures with a range of different exposures.

Figure 9.1 shows what might happen when we record a scene containing a grayscale made up of 10 steps. In this graph, the horizontal axis represents exposure steps, the grays in the original scene. The vertical line represents image steps, groups of grays in the recorded image.

Each exposure step is the same length on the graph as any other exposure step. This is no accident. Photographers and scientists who invented the scale deliberately decided to divide the range of possible grays into equal steps. However, the size of corresponding brightness steps in the final image may not be equal to one another. This difference

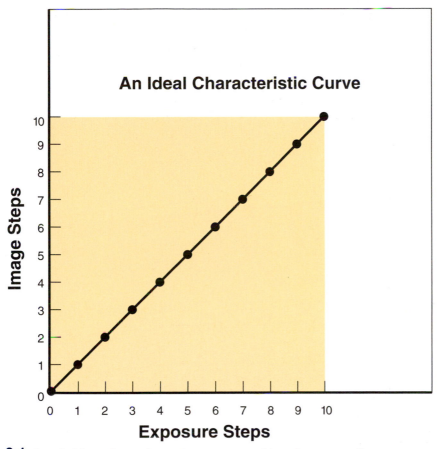

9.1 A perfect "curve": any change in exposure would produce an exactly corresponding change in the recorded image.

in the size of the steps is exactly what the characteristic curve is designed to graph.

The important characteristic of an ideal image is that *all its steps are the same size*. If you measure the length of the vertical line marked "step 2," for example, you will find it to be the same as the length marked "step 5."

This means that *any change in exposure will produce an exactly corresponding change in the brightness of the recorded image*. For example, Figure 9.2 is a graph of the same scene, shot with an ideal digital sensor (or an ideal film) with the exposure increased three stops.

Later, if we decide the image is too light, we can simply darken it. If an ideal digital sensor existed, exposing it would be easy. Any photographer who had any doubt about the ideal exposure could be safe in simply giving more exposure than necessary. The resulting image could, with

245

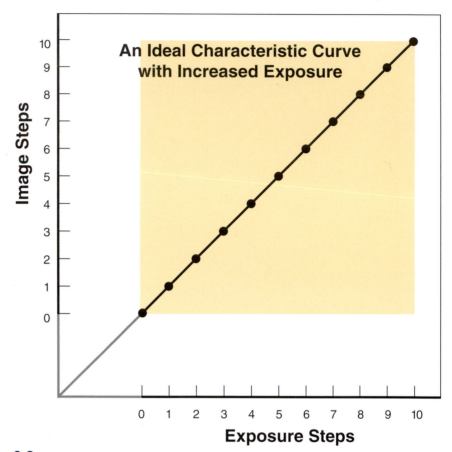

9.2 An ideal curve with exposure increased by three stops. After postproduction correction, it could print the same as the previous one because the relationship of the density steps is the same.

manipulation, produce a print with the same grayscale. (Furthermore, as long as we are talking about ideals, we might as well assume the film grain would be fine also.)

In the real world, however, exposure is a more critical decision. This is because the graph of density steps in a recorded image is not a straight line; it's a curve.

A Bad Camera

Photographers almost never use a diagram of a characteristic curve in their daily work, but they keep a mental image of the shape of a curve with them always because it helps them previsualize how a real scene will appear in the picture. Furthermore, this mental image slightly

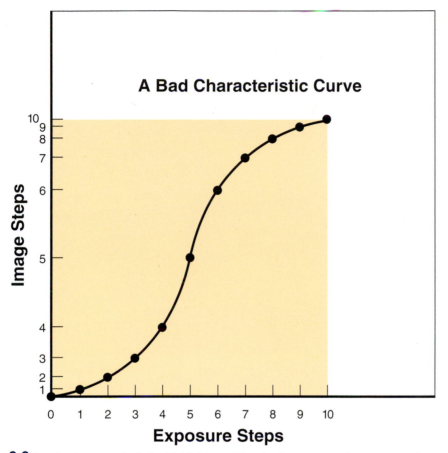

9.3 In a bad camera, both the highlights and the shadows are greatly compressed.

exaggerates the problems found in reality. We will call this exaggerated example a "bad" camera.

Figure 9.3 shows the characteristic curve we would get from a bad camera if we exposed it like the ideal one in the first example. The exposure steps shown on the horizontal line are identical to those in the first graph because we are photographing the same scene, but look what has happened to the recorded brightness on the vertical line.

Steps 1 to 3 occupy very little space on the brightness scale; likewise for steps 8 through 10. The shadows and the highlights have been greatly compressed. *Compression* means that tones that were very different and easy to distinguish in the scene are now very similar and difficult to distinguish in the photograph.

Figure 9.4 is a normally exposed scene. The building wall is largely composed of gray/brown tones, but the late afternoon light gives us a wide range of highlights and shadows to study. Notice that individual

247

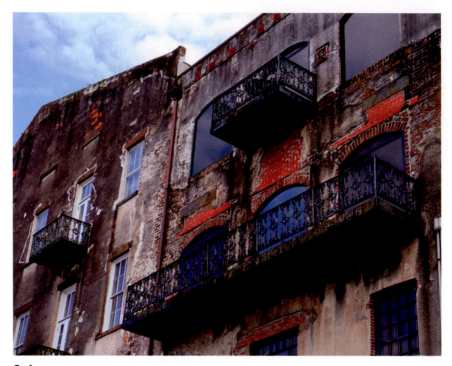

9.4 A scene exposed normally has some compression in both the shadows and the highlights, but the problems are not obvious.

stones are faintly visible in both the highlight and shadow areas of the wall. There is some compression in both those highlights and shadows.

Overexposure

Keep in mind that in an average scene with a normal exposure, compression occurs at *both* extremes of the density grayscale. Changing the general exposure decreases compression at one end of the grayscale, but it worsens the compression at the other extreme. Figure 9.5 shows the benefits and the sacrifices of overexposure.

As we can see, increased exposure eliminates some of the shadow compression. This is good, but the highlight compression is made much worse. Let's see what might happen if we overexpose the earlier building to such a degree.

Figure 9.6 is the result. We see improved shadow detail in the floors of the balconies, but the rest of the picture is much too light. That is only part of the problem, however. We can fix that part by making the image darker in postproduction.

Let's look at a Figure 9.7 to see what would happen if we did that. Now the middle tones are similar to those in the earlier print. However,

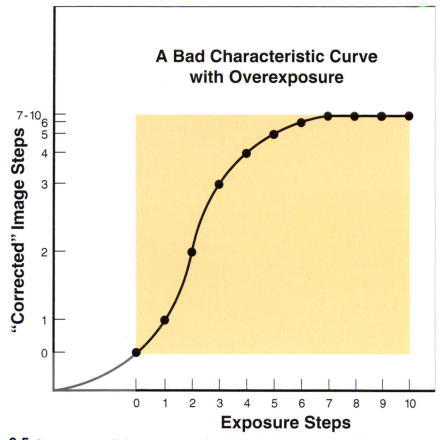

9.5 Overexposure eliminates compression in the shadow tones but at the cost of making the highlight compression much worse.

we cannot remedy the compression caused by overexposing the picture. The distinctions within the building's facade are still not well delineated. Although the highlights are darker in this version, the detail in them is not improved.

Notice, however, that this terrible picture is not without virtue. Overexposure put detail into the deepest shadows that survived, even in the darker print.

Underexposure

If the image is underexposed, we see similar problems with the shadow tones. Figure 9.8 is the characteristic curve for an underexposed picture.

Figure 9.9 is such an image. The highlight steps are better separated. In other words, each step appears more different from the steps above and below it. Whether this technical improvement is more

249

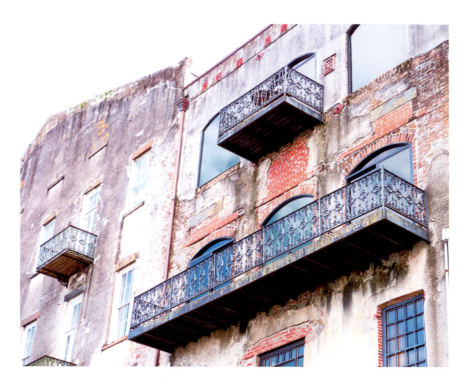

9.6 The same scene, greatly overexposed.

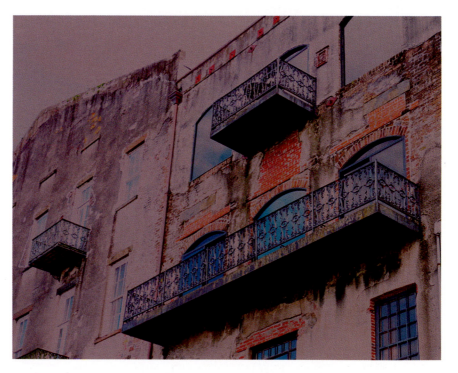

9.7 A "correction" of the overexposed photograph offers little additional distinction between the highlights.

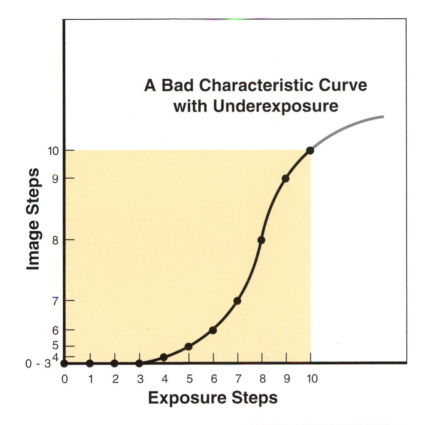

9.8 The characteristic curve that results from underexposure. The shadows are compressed badly.

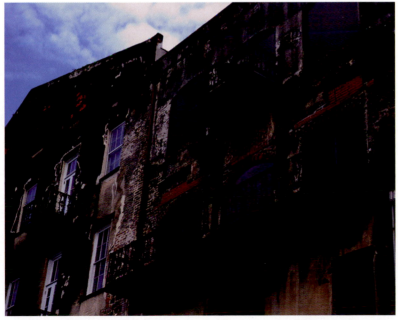

9.9 An underexposure. Many shadow tones, different in the original scene, are now compressed.

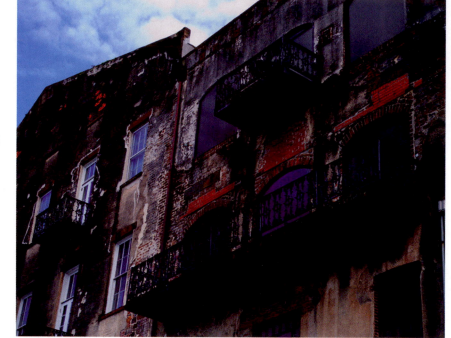

9.10 A lighter print from the underexposed image. Even though the overall scene is lighter, shadow detail has not been restored.

pleasing depends on the particular scene and the opinion of the viewer. In this scene, the highlights in the building's facade are now better differentiated. Of course, no viewer would consider that gain worth the increased compression of the shadow we see here.

Once again, we will try to cure the problem. We've lightened Figure 9.10 in an attempt to recover the shadow detail. As we might have expected when looking at the characteristic curve, the lighter version does not restore the shadow detail. This is because the underexposure has compressed those tones too much for them ever to be salvaged.

A Real Sensor (CCD or CMOS)

The part of the characteristic curve representing the shadow steps is called the toe of the curve. The *toe* of a real characteristic curve is likely to be only slightly straighter than the toe of the bad curve, so shadow compression is almost as bad in a real image sensor.

The part of the characteristic curve representing the highlight steps is the *shoulder* of the curve. Between the toe and the shoulder is the *straight line*. The straight line of a real characteristic curve is longer than that of bad digital sensor (either CCD or CMOS). Therefore, the shoulder occurs at higher density ranges than the important highlights in some scenes. Highlight compression is less of a problem in a real sensor than in a bad sensor.

Real films were compromises between our imaginary ideal ones and our imaginary bad ones. The flattening of the characteristic curve shoulder reduced highlight detail but didn't eliminate it entirely. Within very wide ranges, short of, say, brightness of a thermonuclear detonation, the negative had at least *some* differentiation of the very light grays. With extra work, a print could be made that showed that differentiation, even if it did that badly!

The real sensor has an additional disadvantage that film didn't. The curve simply *ends* at the top. Photographers tend to routinely overexpose, whether shooting film or shooting digitally; although it may not be a virtue, it's still a fact. Photographers shooting film do so because it's "safe." Highlight loss is easier to compensate than shadow loss. Photographers shooting digitally do so to keep as much if the image as possible out of the "noisy" lower ranges. Digital photographers cannot overexpose nearly as much, however, because of the abrupt loss of detail at the top of the curve.

USING EVERY RESOURCE

The difficulties of white-on-white and black-on-black subjects are not caused by just the subjects themselves. The problems are related to the very basics of the photographic medium: scenes get recorded on those portions of the characteristic curve that preserve the least detail. This means that no single technique, or even group of techniques, is always adequate to deal with such subjects.

White on white and black on black require complete command of all types of photographic techniques. The two most essential sets of these techniques are lighting and exposure control. These two work together to produce each picture. The relative importance of each varies from one scene to another. We sometimes think primarily about exposure control and in other situations use lighting techniques as the primary tool. The remainder of this chapter discusses both and suggests guidelines about when to use which tool.

WHITE ON WHITE

White subjects on a white background can be both practical and appealing. In advertising, such subjects give designers maximum flexibility in the composition of the piece. Type can go anywhere, even over an unimportant part of the subject itself. Black type on a white background is likely to survive even poor reproduction in a newspaper. Furthermore, photographers do not have to worry as much about making the crop fit the available space. If the picture is reproduced to keep the background pure white, readers cannot see in the ad where the edge of the print might have been relative to the subject.

253

Grain

Some photographers still shoot film, for very good reasons. Even after technology renders film truly obsolete, some photographers will probably still shoot film just to be different, like those few who still print on 19th-century emulsions. You can overexpose negative film to be safe, but we need to warn you that overexposure increases grain.

The two factors that most affect grain size are the sensitivity of the film to light and the density of the image. We usually choose the slowest film that allows an acceptable aperture and shutter speed. After that, we minimize grain by paying attention to density.

The denser the image is, the coarser the grain size is. It makes very little difference whether a density increase is caused by an exposure increase or a development increase. The effect on the grain is similar.

This means that the grain is not uniform throughout the scene. The highlight area has more grain than the shadow area because of the density difference. This fact surprises some photographers, especially those whose negatives are consistent enough to print with very little manipulation.

The denser areas in most negatives produce light gray or white in the print. The grain is coarse in those areas, but it is too light to see. Highlight grain is also concealed in a print by further highlight compression inherent in the characteristic curve of the paper itself.

Suppose, however, that the highlight detail is not adequate with a normal printing exposure. Depending on the scene, most photographers remedy the problem by increasing either the general printing exposure or the exposure just in the problem area (a "burn"). This makes some of the highlight steps print as if they were middle steps. Printing the denser gray steps as middle steps reveals the coarsest grain in the negative.

Highlight compression in the negative is not as bad as shadow compression, but the defect is compounded by increased grain. The resulting effect on image quality can be even worse.

For many years, good photographers realized that black-and-white film, printed with modern enlargers, needed about 20% less development than the film data sheets told them, and they got much less grain with the reduced development. Photographers shooting color negative film, however, were pretty well stuck with standardized development times because reducing development hurt the color badly. Those photographers owe a lot to the former president of the Professional Photographers of America, Frank Cricchio, who, before he started shooting digitally, worked out an exposure system for color negative film that guaranteed adequate exposure without overexposure. He proved his system by making much larger prints than other photographers, with better sharpness.

Raw

For at least a century photographers regretted that S-shaped characteristic curve and wished the filmmakers could get it straight. They saw the loss of highlight and shadow detail in those parts of the curve and rightly thought that detail could be improved by a linear curve. Now, with digital photography replacing film, we have our wish, but it turns out that it has its own shortcomings.

The Raw file format offered by digital cameras straightens the curve and keeps the highlight and shadow detail that used to be lost *if* we do not overexpose or underexpose the scene. The trouble, now that we can actually see such a picture, is that it looks flat. We *like* to see more contrast in the middle tones and we're willing to sacrifice a bit of highlight and shadow detail to get it. So it appears we will have to keep those photographic defects until, possibly, a major and unlikely change in human psychology.

The advantage of Raw is that we get to keep the detail until postproduction and make judgments about what detail we need to sacrifice to make the picture look right. Raw is often called

"the digital negative" because photographers can make some of the same decisions they used to make in the darkroom. Like a negative, a Raw file also gives the photographer the freedom to change his or her mind, tomorrow or next year, and use the Raw file to make a new, wholly different TIFF or JPEG than whatever he or she first liked.

The disadvantage of Raw is that every camera maker defines it differently and keeps that definition a secret. This potentially makes the Raw format hostage to the camera makers' proprietary software. That's a huge problem. You or I could print Matthew Brady's negatives today, maybe better than he did, but if the Raw software to interpret today's digital file doesn't exist in another 150 years, what will our descendents do with our digital negatives?

It's interesting to go to the U.S. National Archives to look at pictures shot by Edward Steichen when he was a Navy photographer during World War II. The government owns the negatives and generally makes much worse prints than he did. But once in a while a government lab technician makes a better print than he did. Old film can reveal new information.

Some feel that a better solution to proprietary Raw is Adobe's Digital Negative Format (DNG). It's an open, nonsecret standard, likely to survive history's forgetfulness. It preserves the advantages of Raw, but anyone with software savvy, including those using whatever computers we'll have in 150 years, can read it and interpret it. Some camera makers have made their Raw formats compatible with DNG but, alas, too few.

Unfortunately, white-on-white subjects are also among the most difficult of all scenes to photograph. A "normally" exposed white-on-white subject is recorded on the worst portion of the usable characteristic curve. Lesser contrast in that portion of the curve causes compression of that part of the grayscale. Gray steps that were distinctly different in the scene can become similar or identical grays in the photograph.

White subjects on white backgrounds also largely deprive us of the use of one of our favorite lighting ingredients: direct reflection. We have seen in earlier chapters that balancing direct and diffuse reflection can reveal detail that might otherwise disappear. Direct reflection is especially controllable by polarizing filters on light sources or lenses.

White-on-white scenes generally have as much direct reflection as any other scene, but the diffuse reflection is usually bright enough to overpower the direct reflection. With so much competition from diffuse reflection, the camera cannot see much direct reflection, and photographers accomplish little by trying to manipulate it.

However, we will accomplish even less by continuing to complain about the problems. So we will go on to a discussion of how to deal with them.

Good lighting control produces tonal distinctions in white-on-white subjects. Good exposure control preserves those distinctions. Neither control alone is adequate to do the job. We will discuss both.

Exposing White-on-White Scenes

The extremely high and extremely lowest ranges of the characteristic curve are those areas where we are most likely to lose detail. Reducing the exposure of a white-on-white scene puts the exposure in the middle of the characteristic curve. Doing this may make the scene look too dark, but we can fix it later. The worst thing that can happen is that we fix a picture so that it has the same loss it would have had with a normal exposure, and that's not too bad. The other thing that can happen is that we find we can get more highlight detail, and that's a very good thing. Keep in mind that the loss of shadow detail that comes from underexposure of a normal scene is nothing to fear here because the shadow area of a white-on-white scene is pretty light. How much can we reduce exposure without getting into other trouble?

Following are some definitions we will be using. We will consider a *normal* exposure to be a reflected light reading from an 18% gray card or an incident light reading. We will further assume that *standard* reproduction renders that card as exactly 18% reflectance in the printed image. Finally, we will consider *reduced* exposure and *increased* exposure to be deliberate deviation from the normal. This differentiates them from accidental underexposure and overexposure.

A typical white diffuse reflection is about 2½ stops brighter than an 18% gray card seen under the same light. This means that if we meter a white subject, instead of a gray card, we need to increase exposure by 2½ stops more than the meter indicates to get a normal exposure.

Suppose, however, we fail to make that 2½-stop correction and expose exactly as the meter suggests. This means that the same white will reproduce as 18% gray with a standard printing exposure. This is much too dark. Viewers will almost never accept 18% gray as "white." Such an exposure does have its advantages, though: it places the white subject on the straight-line portion of the characteristic curve.

However, we are under no obligation to use standard reproduction. We can reproduce the image as light as we need so that the resulting image is an appropriately light gray that viewers will call "white." Once we move the image up the tonal scale and convert it from Raw to a standard file format, we get the expected highlight compression.

So if we're getting the highlight compression anyway, why not shoot it normally and let the compression happen from the beginning? We should not do so for two reasons: (1) the reduced exposure reserves more choices for later, and (2) the digital sensor does not have a perfectly linear response; it also has a characteristic curve with a shoulder, albeit slight. Reduced exposure keeps the hard-to-hold detail away from that shoulder.

Reducing the exposure of white-on-white subjects by 2½ stops is the *minimum* exposure we are ever likely to use. Try it for scenes that have very, very bright whites. The way to do this is to use the exposure indicated by a reflection meter and ignore the routine correction.

Photographers who have thoroughly mastered metering techniques may be offended by our suggestion to just point the meter and read, then do what the meter says, without any calculation or compensation. They ought to be! We would be completely irresponsible to make such a recommendation if we did not go on to warn you about secondary black subjects and transparencies.

Using the uncorrected exposure indicated by the reflection meter works fine if the scene is composed entirely of light grays. If an additional black subject is in the scene, however, that part of the scene will lack shadow detail.

Whether this lack of detail is a problem depends entirely on what the subject is in the specific scene. If the black subject is unimportant and if it is too small to advertise the defect, then the lack of shadow detail will not be objectionable.

However, if the significance or the size of the secondary black subject commands the viewer's attention, the defect will also be apparent. In such a case, it would be better to use a normal exposure instead of a reduced one. "Importance" is a psychological judgment, not a technical one. It is entirely reasonable to decide to reduce the exposure for one white-on-white scene but to use a normal exposure for another technically identical scene.

If we consider the possible errors and accept the reflection meter reading of a white-on-white scene without compensation, then that is a deliberate decision to reduce exposure. If we use the exposure that we read on the meter without thinking about the dangers, the result may be accidental underexposure.

Realize that being free to use less exposure in a white-on-white scene also allows using a slower ISO. Deciding to reduce exposure by 2½ stops means that we can use the same aperture and shutter speed for ISO 32 as those for an ISO 180 exposed normally.

Lighting White-on-White Scenes

Lighting a white-on-white scene requires enhancing both texture and depth, like the lighting of any other scene. We can do this with the same techniques we used in Chapters 4 and 5. The other special requirement of white-on-white scenes is to keep all parts of the subject from disappearing!

The easiest way to obtain a true "white-on-white" scene is to simply "print" a blank piece of paper. Of course, photographers do not really mean "white on white" when they use the term. Instead, they mean "very light gray on very light gray, with some whites in the scene."

We have talked about why these similar light tones tend to become the same tone in a photograph. Good exposure control minimizes this problem. But a light gray still disappears against an identical light gray. The only way to keep such a subject visible is to make one of those grays lighter or darker. This is what lighting does.

Subject and Background

The most important grays to distinguish are those of the subject and its background. Without this separation, the viewer cannot see the shape of the subject. A viewer may never notice the loss of minor detail within the subject, but a lost edge is readily apparent.

We can light either the background or the edge of the subject so that it reproduces as white (or very light gray) in the photograph. Once we decide which of these is to be white, we know that the other must be at least slightly darker. Technically, it does not matter whether the main subject or the background is slightly darker. Either way preserves tonal distinction.

Psychologically, however, it matters a lot whether the background or the subject is white. Figure 9.11 shows a white subject against a white background. We have lit the scene to render the background white and the subject light gray. When you look at the picture, your brain interprets the scene as white on white.

However, the brain is less willing to accept a gray background as a white one. Look at Figure 9.12. We have relit the scene to render the background light gray and the subject white. You no longer see a white-on-white scene; you see a white-on-gray one.

Figure 9.12 is not a bad picture. It still has good tonal distinction between the subject and the background, and it is pleasing in every other way. You may prefer the lighting, and we have no reason to discourage it. We are simply saying that it is not a good white-on-white example.

Because this section is about white on white, we will keep the background white, or nearly so, in all remaining examples. In these examples, the background needs to be between ½ stop and 1 stop brighter than grays in the edges of the primary subject. If it is less than ½ stop brighter, part of the subject may disappear; if it is more than 1 stop brighter, flare may scatter enough light inside the camera to cost contrast in the subject.

9.11 The background looks white and the Bach bust looks to be a light gray. The brain interprets such a scene as white on white.

9.12 The background is now a light gray and the bust appears white. The brain now interprets the visual message as white on gray rather than white on white.

9.13 One good lighting arrangement for a white-on-white subject.

Using an Opaque White Background

The easiest white-on-white subjects are those that allow separate control over the lighting of the primary subject and its background. In those cases, we can slightly increase the light on the background to keep it white. Putting the subject directly on a white opaque background is the most difficult white-on-white arrangement because whatever we do to one also affects the other. This is also the most common arrangement, so we will deal with it first. Figure 9.13 illustrates the process.

Light the Subject from Above

Lighting from above places the front of the subject slightly in shadow but fully illuminates the tabletop. This readily establishes the gray subject and white background we want. In most cases, the camera sees good distinction between the sides of the subject and the background without any further adjustments. Figure 9.14 is the result.

9.14 There is good differentiation between side edges of the Bach bust and the background. However, the top of the head has vanished.

Notice, however, that such an arrangement also fully illuminates the top of the subject. The loss of tonal distinction in that area means we have to do some more work before exposing.

Use a Gobo above the Subject

This step is almost always necessary. We place the gobo to cast just enough shadow on the top of the subject to bring its brightness down to a level similar to that of the front. You can see the improvement in Figure 9.15.

You may have been surprised that we did not discuss the size of the light in the previous step. As far as the subject is concerned, you can use a light of whatever size that looks good. However, we recommend a medium-sized light because it is likely to work most effectively with the gobo in this step.

261

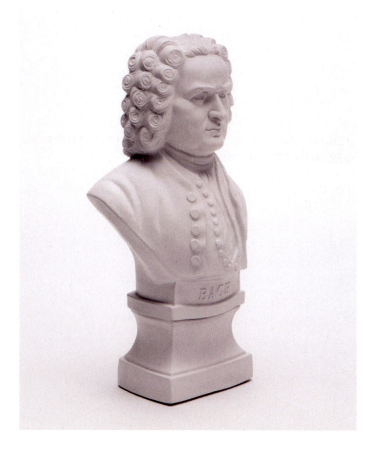

9.15 A gobo blocking light from the bust's head takes care of the problem we saw in the previous picture. The top of the head is now clearly visible.

The hardness of the shadow cast by the gobo is usually more critical than that of the subject. If the light is too small, we may not be able to get the shadow of the gobo soft enough to blend with the rest of the scene. A light that is too large may keep that shadow too soft to effectively shade the subject. Using a medium-sized light from the beginning reserves the privilege of experimenting with the gobo later.

If you have not done this before, you may not know how large the gobo should be or how far it should be from the subject. These factors vary with the subject, so we cannot give you formulas. We can, however, tell you how to decide for yourself. Begin with a gobo about the size of the offending highlight. For ease of movement, hold it in your hand while experimenting. You can alter the size of the gobo and clamp it appropriately when you fine-tune the setup later.

The closer the gobo is to the subject, the harder the shadow of the gobo becomes. Move the gobo closer to the subject, then farther away, to see this happen. The edge of the shadow of the gobo needs to blend nicely with the edge of the highlight we need to conceal.

The shadow of the gobo may become too light as you move it farther from the subject. If this happens, try a larger gobo. Conversely, if the shadow of the gobo blends well but is too dark, cut the gobo smaller.

Finally, when the gobo position is right for the primary subject, look at its effect on the background. The gobo will also cast a shadow there. On most subjects, the shadow the gobo casts on the background will blend nicely with that of the subject and will not be noticeable. The gobo shadow will be softer on the background than on the top of the subject because the background is farther away from the gobo than the subject is.

If the subject is tall enough, the gobo may produce no perceptible shadow on the background at all. There will be a problem, however, with very shallow subjects. In an extreme case, such as a white business card on a white table, it is impossible to put a shadow on the card without shading the background equally. In those situations, we must either use one of the other backgrounds discussed later in this chapter or resort to masking or retouching after the photograph is completed.

Add Dimension

The white background on which the subject sits will provide a great deal of fill light. Unfortunately, this fill illumination will usually be too even to give the picture a good sense of dimension. Figure 9.15 is technically acceptable because the subject is reasonably well defined, but the bland uniformity of the grays makes it boring.

If the subject is very much darker than the background, we need to add a reflector to one side. This adds both fill and dimension. More often, white-on-white subjects are only slightly darker than the background, and we dare not further brighten them with fill. Instead, we usually add a black card, again to one side. This blocks some of the light reflecting from the background and produces a shadowed side to the subject. Figure 9.16 has a black card on the left, just out of camera range.

Using a Translucent White Background

If the shape of the subject is very flat, there is no way to shadow it without doing the same to the background on which it sits. One good solution to this problem is to use a translucent background that can be lit from behind. White acrylic is good for this purpose. As long as the subject is reasonably opaque, we can light the background to whatever brightness we please without affecting the subject. Figure 9.17 shows the lighting diagram.

Figure 9.18 applies this technique. The subject is well differentiated from the background. Notice, however, that the illumination under the subject has erased any hint of a ground shadow.

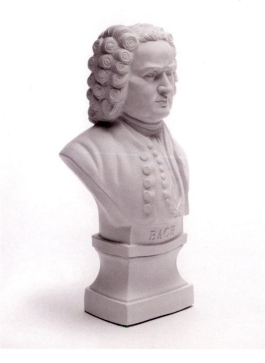

9.16 A black card on the left reduced the fill reflected from the tabletop, creating a sense of depth.

9.17 A translucent background photographs whiter than a white subject.

Main Light

Reflector

Translucent Background

Background Light

9.18 Light from under the flower eliminated any hint of a ground shadow in the print.

After looking at this picture, we might be inclined to avoid this setup any time we want to preserve a shadow under the subject. Should we avoid it? Absolutely not. One of the single biggest advantages to this technique is that it allows us to control the apparent shadow of the subject completely independently of the lighting of the subject. Here's how.

Begin by turning off any lights we intend to use to photograph the subject. Next, set up a test light to produce a pleasing shadow. It doesn't matter whether this light is good for the subject because we will not use this light to shoot the picture. We intend to use the light to trace a pattern (as we did for the family of angles in Chapter 6 and the reflector behind the glass of liquid in Chapter 8).

265

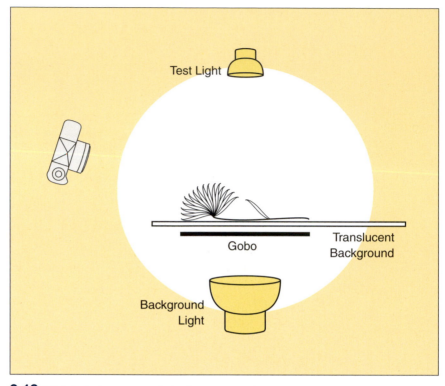

9.19 Manufacturing a ground shadow.

Next, slide any opaque or semi-opaque paper under the subject. (If you move the subject in the process, don't worry. Critical positioning is unnecessary at this time.) Trace the shadow pattern on the paper with a pencil. Then remove the opaque paper and cut out the shadow pattern. The final step is to glue the shadow pattern *under* the translucent background, as shown in Figure 9.19.

Now you can turn off the test light and light the subject in any manner you please. Figure 9.20 is the finished picture. The shadows under the blossom and stem were not cast by the light illuminating the subject. However, it certainly looks like it.

Using a Mirror Background

Probably the easiest "white" background to use is a mirror. A mirror reflects almost nothing but direct reflections. These reflections are likely to be much brighter than the diffuse reflections from a white subject.

We begin the arrangement with a light large enough to fill the family of angles that produces direct reflections on the entire mirror surface. (We determine where that family is exactly as we did with the flat metal in Chapter 6. You can look back at that section if you need a lighting

9.20 A gobo was placed under the table to produce a shadow that looks as though it was cast by the flower.

diagram.) Because the light source must fill the family of angles defined by the entire background, this may turn out to be the largest light we will ever need for a flat subject.

The other special requirement for the light source is that it show no distracting texture. Remember that the light itself will be visibly and sharply reflected in the mirror.

No additional steps were needed to produce Figure 9.21. A light so large usually produces shadows so soft that no other light is required for fill. Furthermore, this is one of the few techniques in which the background can reflect much fill light *under* the subject.

An occasional drawback to this technique is the reflection of the subject. It may be confusing, depending on the crop and on the shape of the subject. If the subject is appropriate, try misting the tabletop with water to camouflage and break up that reflection.

267

9.21 A mirror reflecting the light source is another background that is "whiter" than the "white" flower.

The other possible complaint is the lack of ground shadow. There is no way to obtain one with this setup. If you feel the shadow is necessary for your subject, then some other arrangement will be better.

In Any Case, Keep the Background Small

We have explained why direct reflections are usually not very important to white subjects. The few we see generally add a bit of dimension, but compared with the diffuse reflections, they tend to be too weak to be major players in the lighting event.

The exception to this is direct reflection on the edge of the subject. Direct reflection in those areas is especially likely to make the subject disappear against the white background. To make matters worse, the white backgrounds in all of these arrangements are in exactly the position most likely to cause these reflections.

The most common solution is the same as the technique for keeping reflection off the edge of the glass in the bright-field method, as discussed in Chapter 7: keep the background as small as possible. Sometimes our background is much larger than the area the camera sees, and we do not want to cut it. In those situations, we either confine the light to the image area or surround the image area with black cards.

Another danger of white-on-white situations is camera flare. Large white backgrounds scatter a lot of light inside the camera. This flare will probably be so uniform that you will not see it, even when the general loss of contrast is significant. However, if you stay in the habit of keeping the white background only as large as it needs to be, you will not need to worry about the flare.

BLACK ON BLACK

Mastering white on white is a good step forward in the process of mastering black on black. Many of the principles are similar but applied in reverse. We will point out some of these similarities, but we will emphasize the differences.

The major difference in exposure considerations is not recording in the camera's noise range. The major difference in lighting considerations is the increased visibility of direct reflection.

Exposing Black-on-Black Scenes

The section on the characteristic curve pointed out the compression of gray steps in both the shadow and the highlight steps. This happens whenever we shoot a JPEG, and it happens whenever we convert an image from Raw to any other conventional format. We also saw why overexposure exaggerates this problem in white-on-white scenes and why underexposure exaggerates it in black-on-black scenes.

The problem is somewhat worse in the shadow steps as a result of digital noise. These random, minute speckles may be unnoticeable in a normal scene with no large dark areas but apparent in black on black. The severity of the problem depends on the quality of the camera, but for now at least we see it to some extent in all cameras. So we increase the exposure of a black-on-black scene to move it closer to the middle grays, even if we know we're going to darken it back down later in post-production.

The most extreme amount that we might use to modify the exposure is similar to white on white, 2½ stops, except that, because of noise, we're more likely to actually go to that extreme here. This means we expose that much more than what a gray card reflection reading or an incident reading tells us. Or we can accomplish about the same thing by simply

269

pointing a reflection meter at the subject and exposing as it says, without any compensation.

This is a satisfactory shortcut to more sophisticated metering techniques if we remember the potential problems it can create. These, too, are similar to those for white-on-white subjects.

This method will, of course, overexpose any secondary light-gray subjects in the same scene. Therefore, it's applicable only when the scene truly approximates black on black.

Lighting Black-on-Black Scenes

Black-on-black scenes require special attention to exposure to record as much detail as possible. However, increasing the exposure of a black-on-black scene works only if there are no secondary white subjects in danger of overexposure.

Even without any white subjects, increased exposure of a black-on-black scene sometimes does not *look* right, even if it records more detail than a normal exposure. Although good exposure is essential, it is not enough. The manipulation of exposure and lighting helps one another to record the scene well. Now we will look at the lighting principles and techniques.

Like "white on white," "black on black" is an accurate description of a scene only when we acknowledge it to be an abbreviation for a longer description. A better description would be "a scene composed mostly of dark grays but with some blacks in it also."

Like all scenes, lighting black-on-black scenes requires that we reveal depth, shape, and texture. Just as with white-on-white scenes, the lighting of black-on-black scenes needs to move some of the exposure steps in the scene to the middle of the density scale. This is how we overcome the tendency for very light or very dark similar tones to become identical in a photograph.

White-on-white scenes produce a great deal of diffuse reflection; this is what makes them white. Conversely, black subjects are black because of their lack of diffuse reflection. This difference in diffuse reflection is important mainly because of what it implies about direct reflection.

The greatest single difference between lighting black-on-black and white-on-white scenes is that most black-on-black scenes allow us the full use of direct reflection. White subjects do not necessarily produce less direct reflection. Instead, whatever direct reflection a white thing does produce is less noticeable because the diffuse reflection is so much brighter by comparison. By the same token, black things do not produce any more direct reflection. However, the direct reflection they do produce

is more visible because those reflections have less competition from diffuse reflections.

Thus, the rule of thumb for lighting most black-on-black scenes is to capitalize on direct reflection whenever possible. If you have mastered lighting metal, you know that we usually do the same for those cases. (Direct reflection makes the metal bright. We rarely want to photograph it to appear dark.) Therefore, another good rule for black on black is to light it as if it were metal, regardless of the actual material.

Generally, this means finding the family of angles that produces direct reflection and filling that family of angles with a light source or sources. (Chapter 6 describes how to do this.) We will talk about specifics during the remainder of this chapter.

Subject and Background

We can only photograph a scene composed of grays, not a truly black-on-black one. This means that either the subject or the background needs to be dark gray, not black, to keep the subject from disappearing.

Figure 9.22 is a black subject on a black background. Notice that we have lit it so that the background is absolutely black. Doing this meant that we also had to keep the subject from being absolute black. Rendering the subject as a dark or middle gray keeps it distinct from the background and preserves its shape.

A black subject on a dark gray background could maintain the same distinction. In either case, there is enough difference between the subject and the background to keep the subject from disappearing. However, illuminating the background causes additional problems. Figure 9.23 shows them.

The background no longer looks black. We are psychologically willing to accept a dark gray subject as black, but we cannot accept a dark gray background as black. This is almost always true for simple scenes that do not give the brain many other clues to decide how the original scene looked. The same is also true for many complex scenes.

This correlates with the earlier principle that human brains consider most scenes to be white on white only when the background is pure, or nearly pure, white. It also suggests similar action. If you just want to differentiate the subject from the background, keep either one of them black and make the other one gray. However, if you want to successfully represent "black on black," make sure the background is as black as possible.

9.22 The brain interprets a gray subject, such as this pot, against a black background as a black-on-black scene.

9.23 The subject is black, and the background is dark gray. The brain no longer accepts the scene as black on black.

You will see that this opinion influences almost every technique we are going to suggest. There is only one exception, and we will talk about that next.

Using an Opaque Black Background

Putting a black subject on an opaque black background is usually one of the worst ways of creating a black-on-black scene. We discuss it first because it is often the most available solution. Most studio photographers have black seamless paper handy.

Figure 9.24 shows the problem. (The lighting is a large overhead source like that used for a box in Chapter 5.) The paper background directly under the subject receives as much illumination as the subject itself. There is no easy way to light the subject any brighter than the background. We know that we need to render the subject dark gray, not black, to preserve detail. However, if the subject is not black, then the background under it cannot be black either.

We could use a spotlight to concentrate the light on the primary subject, thus keeping the background darker. Remember, however, we want to produce as much direct reflection on the subject as possible. This requires a large light source to fill the family of angles that does that. Using large lights generally means using no spotlights.

9.24 The black paper cannot be exposed dark enough to render it black if the flashlight is properly exposed.

273

We could also hope that a lot of the reflection from the background is polarized direct reflection. Then we could use a polarizing filter on the camera lens to block that reflection and keep the background black. Sometimes this works, but in most of those scenes the direct reflection from the subject is also polarized. Unfortunately, the polarizer is likely to darken the subject at least as much as it darkens the background.

The best solution is to find a background material that produces less diffuse reflection than the subject. Black velvet serves this purpose for most subjects. Figure 9.25 is the earlier subject photographed with the same lighting and the same exposure but with black velvet replacing the paper.

There are two possible problems to the black velvet solution. A few subjects are so black that even the velvet will not be blacker than they are. A more common problem is that the edges of the black subject merge with their own shadow, and we see some of that in this picture. Whether the loss is acceptable is a judgment call and will differ from one picture to another, but we'll assume it's unacceptable here because we want to talk about how to deal with it. Fill light does not help much. Remember that the subject does not produce significant diffuse reflection, and the only place from which a light can produce direct reflection on the edges of the subject is located within the image area.

9.25 With the same exposure, the black velvet is much darker than the black paper used in Figure 9.24.

Notice that this problem is similar to the one presented by the metal box shown in Chapter 6. We solved that problem with invisible light. Unfortunately, we cannot reflect very much light, invisible or not, from black velvet. That requires a glossy surface.

Using a Glossy Black Surface

In Figure 9.26 we substituted a black acrylic surface for the black velvet. Then we bounced a little invisible light from the glossy surface to fill in the sides of the subject. This works for almost any black subject. Or does it? Notice that the large light above the subject also fills the family of angles that produces direct reflection on the glossy acrylic. Therefore, the background is no longer black. Because you saw that so quickly, you probably also remember that we said earlier that the background had to stay black.

We would like to talk our way out of this apparent discrepancy by pointing out that the brain needs to see a black background in *simple* black-on-black scenes. The subject, background, and *reflection* of the subject add up to a more complex scene. We maintain that the black reflection under the subject is a sufficient visual clue to tell the brain that the surface is black but glossy and reflecting light. So this is still a black-on-black scene!

9.26 A black acrylic background. Notice the sharply outlined reflection of the flashlight. Is the scene black on black?

This argument ought to convince most readers to let us get by with the gray background, but a few of you will be less charitable and insist that we keep our original commitment. We will do so with the next solution.

Keep the Subject away from the Background

Suppose we place the subject far enough from the background that the lighting of the subject has no effect on the background. We can then light the subject any way we please and the background will remain black.

This is easy if we crop the bottom of the subject out of the picture. In Figure 9.27 the model hand is on a pedestal several feet from the background. This allows us to light the hand well with almost no light on the background. However, if the entire subject has to show, we have to support it with trickery.

Amateurs assume professional photographers do this with string. Sometimes we do, but too often the string needs to be retouched.

9.27 The subject is several feet from the background. This makes it easy to light without light falling on the background.

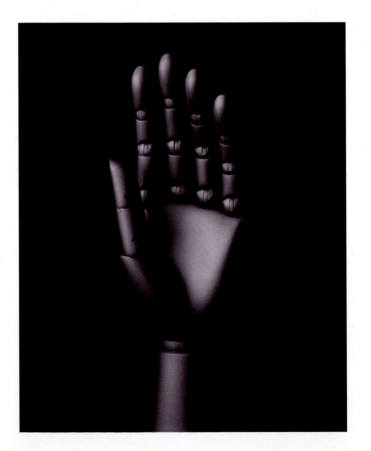

(String might *occasionally* escape undetected in a brief motion picture or video shot, but it is likely to be apparent in a high-quality still.) Retouching a black background is usually not difficult. However, doing no retouching at all is even better, so we will suggest some other ways.

In Chapter 6 we invisibly supported the metal box on a sheet of glass. Then we had to use a polarizing filter to remove the polarized direct reflection from the glass surface. This did not affect the metal because direct reflection from metal is rarely polarized.

The glass table will not work for most black subjects. Much of the direct reflection from a black subject is likely to be polarized. If we use a polarizing filter to take the reflection off our table surface, we will probably turn the subject black too.

THE HISTOGRAM

A chapter on black on black and white on white requires more talk about the technology of photography than any other. This makes it a good place to talk about the histogram. We will close with that.

Many photographers first encountered the histogram in Adobe Photoshop (Image > Adjust > Levels gets you there). After learning to use histograms, many of us decided this was a much more straightforward method of image control than any technology in traditional photography. Now many digital cameras have brought the histogram into traditional photography. (Is a digital camera traditional photography? We maintain that it certainly can be.)

Many cameras display a histogram of the scene we are about to shoot and allow us to make Photoshop-like corrections *before* we shoot. None of the digital camera makers has yet implemented the histogram as elegantly as Adobe, but presumably they will get there.

Conceptually speaking, histograms are simple enough. They are nothing more than graphs—and quite simple ones at that. However, once you learn how to interpret them—how to decode the information they contain—histograms become extraordinarily useful tools. The truth is that in today's digital world, an understanding of histograms is so important no photographer can afford to be without it.

A histogram is made up of lines. Each line represents the number of pixels the image contains for each of the 256 values that constitute the gray tonal scale from the blackest black to the whitest white.

If we are shooting color, usually the case when we are shooting digitally, the basic histogram is a composite of three histograms: one each for red, green, and blue. If we need to make color adjustments, we can select the histogram for a single color and manipulate it alone.

277

For now, however, we will ignore that and assume we are shooting a black-and-white photograph as we do in most of the rest of this book. It's just simpler to talk about and simpler to understand that way.

Look at Figure 9.28. It is a typical histogram, and it represents information about the photograph we saw earlier in Figure 9.27. Put another way, we can say that Figure 9.28 is a graph showing the number of pixels at each of the many different brightness levels that make up Figure 9.27.

The y-axis at the far left of the graph shows the number of pixels, and the x-axis along the bottom shows their brightness, or where they fit into the picture's overall tonal range. The darkest pixels are on the histogram's left side. The lightest are on the right, and the middle-gray tones are in the middle. When we put all this pixel information together, we end up with a graph that shows us what tonal values are present in a picture and how they are distributed throughout it.

To translate this into the language of grayscale values, we can say that the blackest of blacks at the histogram's far left has a tonal value of 0. The whitest of whites has a tonal value of 255, and the middle gray has a tonal value of 128. For those familiar with the Zone system, the far left of a histogram corresponds to the "0" Zone. The middle gray corresponds to Zone V, and the far right corresponds to Zone X.

9.28 The histogram shows how much of each grayscale or color value exists in the scene.

Earlier we told you there were 256 shades of gray from black to white. Now we tell you the highest number on the scale is only 255. This is not a typo: the zero counts as a color also.

Because this is a histogram of a black-on-black scene, it shows no white or light grays. Notice that the lightest pixel in the scene is about 218 or 220, not 255. Similarly, a white-on-white scene would have very few pixels at the left side of the graph.

Preventing Problems

We can also look at this histogram and tell that the picture has probably been manipulated. Look at the gaps in the histogram at brightness levels of about 93, 110, and 124 and in four other places. Such gaps are rare in scenes we photograph and they usually indicate data lost through subsequent manipulation. In this case, the loss is minor. Overmanipulation, however, can lead to severe problems.

Suppose we had decided that Figure 9.27 was too dark and then lightened it. Figure 9.29 is the result and Figure 9.30 is its histogram.

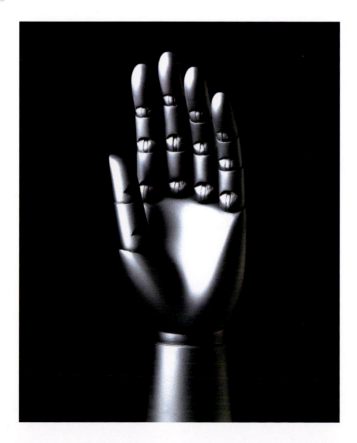

9.29 The same photograph we saw in Figure 9.27, now substantially lighter.

9.30 The histogram for Figure 9.31.

The new histogram has approximately 100 gaps. This is exactly why histograms are so useful. By glancing at a histogram, fairly inexperienced photographers can see problems they might otherwise overlook and even the most experienced eyes get reassurance. Even if we decide that Figure 9.29 is a good picture, its histogram should cause us to worry.

Overmanipulation

Many aspects of manipulating the histogram are identical in the camera and in postproduction, but the differences between the two are important. Although postproduction has nothing to do with lighting, we would be remiss in telling you as much as we do here and then leaving you to think we have told the whole story. We haven't. There's more, and it's so important we ought to mention it even if it doesn't directly relate to lighting.

The best way to avoid a "bad" histogram is to light the scene correctly and expose the picture correctly in the first place. Sometimes this is impossible. We can't ask a rapidly evolving news event to wait for us to set up lights!

Overmanipulation is often caused by repeated adjustments to the image: we adjust the image, look at a proof, tweak a bit more, then run another proof. *Please don't do this!*

In today's digital world, images often move around from place to place and person to person. At each step along the way, their color range, saturation, hue, and all the other parameters may shift and change.

It is not unusual that such "refining" produces an image that is hopelessly overmanipulated. Unfortunately, however, this condition may not be immediately obvious when we look at the picture on almost any existing monitor. Fortunately, however, its histogram will warn us at a glance.

When we adjust a histogram, we spread certain grayscale values over a larger range. (That's what causes those gaps in the "bad" histogram.) However, the tonal scale is limited, and when we expand part of the range we often compress another part. Compression means that grayscale values once represented as a wide range now occupy a narrower range. This means that two values that were originally different grays *now become the same gray*. Detail is lost. Is this all right? Very often, yes, if the sacrifice is more than compensated for by improvements in other parts of the image.

The more serious problem comes from repeated adjustment. The loss is cumulative, and if it happens in small steps, you may not even notice it.

The solution is to keep the original file, to make adjustments to a copy, and to keep notes about what the adjustments were. Then if we are not happy with the result, delete the altered file and return to the original to readjust based on our notes. Recent versions of Photoshop allow keeping such notes in the file itself.

Another alternative is to use a Photoshop *adjustment layer*. This way, no adjustment is made to the original; instead, the adjustment layer represents the image on the monitor or in a printout as if the adjustments had been made. There is, therefore, no harm in returning to the adjustment layer and readjusting as many times as we please.

CURVES

Because the digital realm forces us to talk about issues that do not strictly relate to lighting, we should also mention curves. We will not give detailed information here because existing digital cameras display only histograms. (Some cameras may display curves, however, by the time you read this.) Curves are a postproduction tool that on the monitor look very much like the film characteristic curves we saw earlier in this chapter. They look quite different from the histogram but represent much the same information (Figure 9.31). Their use differs from that of the histogram in two ways: (1) they do not tell us how much of

9.31 The Curves dialog box.

each value is in the scene, and (2) whereas the histogram allows us to adjust three points on the scale (black, white, and the midpoint), curves allow us to set and adjust as many points as we please.

The ability to correct multiple points in the scale makes curves a much more powerful tool for correcting a picture and for ruining it. As it does for levels, Photoshop allows making curves adjustments in a nondestructive layer.

We encourage beginner photographers to learn to control the histogram first and then, later, to move on to curves and use those nondestructive adjustment layers.

NEW PRINCIPLES

We have introduced very few new principles in this chapter. Instead, we have talked mostly about basic photography and basic lighting (plus a few bits of magic and chicanery).

White-on-white and black-on-black subjects do not require many special techniques. These subjects do, however, require the basics, applied meticulously. This may be true of photography in general.

Professional development may not be so much a matter of learning new things but of learning and relearning the basics and combining them in more perceptive ways.

One of these basics is that light behaves like light, and none of our piety or wit can ever make it do otherwise. We like to say we control light, but often all we can really do is to cooperate with what it wants to do. This is true of any light, in the studio or out of it.

You will hear more of this in the next chapter.

284

Traveling Light

Location lighting presents all sorts of challenges. Some are relatively easy to solve. Others require a good bit more effort. Some require you to move hundreds of pounds of gear around, whereas others can be taken care of by the clever use of a portable flash weighing less than a pound. In the following pages we present a number of approaches that we have found helpful.

SOME VERY GOOD NEWS

During the years since the first edition of this book was published, photography has experienced an amazing revolution—the digital revolution. It has turned the world of image making on its head. Be it involving cameras, lights, or postproduction—the art and science of freezing a moment in time have changed to such a degree that they would be almost unrecognizable to photographers plying their trade an amazingly few years ago.

And this is almost all good news—very, very good news as we see it. This is because the new world of photography lets more folks in and allows them to enjoy ever more sophisticated modes and manners of picture making.

And of all the many assorted venues for picture making, none has benefited more than location shooting—particularly the lighting side of it. The reason for this is simple: Picture making has gone digital!

The simple truth is that the fantastic little external or "hot shoe" flashes that are at the heart of the lighting techniques favored by so many of today's top professionals are actually minicomputers connected to flash tubes. But that's not all. Today's computer-centric flash gear is married. It is married to the computer-lens combinations that are today's ever advancing digital cameras.

Fortunately for us, theirs is an extraordinary union. Today's light-giving and picture-recording computer-driven units are in constant electronic communication—communication that, once we users understand it, is capable of, and often does, produce amazing results.

With the above in mind, let us move on to a brief about choosing the lights that are best for what you want to do.

CHOOSING THE RIGHT LIGHT

Three basic kinds of strobes, or "flash," are available today. They range from the big, heavy and hugely powerful to the very small and light, but still amazingly powerful.

In my own shooting, I usually use one or the other of these. However, it is not uncommon for photographers to combine them. For example, one accomplished husband and wife wedding team I know frequently uses a medium-weight battery pack portable strobe mounted on a stand and aimed at the ceiling and a camera-mounted hot shoe flash together. These two lights are connected by a wireless command system. Whenever a picture is taken, both lights fire simultaneously.

Studio Strobes

At the heavy—frequently very heavy—end of the gamut are the studio strobes. But just because they have the word *studio* in their name does not mean that they are destined to always stay in that environment.

When, for example, you are called upon to shoot the 25 members of a board of directors sitting around an enormous conference table, all in dark suits and surrounded by dark paneling, you need plenty of light. Studio strobes can provide enough watt-seconds, usually 1200 to 4800 watt-seconds per power supply, to meet such large-scale, high-quality demands.

Of course, there is no denying that studio strobes are cumbersome to work with on location. And they are even more so if the location lacks electrical power and you have to lug a generator, numerous heavy-duty industrial extension cords, plug-in boards, stands, and other such accessories with you. During such shoots it is easy to become lost in wonder about why one ever thought it would be great fun to become a photographer.

Portable Strobes

Next down the portability scale are the heavy-duty portable strobes. Battery powered, these are less powerful than their studio counterparts. They are, however, considerably easier to carry around. Averaging

from 100 to 1200 watt-seconds, the lower wattage type power packs of such strobes are supported by shoulder straps and attached to the flash head by a power cord. The higher wattage types are placed on the ground and connected to a flash head on a stand.

Lightweight Hot Shoe Strobes

Lightweight and powerful, today's advanced hot shoe strobes offer a high degree of portability and more than enough light for many subjects. Not only can these units be used on camera (hence the common name, *hot shoe*) they can also be fired off camera.

In addition, these units can be combined into multiple flash "gangs" and fired by both radio and infrared wireless control systems. And, making them even more useful, there is a large array of diffusers and other such accessories available for them.

Because of all of the above, these flashes have become the lights of choice for many of today's top-flight shooters—particularly those who spend much of their lives on the road shuttling between locations.

GETTING THE EXPOSURE RIGHT

Studio photographers often work under such consistent conditions that they can use the same exposure they did the day before without thinking about it. Determining exposure is more difficult on location. Ambient light varies. The brightness of reflective walls and ceilings differs from one location to another. The distance to those reflective surfaces depends on the size of the room.

There are three basic ways of coming up with the right exposure using strobes: let the strobe do the work, use a flash meter, or calculate. In this edition we have decided to concentrate on the first two and leave the third out. We came to this decision for two reasons. First, today's digital cameras are the masters of instant gratification. A moment after you press your shutter release, the result is staring up at you from your camera's LCD. That lets you see how things are going *while you are shooting*. If, for example, your shot is on the dark side, you know it immediately and lighten it then and there. Second, today's through-the-lens metering systems are amazingly accurate. They almost always produce flash results that are at least acceptable. With a few test shots, it is then relatively easy to arrive at exactly the exposure you want.

If, however, you are interested in learning the calculations behind the exposure decisions made by today's advanced flash units, you go to their instruction manuals. They provide detailed information on how to calculate flash exposure with their particular gear.

287

Letting the Strobe Determine the Exposure

Today's hot shoe strobes read the light reflected from the subject, and then quickly turn off when they think they have seen enough light to expose the scene properly. Several of the major manufacturers offer automatic strobes specifically designed for use with their cameras. These dedicated units maximize the ability of the camera and strobe to work together.

One of the most important features that dedicated strobes offer is the option to use through-the-lens metering. In addition to ease and speed of operation, the chief advantage of such strobes is that they account for the environment where you are shooting. If, for example, you use one in a large gymnasium and then take it into the coaches' office, it will make the proper exposure adjustment to compensate for the strobe light reflected from the walls of the smaller room.

Using a Flash Meter

A number of different flash meters are available. Although the details of their operation vary somewhat, they all calculate the proper aperture at which the lens should be set for any given combination of ambient light and flash.

We use flash meters from time to time and we like them. Such meters can be a useful accessory for any photographer who uses strobes. However, they have too many disadvantages to depend on them entirely. Like any other sophisticated equipment, they can break when we need them most, especially after they have been knocked around in a camera bag on the way to a location assignment.

However, a bigger disadvantage is that on many location assignments, photographers often find themselves with too little time to work and too much bulk to manage. Flash meters worsen both problems.

GETTING MORE LIGHT

We photographers tend to want more light than we can have. This is especially true of location assignments because mobility and available electrical power often preclude carrying all the lighting equipment we would love to have with us.

There are times, of course, when all that really counts is having enough light to get the picture. We have all been up against such situations. We know before we even release the shutter that the lighting will produce harsh, high-contrast results, but, due to situations beyond our control, such lighting is the best we can get.

Some time ago we accompanied police officers working in a busy precinct. They worked at night and when things happened, they happened fast. There was no time to think the shot through, no time to put the flash in another spot. Because most of the action took place on the street, there were no ceilings or close-by walls from which to bounce a light. The only alternative was to use a flash mounted on the camera.

When the action started, the only thing we had time to do was aim and shoot. Under such circumstances, it would have been foolish to worry about the "quality of the light." All that counted was having enough light to record the scene on film.

Another time, one of us went to shoot pictures of jungle wildlife. As in the busy police precinct, many of the animals became active at dusk. Once again, all that really mattered was being able to light the scene well enough to get the shot.

The list of such situations could go on and on. Examples could be drawn from almost any kind of photography. But no matter how diverse such situations may be, the common thread is that *you must have the amount of light you need to make the picture you want.*

The first thing you can do to provide as much light as possible is to use common sense: take the brightest light you can use practically. Less obvious is that this does not simply mean using as many watt-seconds as possible. Some strobes have more efficient reflectors than others; others offer interchangeable reflectors. Efficient reflectors can multiply light output without increasing weight.

In the case of hot shoe strobes, getting all the light you need usually boils down to taking more than one. An accomplished editorial photographer I know always carries three or more. One serves as his key light while the others provide fill and illuminate those parts of the location he wishes to emphasize in his composition. In one recent shoot he was forced to use eight different flash units to get the results his client demanded.

Focused Flash

You can also use accessories to focus your flash on distant subjects. This is a commonly used technique with wildlife photographers. One of the most popular uses a Fresnel lens to focus light from a camera-mounted flash into a powerful, far-reaching beam. With such a unit it is possible to photograph animals, and other such subjects, at a considerably greater distance at night than it would be with the flash alone.

289

Multiple Strobes

Several portable strobes together produce as much light as, but allow more flexibility than, a single studio strobe. We can use them separately as a multiple-light setup, as larger lights might be used in the studio, or we can group them as a cluster to behave as a single, very powerful strobe.

Today's hot shoe strobes are especially well suited for multiple use. Not only does their small size and low weight make them relatively easy to carry, it also means that you can rig them on lightweight light stands. And that can make a huge difference if the location at which you are going to work is a hard one to get to.

Along with being relatively easy to carry, hot shoe strobes are also designed to work well together. Once you invest the time in mastering how to do it, it is a relatively straightforward matter to get a bunch of these little technological wonders to work together the way you want. In addition, the recent arrival on the market of several different radio control systems allows far more flexibility than standard infrared line of sight setups provide.

IMPROVING THE QUALITY OF LIGHT

The previous section offered some suggestions for obtaining enough light using the limited equipment available for many location assignments. The other problem common to most easily transportable location lighting equipment is obtaining lighting that looks good. Thus we will now move from quantity to quality.

Location lighting often suffers from two basic defects: illumination that is too hard and illumination that is uneven. The hard lighting is caused by the need to use small strobes for portability. Uneven lighting is the result of needing to illuminate larger areas with fewer lights.

Fortunately, two relatively simple techniques can be used to produce an acceptable quality of light with many portable strobes. These are bouncing and feathering. Both help to even out the light in a scene and to reduce unwanted shadows.

Bounce Flash

Portable flashes are, by their very nature, small light sources, and small light sources produce hard-edged, unattractive shadows. One way to soften these shadows is to bounce the light from a wall or ceiling, as shown in Figure 10.1. The ceiling becomes the effective light source. Because the ceiling is a much larger light source, it makes the shadows in the scene far softer and less noticeable.

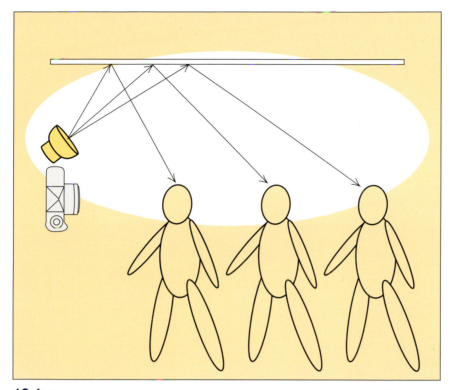

10.1 Bouncing the strobe light from a ceiling or wall enormously increases the effective size of the flash. This causes shadows to become much softer and lights the room more evenly.

Although bounced light is generally far more attractive than direct flash, it does have one major drawback: efficiency. One reason is that the light has to travel farther. The distance from the strobe to the ceiling to the subject is farther than a direct path from the strobe to the subject. Furthermore, part of the light our strobes provide is absorbed by the ceiling. All this adds up to less light where we need it.

The amount of light lost by absorption and scattering varies according to how the ceiling is painted and what its texture is. In most situations, however, compensating by two or three stops is usually adequate. If, for example, you are working in a situation in which you would normally shoot at f/8, the proper exposure is probably f/4. Open up a bit more for darker ceilings. Of course, the technique usually produces good pictures when the ceiling is reasonably neutrally colored.

If the ceiling is very high or if the subject is close to the camera, a ceiling bounce will cause dark shadows in the subject's eye sockets.

291

Many photographers minimize this defect by using small bounce cards, such as the one we show in Figure 10.2. They can be attached to the strobe by a rubber band or tape. In addition, some of the newer hot shoe flashes have a built-in bounce card. This is a great help because they are always available when you want to use them.

These cards bounce some of the light directly onto the subject's face. The rest of the light is bounced from the ceiling. The combined result is a more evenly illuminated picture.

Figures 10.3 and 10.4 show the same scene shot both without and with a bounce card.

10.2 A small bounce fill card on the flash will reduce the facial shadows caused by bouncing light from the ceiling.

10.3 Without a bounce fill card, bouncing the strobe light from the ceiling causes unflattering facial shadows.

10.4 Look at how much lighter and less objectionable the bounce fill card makes the shadows on our subject's face.

Any reflector that is useful in the studio is also likely to serve as a good bounce card on location. You can bounce strobes from them and use them to reflect ambient light into a scene. The only special requirement is that they be transportable. Some reflectors collapse or fold for this purpose. The most common example is the lighting umbrella.

Bigger reflectors are often useful outside the studio because many of the subjects are larger. However, the bigger the reflector is, the harder it is to transport. The most creative solution to this dilemma comes from a photographer we know who once rented large trucks and parked them so that their sides acted as fill cards. Even if you think this tactic is extreme, remember it if you decide to buy a van—consider getting a white one.

Feathering the Light

Feathering a light means aiming it so that part of the beam illuminates the foreground and another part lights the background. Figure 10.5 shows how this technique can be used.

293

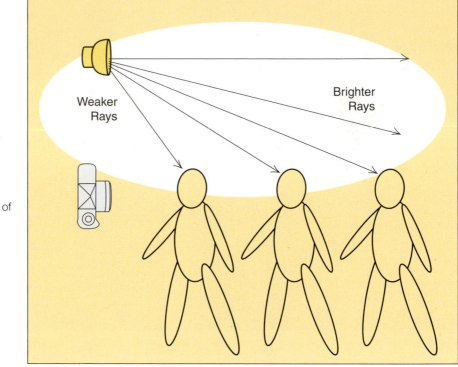

10.5 Feathering the strobe light. The success of this technique depends greatly on the design of the strobe reflector.

Before explaining feathering, a word of caution is due. How well feathering works or whether it will work at all depends on how the flash head is constructed. Some of the larger portable strobes are made with large-diameter, circular reflectors. These usually scatter a great deal of light in directions other than toward the subject. Such units can almost always be feathered well.

On the other hand, many lightweight strobes have very small flash tubes surrounded by efficiently focused reflectors. These direct most of the light toward the subject and waste very little in other directions. This type of beam is far less well suited to feathering. What this means is that the only way to find out if your strobe can be feathered is to try it out. The preceding warning noted, let us now move on to what is actually involved in feathering.

In Figure 10.5, notice how the strongest rays of light are emitted from the center of the strobe head. If the strobe is held at the proper angle, these will illuminate the rear of the scene. The light rays that spill out of the sides of the reflector are far weaker. They illuminate things that are closer to the camera. With a little practice, it is fairly easy to learn how to hold the strobe to achieve the desired degree of feathering.

There is still another lesson to learn from Figure 10.5. In it you will notice that the flash is being held as high as possible. This is done to

10.6 Holding the strobe too low causes distracting shadows on the wall.

10.7 Holding the flash high enough causes many distracting shadows to disappear.

position it so that any shadows its light casts will be as unobtrusive as possible. The higher the light is, the lower the shadow will be cast. Thus, if a subject is standing near a wall and the flash is held high, the shadow will fall where the camera cannot see it.

We made Figures 10.6 and 10.7 of the same subject, with the strobe in two different positions. In Figure 10.6, we held the flash low, at about camera height. Notice the very pronounced and distracting shadow on the wall that this lighting produces. Now look at Figure 10.7. This time we made the picture holding the flash as high above our head as possible. Notice how that action caused the shadow to disappear.

LIGHTS OF DIFFERENT COLORS

Photographers in the studio carefully control the color temperature of their light. All lights usually have the same color balance. Adding other lights with gels or lights of another type is a deliberate attempt to alter the color, not a whim or an accident.

Photographers working on location may not be able to carefully control the color temperature of the light. The existing light in the scene often does not match any standardized photographic color

295

balance. It may be impossible to get rid of the existing light. Even in an indoor location in which the existing light can be turned off, it may be essential to leave it on for enough light to illuminate a large area. This nonstandard color has unpredictable consequences if photographers do not anticipate problems and take steps to deal with them.

Why Is the Color of the Light Important?

Shooting a color image with light sources of different colors can be a serious problem. When we look at a scene, our brains compensate for some fairly extreme differences in the color of light to interpret most scenes as lit by "white" light. There are exceptions: if you are traveling at dusk, with your vision adjusted for dim daylight, you can see the lights of a distant house to be the orange color that they really are; if you stop at that house, however, and go in, your brain will immediately compensate again and you will see the light as white. To see why this happens, let's look at the two standard light colors, *tungsten* and *daylight*.

Tungsten

This term applies to a scene lit by tungsten bulbs. These tend to be relatively orange. Set for tungsten, the camera white balance compensates for the orange. Used with tungsten lights, it produces picture colors that are close to natural.

If, however, we were to use a tungsten white balance to shoot a picture illuminated by daylight, the resulting color would be nonstandard. Instead of looking "normal," the entire scene would appear very blue.

To be accurate, we have to point out that household tungsten bulbs almost never produce light that is the color of photographic-standard tungsten. They are more orange when they are new and get still more orange with age. Quartz-halogen lights, used by photographers and theater producers, do have accurate tungsten color and keep that accurate color throughout the life of the lamp.

Daylight

Daylight white balance produces standard color in a scene that is illuminated by the sun. Obviously, sunlight is different colors at different times of day and in different weather conditions. Originally "standard daylight" was sunlight, at a specific time of day, at a specific time of year, at a specific location, and on a cloudless day, in Britain.

Such light is rich in blue, and that is why the sky on a clear day is blue. A daylight color balance compensates for this and gives the most

accurate color reproduction used with either midday sunlight or strobe. If this balance is used with tungsten light, the pictures look orange.

Nonstandard Light Sources

Photographers consider daylight and two slightly different colors of tungsten light to be standard. All of the others are nonstandard to us. Unfortunately, "nonstandard" does not mean "unusual" or "rare." Other lights are quite common. We will use a few of them as examples. This does not approach a complete list of nonstandard sources, but they show the dangers well enough to keep you alert to the potential problem in any location assignment.

The frequent mix of lighting, especially in many modern offices, is the root of the problem. The digital camera can compensate for the color of almost any nonstandard light. Furthermore, it can compensate for almost any even mix of light colors.

The difficulty comes from an uneven mix: part of the scene is lit by one light, and other areas are lit by lights of other colors. It's expecting too much to want the camera to fix such problems, and we have to think better than the camera does to fix them ourselves. The following are some common light sources we call *nonstandard*.

Fluorescent tubes are the nonstandard light source photographers encounter most frequently. The light produced by fluorescent tubes presents photographers with a special problem. In addition to being nonstandard, it comes in many different colors. Age changes the color of fluorescent tubes slightly.

Furthermore, people replace burned-out tubes with new ones of another type. After a few years, a single large room may have several different types of tubes. A white balance that is good for any particular type of tube may be bad for the rest.

As a rule, the light from these tubes tends to have a strong green cast. This can produce some particularly unpleasant nonstandard colors when either tungsten or daylight film is used. People, in particular, tend to look awful when they are photographed under uncompensated fluorescent lighting.

Nonstandard tungsten light is more common than either of the photographic standard tungsten color temperatures. Ordinary tungsten bulbs are significantly more orange than photographic bulbs, and they get more so as they age. The difference is enough to matter whenever color balance is critical.

Nonstandard daylight does not surprise most people. We all know that sunlight is much redder at dawn and dusk. What surprises most of

us more is learning that daylight can be very nonstandard, even in the middle of a bright day.

Figure 10.8 illustrates two different kinds of daylight. The house on the left has direct sun coming through a window onto the subject. Such direct light from the sun will be slightly warm. It will have a slightly red to yellow color bias. On the right, we see a different "daylight" situation. This time the subject is being lit by light that comes from the blue sky rather than the sun's direct rays. This light is decidedly cool. It has a good deal of blue in it.

Both of these subjects are illuminated by daylight. The only problem is that the so-called daylight is very different in each of them. Each produces a picture with a different color balance. The cause of the problem is that each subject lacks part of what we accept as standard daylight.

When photographers use the term *daylight* we mean light that is made up of a *combination* of rays that come *directly from the sun* and those that come to us from the sky around it. In the preceding example, each subject was lit by only one of the two parts of that combination.

Another common cause of nonstandard daylight is foliage. Subjects shaded from the direct sunlight may still be illuminated by the open sky.

10.8 The direct sunlight striking the house on the left is warm colored, noticeably biased toward yellow. Light reaching the house on the right comes from the blue sky, and it will have a much cooler, blue-biased color.

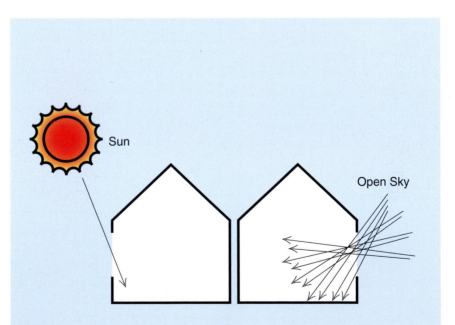

This causes the same blue shift we saw in the subject on the right in the preceding example. This problem is compounded by green leaves filtering and reflecting whatever sunlight does reach the subject. In extreme cases, the result looks more like fluorescent light than daylight.

Once again, the color error may not be significant in many cases, but we have to think about the importance of accurate color in each scene and decide whether the problem needs a remedy.

Do the Colors Mix?

There are two basic situations that we encounter when working with different colored light sources. The first happens when we use what we will call *unmixed color*; the second occurs with *mixed color*. As you will see shortly, unmixed and mixed color present different challenges, and they are handled in different ways.

Mixed color lighting is just what the name implies. It occurs when the rays of light with different color balances *mix or blend together* to produce a color balance different from that of any single light source.

Figure 10.9 shows how light sources can mix together in this way. Fluorescent tubes provide the ambient illumination. A strobe is

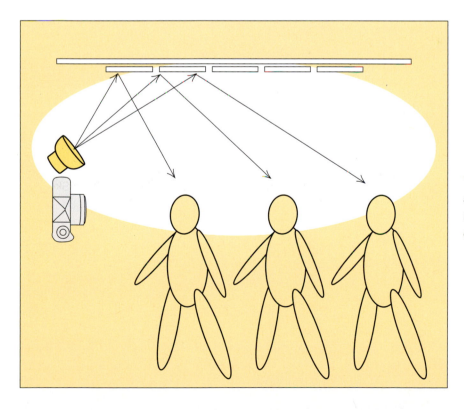

10.9 Mixed strobe and fluorescent illumination produces evenly colored light.

10.10 Mixed color is easy to correct, if everything is lit roughly equally by all sources.

bounced from the ceiling. The bounced strobe illuminates the scene much as the fluorescent tubes do. The light rays from the flash tube mix with those produced by the fluorescent tube. The result is a fairly even illumination throughout the scene by light of a different color balance from either the flash or the fluorescent tubes alone. We shot Figure 10.10 with evenly mixed light sources. Every light was "wrong" for photography, but the mix was easy enough to correct.

Unmixed color is diagrammed in Figure 10.11. The scene is the same, but the strobe is now directed at the subject, not the ceiling. This is a common example of a scene that is illuminated differently by each of the two light sources.

Notice in the diagram that the bulk of the scene is lit by overhead fluorescent bulbs. However, the foreground subject and his immediate surroundings are lit by the flash.

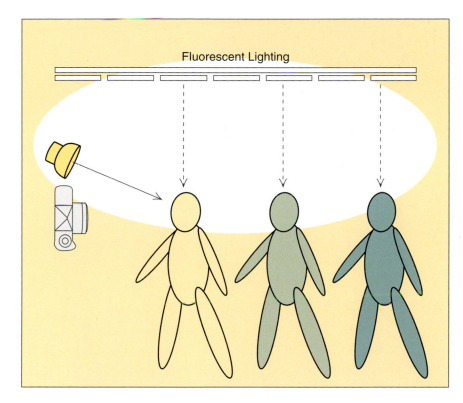

10.11 Using the flash as shown here will produce a picture in which different parts of the scene are lit by very differently colored light. This can cause serious problems in color photography.

The result is two very differently colored areas in the picture. The foreground subject and his immediate surroundings will be illuminated by the relatively blue "daylight" from the electronic flash. The rest of the scene will, however, receive the green light from the overhead fluorescents. The problem is that the camera can be balanced for only one light source.

Sometimes unmixed lighting can occur when we do not expect it. In Figure 10.12, the wall behind the subject is not a great deal farther from the strobe than the subject himself. We might expect to have the same mix of strobe and ambient light on everything in the picture.

Notice, however, that the strobe and the fluorescent light come from different directions. The strobe casts a shadow on the wall, but the fluorescent light illuminates the shadow and makes it green.

The Remedies

Both mixed and unmixed light situations are common, and it is important to be able to handle both of them. We use a slightly different remedy for each.

301

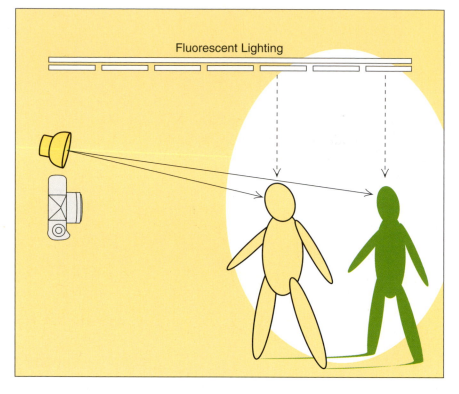

10.12 Because the fluorescent light illuminates the shadow the strobe casts on the wall, the shadow will look green in a color photograph.

Correcting Mixed Colors

Mixed color situations are relatively easy to handle because the improper illumination that results from them is *uniform throughout the scene*. In other words, the entire scene is lit by light that has the same color balance. The color balance of the whole picture will be wrong, but all parts of the scene will be wrong in the same way.

Correcting Color while Shooting

It is this uniformity of error that makes the problem so simple to correct. The camera will probably fix it for you. If it doesn't, it will be close enough that a slight warming or cooling of the image will fix it. The result will be a picture that has the correct color balance and in which colors within the scene reproduce in a standard, or realistic, way.

Correcting Color after the Picture Is Shot

Because any color-balance problems are uniform when mixed colors are used, it is relatively simple to make any required color adjustments during postproduction. This gives you a useful safety margin should you fail

to get the proper correction when you are shooting the picture. The color balance may not be quite as good as a picture that was shot right to begin with, but it is likely to be good enough that an experienced viewer cannot tell the difference without a side-by-side comparison of the two.

One caution is due, however. Beware of those scenes that include a light source or the mirror reflection of one. These extremely bright areas record in the picture as white highlights, regardless of the color of the light producing them. These highlights may then take on the color of whatever correction is used to remedy the rest of the scene.

You can deal with this problem, but it requires more than the straightforward color adjustment most people know how to do in their image editing software and is a topic too far from photographic lighting to deal with in this book. Even worse, only the best offset printers have prepress departments who can deal with it. The way to be sure to get it right is to either correct the color while shooting the picture or to compose it so that it does not contain any troublesome highlights.

Correcting Unmixed Colors

No white balance adjustment can correct unmixed color. Whatever correction is right for one area is wrong for another. Trying a compromise white value between the two produces just that: a compromise in which nothing in the scene is quite right. You can often correct the color balance locally in image editing software—a little more blue here, more yellow there—but that's tedious and it's best to avoid it when you can.

Making the Sources Match

The best way to cope with unmixed color sources is to filter the lights to match each other as closely as possible. The objective of this is to get all of the light sources to be a *single* color but not necessarily the *right* color. Then let the camera adjust the overall scene to be right.

Thus, if we were faced with situations such as those in Figure 10.11 or 10.12, we could cover the flash with a light green theatrical gel that approximately matches the color of the fluorescent. (The gel color is called Tough Plusgreen, equal to CC30G.) This adds enough green to make the strobe light approximate the color of many overhead fluorescents. Then the entire scene is lit by light of at least similar color. The camera can probably get the color close enough that whatever adjustment we need to make is minor. Even better, we can make a global color correction for the entire scene without individually retouching each item in the picture.

303

The filter we suggest here is a solution that frequently, but not always, works. The specific filtration varies with the scene. As was the case earlier, the only really satisfactory way of determining exactly what filter to use is by trial and error.

Filtering the Daylight

Remember that windows are light sources and that they can be filtered like any other light source. Motion picture and video photographers do this routinely, but still photographers tend to overlook the possibility.

Consider a scene in which a room is lit by tungsten photographic lights and by daylight coming through open doors or windows. A quick solution would be to use blue gels on the photographic lights to make them match the daylight. Then the scene could be shot at a daylight white balance. However, our lights are probably weaker than the sun, and we would prefer not to dim them even more with the light absorbed by the filter. A better solution would be to put orange theatrical gels on the outside of the window and then shoot with a tungsten white balance. This accomplishes the same balancing of light colors but better balances the intensity of the two sources.

Correcting Errors in Reproduction

If the color is unmixed, this is the worst solution. Use it only as a last resort. No single correction will work for the entire scene. Local correction within the scene can be fun when you are learning image manipulation software, but it costs extra time, money, or both.

LIGHTS OF DIFFERENT DURATION

Photographers often use photographic light and existing light together so that one source is the main light and the other is the fill. Measuring the relative brightness of the two is easy if both lights are turned on continuously. This is true, for example, if the two sources are sunlight and tungsten.

However, if the photographic light is strobe instead of tungsten, comparing its brightness with the daylight is more difficult. The daylight is "on" continuously, but the strobe lights for only a fraction of a second. We cannot see the relationship between the two.

Figure 10.13 shows a common outdoor shooting situation in which strobes are useful. When we placed the model where we desired, he was backlit. As a result, a normal exposure was far too dark.

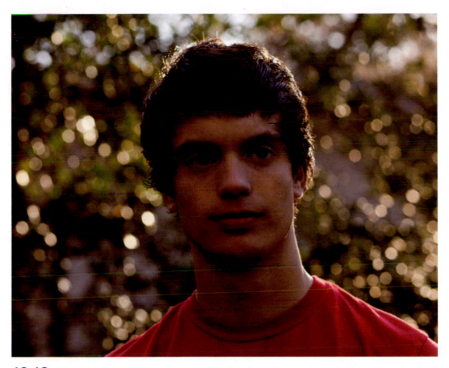

10.13 The composition we wanted called for the model to be backlit. However, with a normal exposure, this arrangement produced a picture that was far too dark.

There were two ways in which we could have corrected this picture. One would have been to increase our exposure substantially. This exposure correction would have lightened the subject, but it also might have caused serious flare from the sunlight coming through the trees.

Our other alternative would have been to use a strobe to fill in the shadow. Figure 10.14 shows the result of such lighting. The fill flash did just what we wanted it to do. It allowed us to produce a picture in which both the background and the subject are properly exposed. Given that the use of a fill flash was a good idea in this situation, the next question is how to calculate the proper exposure for the picture. How were we able to select an exposure that took into account *both* the *ambient daylight* present in the scene and our *strobe output*? Keep the following points in mind:

- In situations such as our example, the strobe exposure will be determined almost exclusively by the aperture. The flash is too brief to be significantly affected by shutter speed.
- The ambient light exposure will, on the other hand, be determined by a combination of both the aperture and the shutter speed.

305

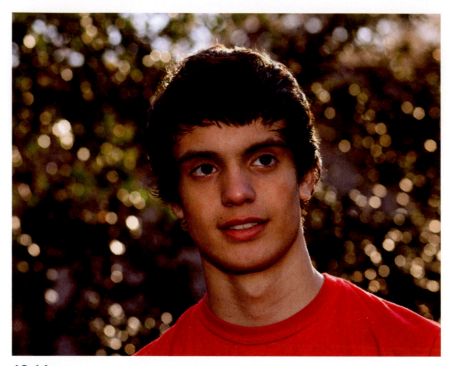

10.14 A fill flash produced an exposure in which both the subject and the background are properly exposed.

If you photograph a political leader dashing to his limousine after his fraud indictment, you will certainly let the camera determine the balance between your strobe and the ambient light. If you photograph a room interior for the cover of a furniture catalog, you will carefully balance the ambient and artificial light. Increase your shutter speed for more of the ambient light. Decrease the shutter speed for less ambient light. If the change in shutter speed makes the image too light or too dark, then adjust the aperture to compensate.

IS STUDIO LIGHTING POSSIBLE ON LOCATION?

Yes, of course studio lighting is possible on location, but it may require much more work to achieve it. Control is more difficult. Habit and experience sometimes will not substitute for calculation. Testing and reshooting are sometimes the only ways to get the best results. Whatever it takes to get those results, we hope this chapter helps you achieve them.

Good pictures require more than good lighting. When we have even less control over the subject than we do the light, speed and spontaneity can count more than technical virtuosity. The success of the picture

depends on being able to record the critical instant, not the instant just after it. So we also hope you can use some of the shortcuts in this chapter to get the picture before the picture gets away.

Either way is good at the right time and place.

This is the most important message in this book. There is no "correct" way to light a scene, just as there is no decidedly "right" camera to use. Good photographers have a toolbox of ideas and techniques. They pick from that toolbox according to the task of the moment.

We will not mind if you never light a single subject exactly as we have in our examples, but we do want you to have our toolbox of ideas to use as you please. Help yourself.

Index

Note: Page numbers followed by *f* indicates a figure.

Check us out at
masteringphoto.com

MasteringPhoto, powered by bestselling Focal Press authors and industry experts, features tips, advice, articles, video tutorials, interviews, and other resources for hobbyist photographers through pro image makers. No matter what your passion is—from people and landscapes to postproduction and business practices—MasteringPhoto offers advice and images that will inform and inspire you. You'll learn from professionals at the forefront of photography, allowing you to take your skills to the next level.